IMAGES
of America

TEMPLE

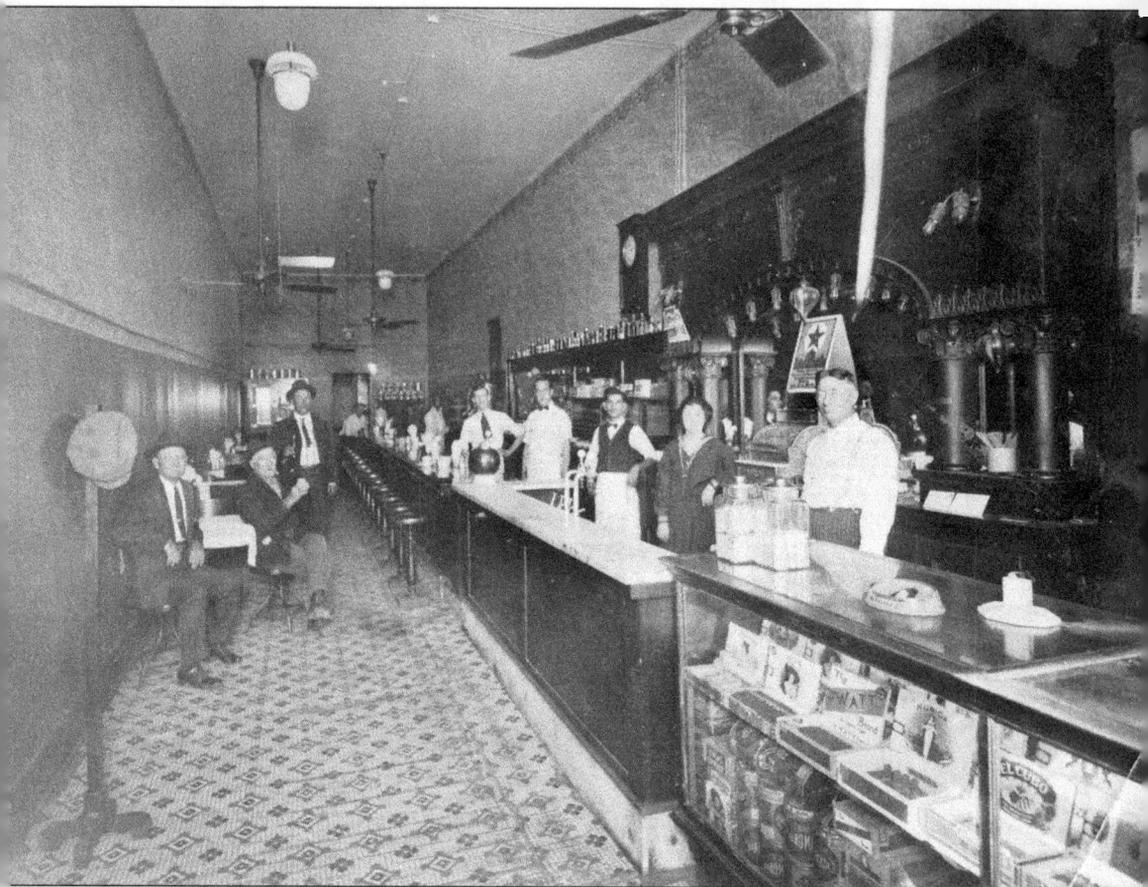

One of the earliest employees of the Gulf, Colorado and Santa Fe Railway was Bill Holden (1870–1957), far right. He came to Temple in 1882. Known as "Uncle Billy," he was reported to be on the first Gulf, Colorado and Santa Fe Railway train to go from Lampasas to San Angelo. In 1906, he retired from the railroad and entered the restaurant business. His patrons coined the slogan, "the man who feeds the people." (Courtesy of Railroad and Heritage Museum.)

ON THE COVER: The last three structures visible in this image of a parade on South 1st Street around 1956 are the oldest group of commercial buildings remaining in the business district. The end building is the oldest. It was erected as a hotel in the 1880s, and Vincent Buranelli used it for a fruit stand. The family lived on the second floor. (Courtesy of Temple Public Library.)

IMAGES
of America

TEMPLE

Michael Kelsey and Nancy Kelsey

ARCADIA
PUBLISHING

Published by Arcadia Publishing
Charleston, South Carolina

Library of Congress Control Number: 2009935207

For all general information contact Arcadia Publishing at:
Telephone 843-853-2070
Fax 843-853-0044
E-mail sales@arcadiapublishing.com
For customer service and orders:
Toll-Free 1-888-313-2665

Visit us on the Internet at www.arcadiapublishing.com

CONTENTS

ACKNOWLEDGMENTS

It has been a pleasant experience for us to research the archives of our city's public depositories and for the generosity of friends and private collectors who shared their photographs, manuscripts, correspondence, and documents in an effort to compile a brief but interesting and informative pictorial essay of the city of Temple. This small collection is neither a history nor a tale but rather a summary of images that depict the everyday lives and events of ordinary people at work, worship, and celebration.

Most helpful was a collection of little-known photographs and negatives of street scenes and businesses of Temple from the 1940s through the 1950s, taken at a time when the commercial district of the city was at its zenith. The Temple Chamber of Commerce deposited these historic photographs and negatives in the Temple Public Library.

In addition to the Temple Public Library archives and our private collection, the Kelsey Collection, we accessed the archives at the Railroad and Heritage Museum. Judy Covington and Craig Ordner at the Railroad and Heritage Museum were most helpful in assisting us. Private collectors who also assisted us were Sam Houston, Jennie Peteete, Carol Dreesen, Calvin Zabcik, Tom and MaryBelle Brown, and the Sullivan family.

INTRODUCTION

In 1881, 36 years after Texas became a state, the Gulf, Colorado and Santa Fe Railway founded Temple on a treeless prairie. Ten years later, in 1891, the railroad established a hospital for its employees at Temple. These two events contributed to Temple's development as a trade and hospital center.

Bell County covers an area of approximately 1,079 square miles at altitudes ranging from 400 to 1,200 feet. Located eight miles northeast of Belton, the county seat, Temple is on the Maximo Moreno Eleven League Grant of October 8, 1833. The grant encompassed approximately 45,000 acres and extended from the Leon River to about three miles north of Temple and as far east as the present town of Heidenheimer. Moreno, a lieutenant in the Mexican army, received a land grant from the Mexican state of Coahuila and Texas. Moreno, his wife Francisca, and two children, Jorge and Francisca, never resided on the land. The Gulf, Colorado and Santa Fe Railway named Temple for chief engineer Maj. B. M. Temple of Galveston.

On June 29, 1881, the Gulf, Colorado and Santa Fe Railway held a public sale of town lots, officially recognizing Temple as a town. Town lots sold at eight percent interest, recorded in the deed books of Bell County, and signed by George Sealy of Galveston. He represented the Gulf, Colorado and Santa Fe Railway. The majority of the deeds were recorded on July 1, 1881. The original town site extended from Barton Avenue south to Avenue G and from 9th Street east to 6th Street. A second railroad, the Missouri-Kansas-Texas Railroad, arrived in 1882. This gave Temple two railroads.

About seven months before the sale of town lots on June 29, 1881, Otto Burwitz opened the first saloon. By April 1881, there were two saloons. Twenty years later, despite the repeated efforts of the prohibition movement, Temple in 1901 had 21 whiskey saloons and 19 beer joints.

Temple's importance as a center of trade contributed to an early and sustained population increase. In 1882, the population was estimated to be between 1,200 and 1,500 and more than 7,000 in 1892. By 1936, Temple's population was 20,000. There were 62 industrial plants with 700 employees, 4 hospitals, 3,600 water meters, 3,300 light meters, 2,200 gas meters, 2,000 telephones, and 4,500 houses. The area of the town was 4.1 square miles. Currently, the population is approximately 60,000.

Temple was home to the following citizens: James E. and Miriam Ferguson, a husband and wife who both served as governor of Texas; Hiram Evans, father of Hiram Wesley Evans, the imperial wizard of the Ku Klux Klan; Lovick Pierce Moore, who came to Texas in 1835 and participated in the battle of San Jacinto; and Frances Hall Ayers (1824–1891), a Mier prisoner. The Ayers family came to Texas in 1833. The last letter William Travis wrote was to David Ayers, the father of Frances. David Ayers took care of Charles Travis after his father's death at the Alamo. Actresses Beatrice Allen, Jene Darnell, and Mary Alice Rice, along with Retha McCulloch, one of the first women in the state to become a solo pilot, in 1928, also made their homes in Temple. Other residents of Temple include George and Herman Brown of Brown and Root; John Wright, the

first licensed embalmer in Texas; F. L. "Pink" Downs, who is credited with the Texas A & M University slogan, "Gig 'em Aggies;" and Jeff Hamilton, a slave of Gen. Sam Houston.

Temple residents Charles Barrett, George C. Pendleton, Huling P. Robertson, and Hugh Harris were in the Texas legislature. Those who served in the legislature in other states were Col. John Jenkins Lowry (Tennessee) and Henry Hicks (Florida).

In 1902, Dr. Raleigh R. White was the first to introduce an automobile to Temple. The Temple Post Office was among the first in the state to secure rural route service, and Temple was the second post office in Texas designated as a postal savings bank. Producers Refining Company opened Temple's first residential filling station in 1923 at the corner of North 3rd Street and Downs Avenue. In 1928, the Arcadia featured the first "talking movie" in Temple. In 1946, the first 7-Eleven convenience store in Temple opened at 217 North 3rd Street.

W. S. Banks, who came to Temple in 1883, is reputed to be the first attorney to locate here. J. W. Moffett was the author of the noted *Texas Civil Form Book* and was among the first attorneys to practice law in Temple. Temple's first dentist was Dr. J. P. Stansell, who came to town in 1881. T. P. Early and Mabry T. Cox were pioneer physicians; Cox was located one mile out of town. Banks, Stansell, and Cox are buried at Temple.

Lillian Seller was the first Temple resident to make a debut in grand opera. Herbert Wall was the first Temple man to become dean of music at a university. Willa Cahoon Watts was the first Temple woman to become dean of music at a university, and Fred Cahoon was the first Temple violinist to have a position in the Damrosch Orchestra. Eva Keys was Temple's first music composer. Few Brewster had the distinction of being Temple's first pianist to appear in an orchestra on a radio artist program.

This volume introduces the reader to a series of images and scenes from Temple's beginning through the present that capture the growth of the city from a predominantly agrarian-dependent economy to the vibrant and diverse manufacturing and advanced medical center of today.

The authors hope to acquaint the reader with the city's rich architectural heritage and, by so doing, instill in future generations the same pride and respect for the city that the progressive city founders possessed. It is also hoped that the memories of those living and who remember Temple more than half a century ago are excited.

One

RAILROADS AND
HOSPITALS

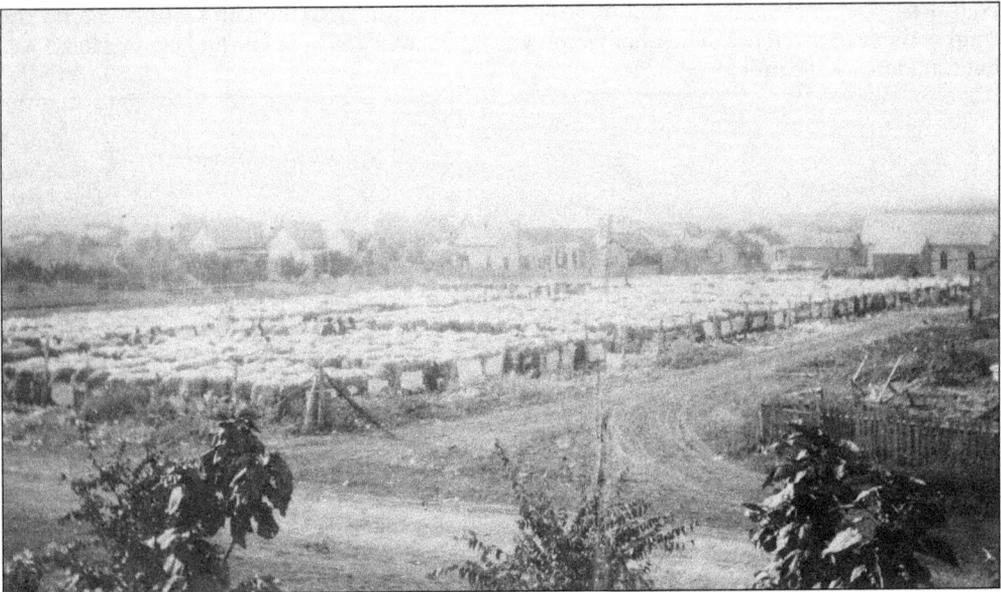

With the arrival of the railroad in 1881, Temple became an important center for trade. From February 2, 1881, when the railroad first starting shipping, to July 1 of the same year, 2,315 bales of cotton were shipped. Cotton, corn, wheat, and oats were the principal agricultural commodities shipped by the railroad. Cotton season was a busy time for railroads, farmers, gins, and merchants. Cotton was stored in cotton yards until shipped to Galveston and other points. In 1892, the town benefited from the availability of new homes, seven churches, three national banks, and three cotton gins. The first Stag Party, a Thanksgiving celebration of a bumper crop of corn and cotton, was in 1892 at the opera house on the public square. Pictured about 1889 is the season's abundant cotton crop stored in the cotton yard. (Courtesy of Temple Public Library.)

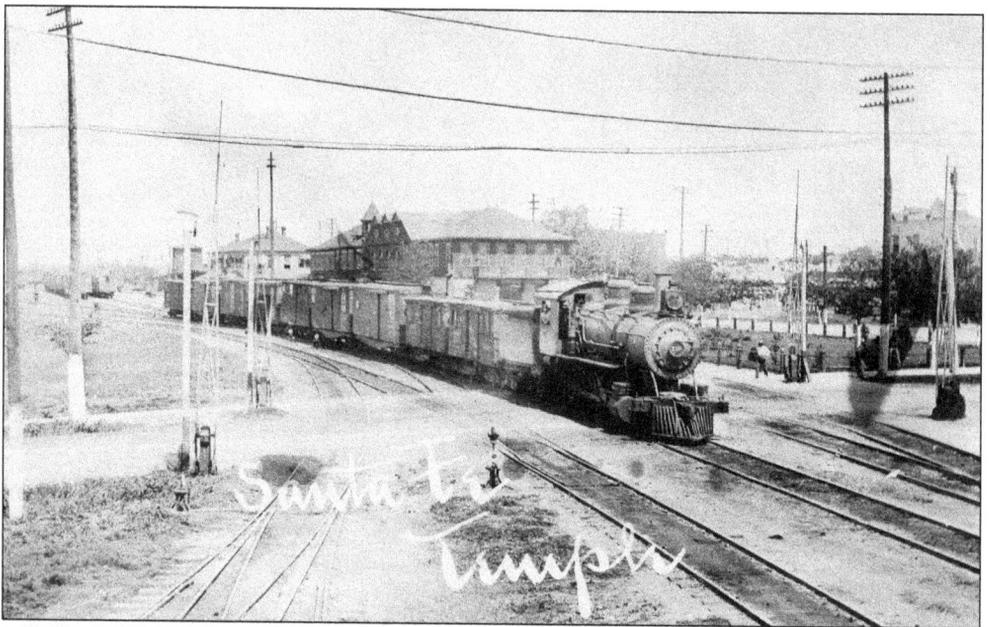

Gulf, Colorado and Santa Fe Railway steam engine locomotive No. 729 is visible as it approaches the intersection of South 1st Street. Notice the early crossing gate. The Gulf, Colorado and Santa Fe Railway Depot is visible behind the train (left), and the larger building visible behind the train is the Harvey House. The photograph was taken after 1898, when the Harvey House was built. (Courtesy of Sam Houston.)

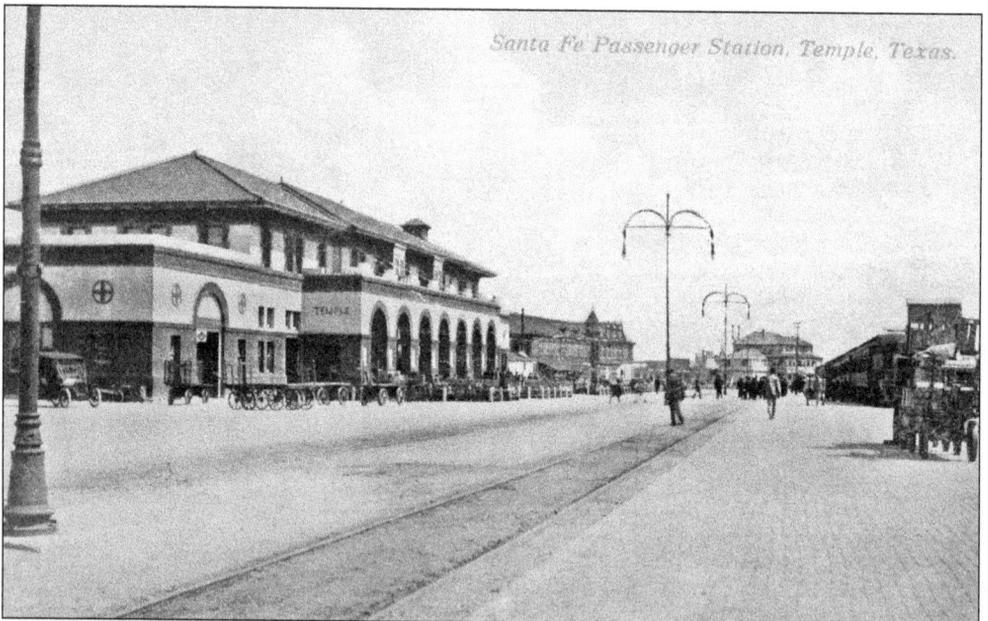

The Gulf, Colorado and Santa Fe Railway depot was completed in 1911. The main floor waiting room was 44 by 88 feet, with gray marble floors and green tinted wainscoting. Provided were a smoking room and an office for every employee from the division superintendent to the porter. Currently, the Railroad and Heritage Museum and Amtrak occupy the building. (Courtesy of Temple Public Library.)

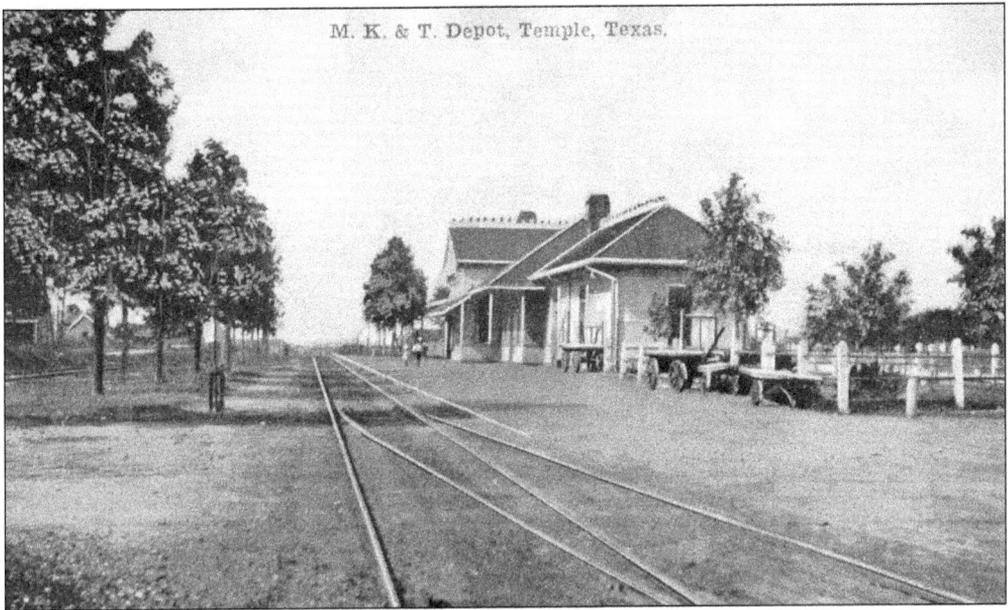

M. K. & T. Depot, Temple, Texas.

In 1882, the second railroad arrived in Temple, the Missouri-Kansas-Texas Railroad, owned by Jay Gould. Between September 1, 1882, and January 27, 1883, the railroad shipped over 2,800 cotton bales from Temple. Pictured is the Missouri-Kansas-Texas depot. A brick depot replaced this one. (Courtesy of Temple Public Library.)

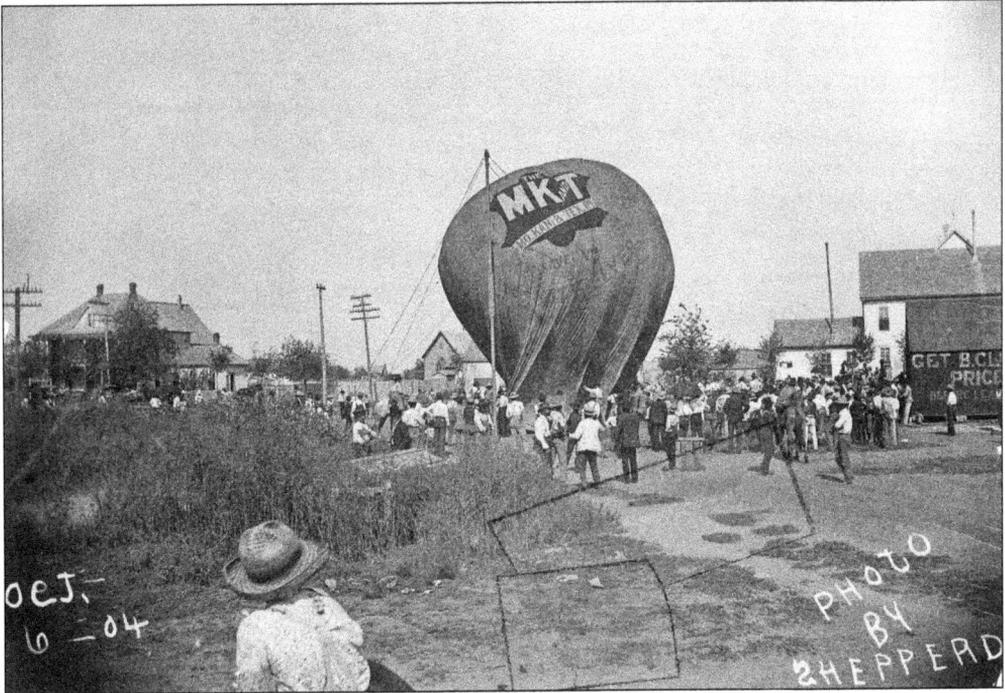

This Missouri-Kansas-Texas Railroad balloon advertised travel on the Katy Flyer. The Katy Flyer was one of three special routes offered by the railroad and it included Temple. Temple photographer E. M. Shepperd took this photograph in 1904. The event most likely took place near the railroad depot and tracks in East Temple. (Courtesy of Sam Houston.)

11

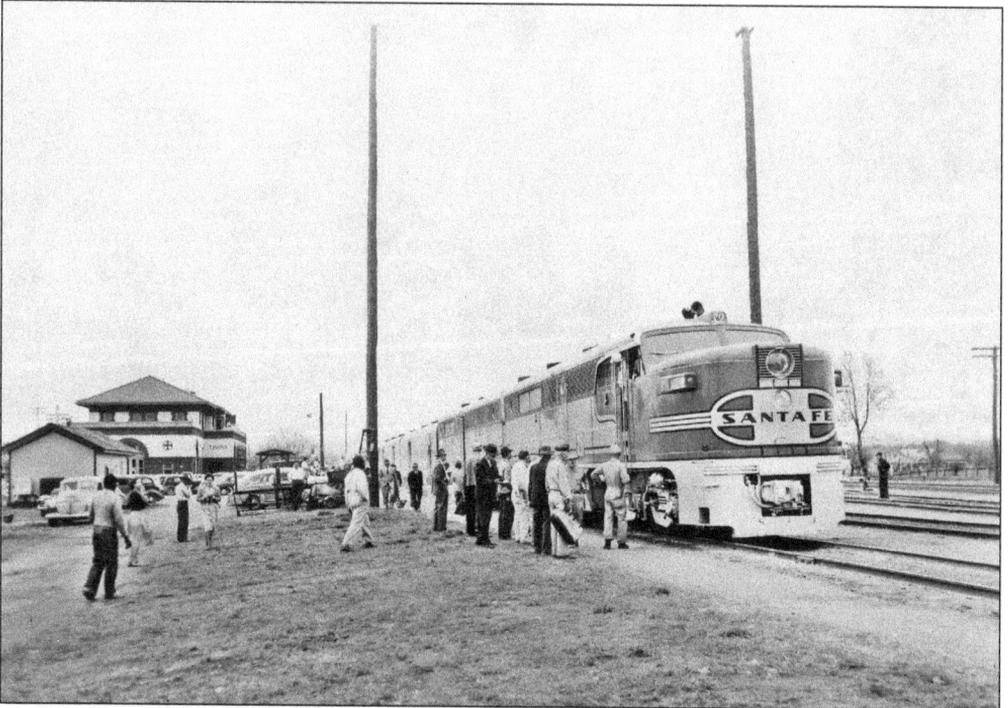

This photograph was taken when the first Gulf, Colorado and Santa Fe Railway diesel locomotive arrived in Temple, about 1948. People came from around the area to view the Alco PA model *Texas Chief* locomotive. The brick two-story Santa Fe depot can be seen in the background, and the photograph was taken from west of the building. (Courtesy of Sam Houston.)

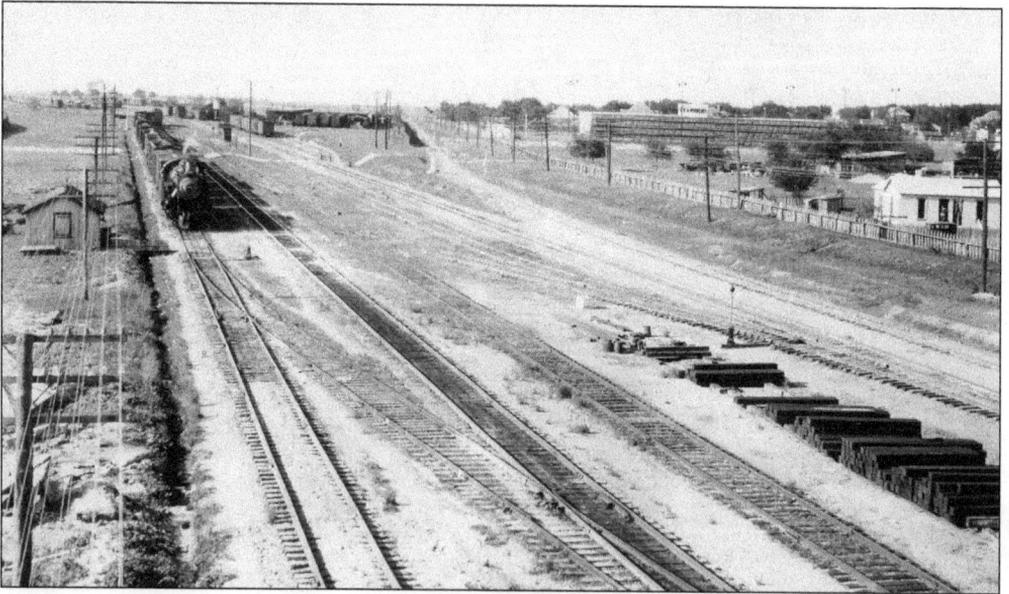

Gulf, Colorado and Santa Fe Railway's North Yard was utilized for making up trains and storage of railroad cars. This view from the West Adams overpass shows a train (left) in the North Yard. At right, the main track entering or leaving Temple is visible. Woodson Field, the old high school athletic field, is to the right. (Courtesy of Temple Public Library.)

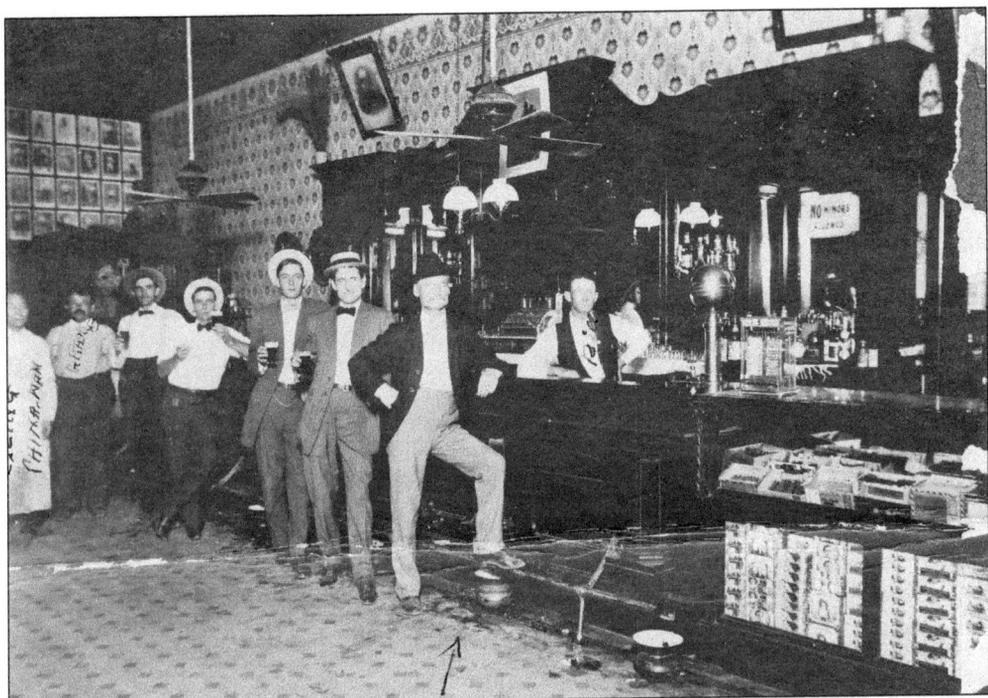

Violence was the norm in railroad towns, and Temple was no exception. There was a predominantly male population and the town had saloons, gambling, and prostitutes. In 1907, there were 21 whiskey saloons. Pictured in a saloon from left to right are E. Ling; ? Grauke; four unidentified; Dr. J. P. Hawkes, a physician for the railroad; and Bill ?. (Courtesy of Railroad and Heritage Museum.)

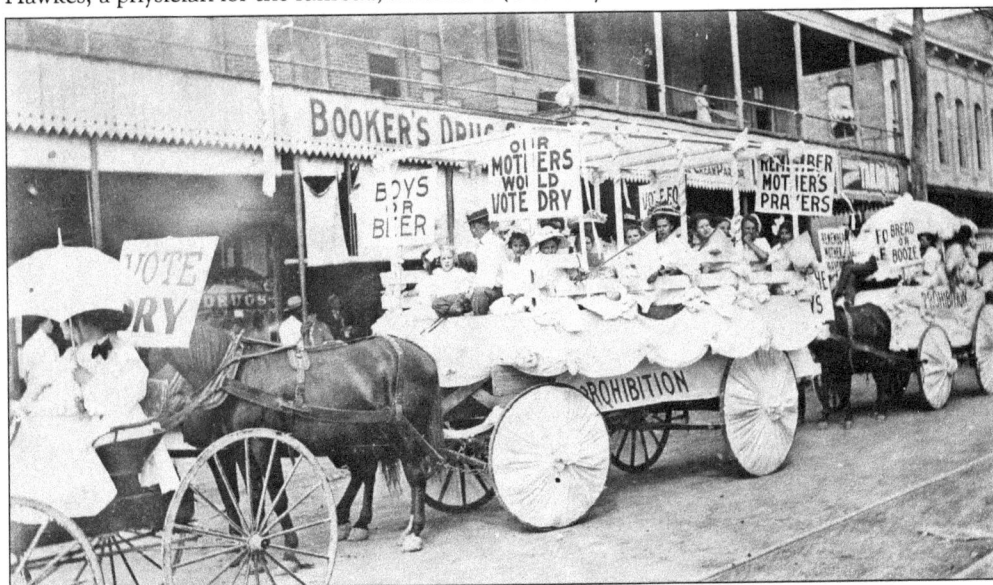

The vice and social ills associated with liquor precipitated prohibition movements from the 1880s to the 1930s. Pictured around 1910 is a prohibition parade on Avenue A in front of J. J. Booker's Drug. Women could not vote, and one of the slogans visible in the photograph reads, "Our mothers would vote dry." Other slogans visible are "Boys or Beer" and "Bread or Booze." (Courtesy of Temple Public Library.)

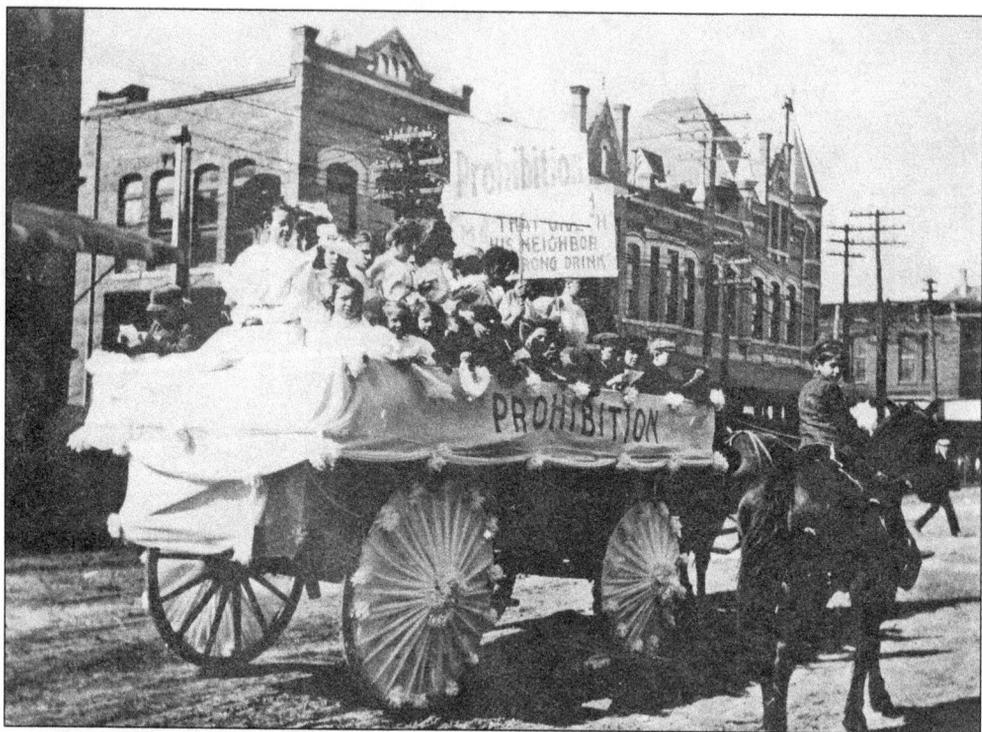

Pictured before 1912 is a prohibition parade on Avenue A, looking west. The wagon wheels are decorated for the parade. The imposing Willcox Building, more familiarly known as the Hammersmith Building, is in the background. The slogan on the sign reads, "Woe unto him that giveth his neighbor strong drink." (Courtesy of Temple Public Library.)

Pictured from left to right are the Santa Fe depot, the Harvey House restaurant and hotel (built in 1898), and the Martin Hotel. They were all built for the convenience of Gulf, Colorado and Santa Fe Railway passengers. When the new depot opened in 1912, the Harvey House was reported to be the largest of the system. (Courtesy of Temple Public Library.)

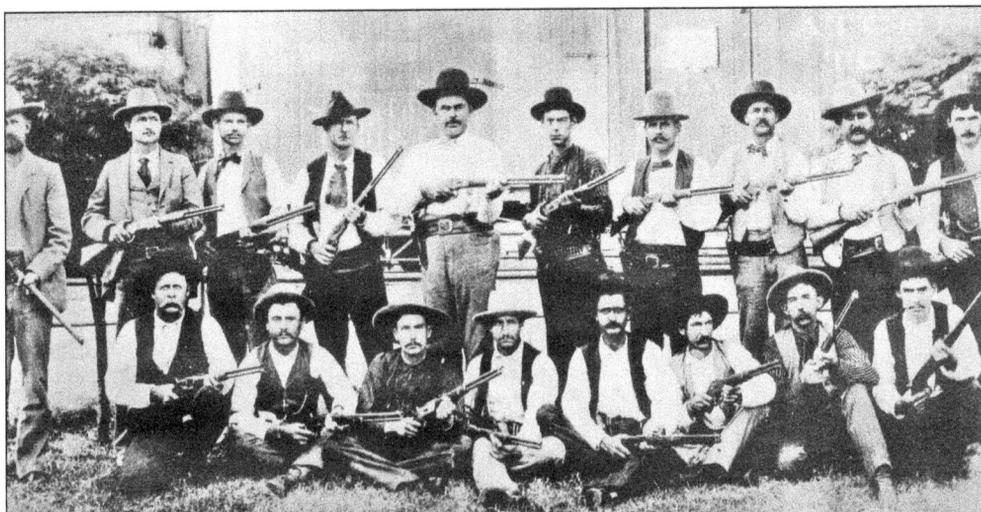

Texas Rangers,at Temple,Tex.,Railroad Strike,July 1894.--Standing, left to right: Capt.J.A.Brooks,Co.F;-Capt.J.R.Hughes,Co.D;-Private John Nix, Co.E:-Corp.E.D.Aten, Co.D;-Private Ed.Connell,Co.B;-Corp.T.M.Ross,Co.E;-Private Lee Queen,Co.B:-Private A.A.Neeley,Co.B;-Private G.J.Cook,Co.F;-Private Dan Coleman,Co.E.-Sitting:Private Jack Harrell,Co.B;-Private Will Schmidt,Co.D;-Private C.B.Fullerton,Co.B;-Private G.N.Horton,Co.F;-Private Ed.Palmer,Co.D;-Private Joe Natus,Co.F;-Private J.V.Lath-am Co.D:-Private E. E. Coleman, Co. F.

Pictured are Texas Rangers at Temple during the national Pullman Palace Car Company strike in 1894. After Pullman cut wages, union railroad workers refused to run trains pulling Pullman cars. Violence broke out nationally, including in Temple, and the rangers came to Temple to break up the strike. (Courtesy of Sam Houston.)

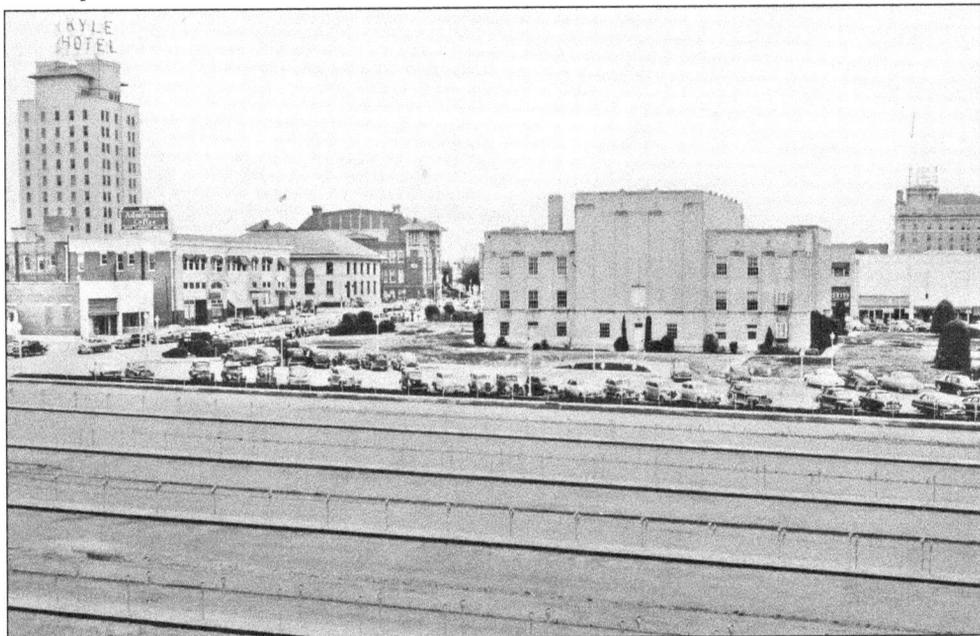

The Gulf, Colorado and Santa Fe Railway set aside a block for a city park. In 1892, Emanuel Pettigrew planted trees. These old trees were uprooted in 1950 to make way for the city parking lot, known as "Texas largest meter parking lot." In 2003 the lot was re-landscaped, and a new visitor's center was built on the west side of the lot. (Courtesy of Kelsey Collection.)

15

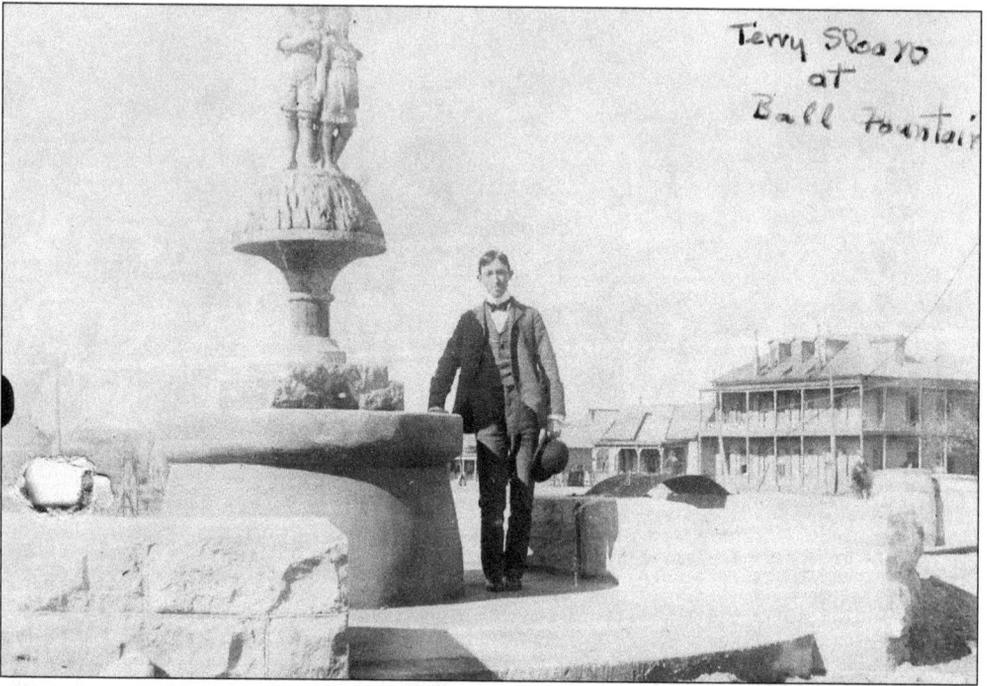

Terry Sloan at Ball Fountain

After seeing the barren look of the square following the opera house fire, and the city's unsightly watering trough, Frank Ball of Galveston donated the fountain placed in 1901. The base was pink Georgia marble, and the top was a statue of a boy and girl. The statue was moved to a cemetery in 1928. Pictured at the fountain is Terry Sloan (1877–1907). (Courtesy of Temple Public Library.)

In 1898, the Gulf, Colorado and Santa Fe Railway agreed to help finance construction of a YMCA building. The building, including furniture, cost $12,000. The railroad donated $7,500, and railway employees and others donated the balance of $4,500. The building opened in August 1899. The Santa Fe company donated 500 books for the library, paid the salary of the general secretary, and furnished heat, water, and electricity. (Courtesy of Kelsey Collection.)

16

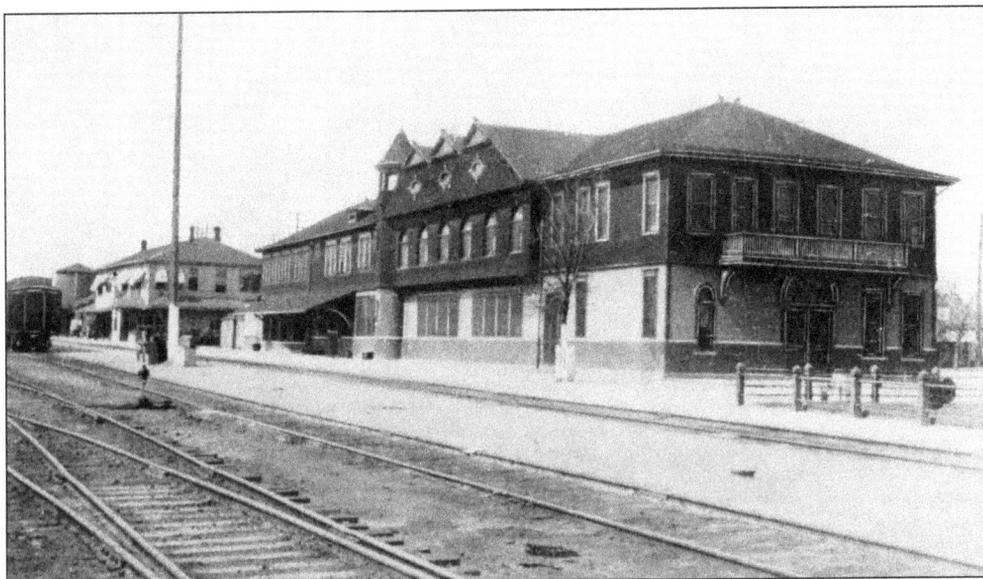

Harvey House (right), a hotel and restaurant built in 1898, stood adjacent to the Santa Fe depot and was used by the railroad for food service. After the opening of the Kyle and Doering Hotels and the shifting of railroad schedules in 1933, trade fell. The Harvey House closed, and in 1937, it was torn down. (Courtesy of Kelsey Collection.)

In 1900, the Gulf, Colorado and Santa Fe Railway constructed a dam across Bird Creek to provide water for the railroad. The result, Lake Polk, provided water for boating and public functions, such as picnicking, golfing, and horseracing. A clubhouse was built in the 1920s. A six-foot alligator was captured in the lake in 1932. (Courtesy of Temple Public Library.)

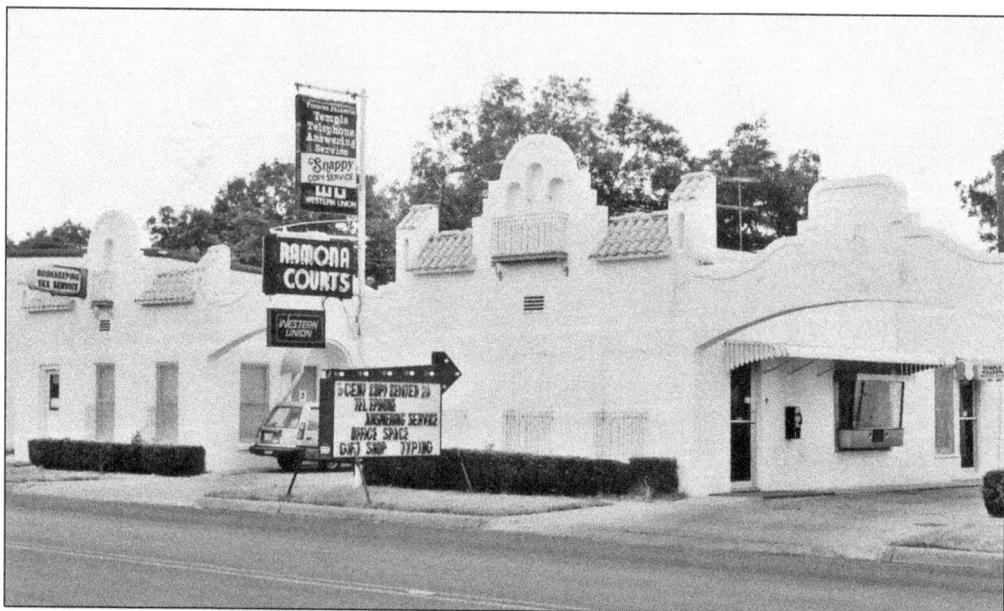

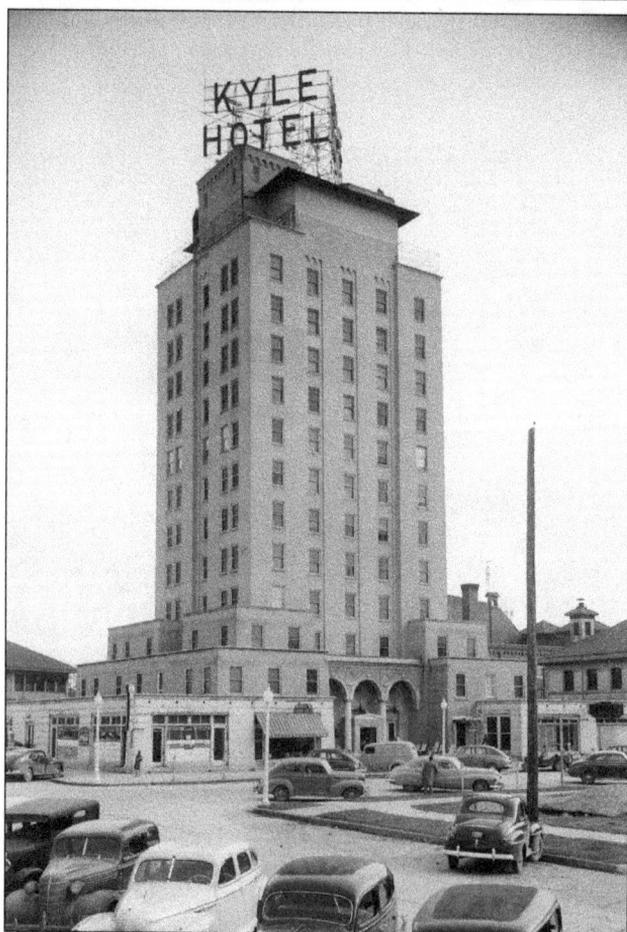

Ramona Courts, a favorite of hospital patients and tourists, was one of the earliest travel courts in Temple. Built about 1929, Ramona Courts is located at 500 West Avenue G near the old Scott and White Hospital. Pres. Lyndon Johnson's brother was a frequent lodger when he was a hospital patient. The courts consist of 12 one-story stucco cottages surrounding a courtyard. The photograph was taken in 1986. (Courtesy of Kelsey Collection.)

L. H. Lacy and Company of Dallas built the 13-story 125-room Kyle Hotel in 1928. Building was overseen by Love Construction of Temple. Dr. A. C. Scott, Scott and White Hospital, and Anna Woodson were major shareholders of the company that owned the hotel. A large red sign, placed on the roof in 1936, gave off a red glow across the city when weather conditions were favorable. (Courtesy of Temple Public Library.)

The nine-story Doering Hotel consisted of 113 rooms, a coffee shop, flower shop, barbershop, beauty parlor, cleaners, men's clothing store, and a drugstore. The garden roof included a maple dance floor. A room with a bath ranged in price from $1.25 to $2.50. R. H. Hawn purchased the hotel in 1943 and the name changed to Hawn Hotel. In 1948, Scott and White Hospital purchased the hotel. (Courtesy of Temple Public Library.)

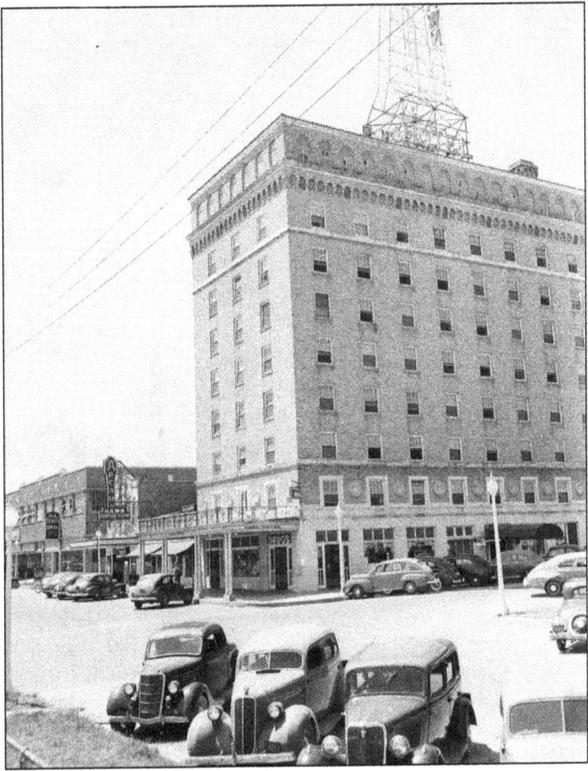

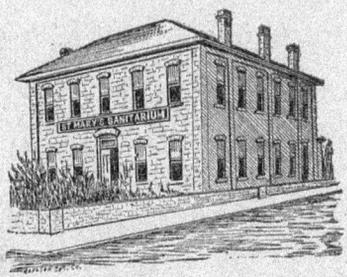

St. Mary's Sanitarium, established in 1899, stood at Avenue F and South 5th Street. The facility included two operating rooms, and Dr. R. A. Miller was the physician in charge. He was followed by Drs. Barton and Noble. In 1900, St. Mary's advertised "an ideal home for the sick at reasonable rates." All doctors in town utilized the hospital for their patients. Father P. A. Heckman managed the hospital. (Courtesy of Kelsey Collection.)

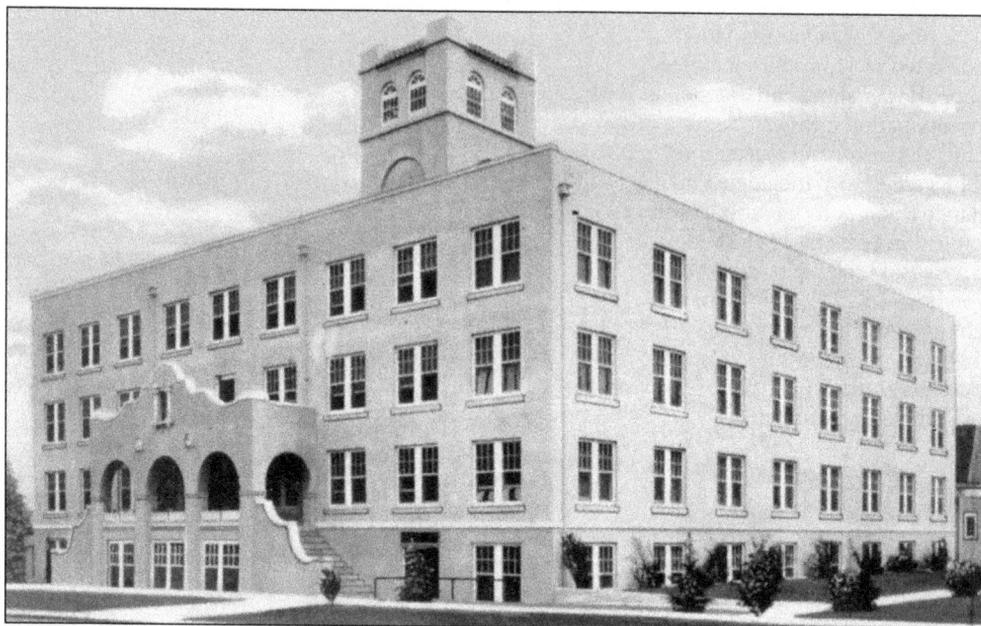

After the new Scott and White Hospital opened in 1963, the old hospital complex, which included four city blocks of buildings and an array of furnishings, sold at auction the following year. This photograph, from about 1946, shows one of the old buildings, the stucco Mission-style four-story West Building on West Avenue F. It was built in 1928. (Courtesy of Kelsey Collection.)

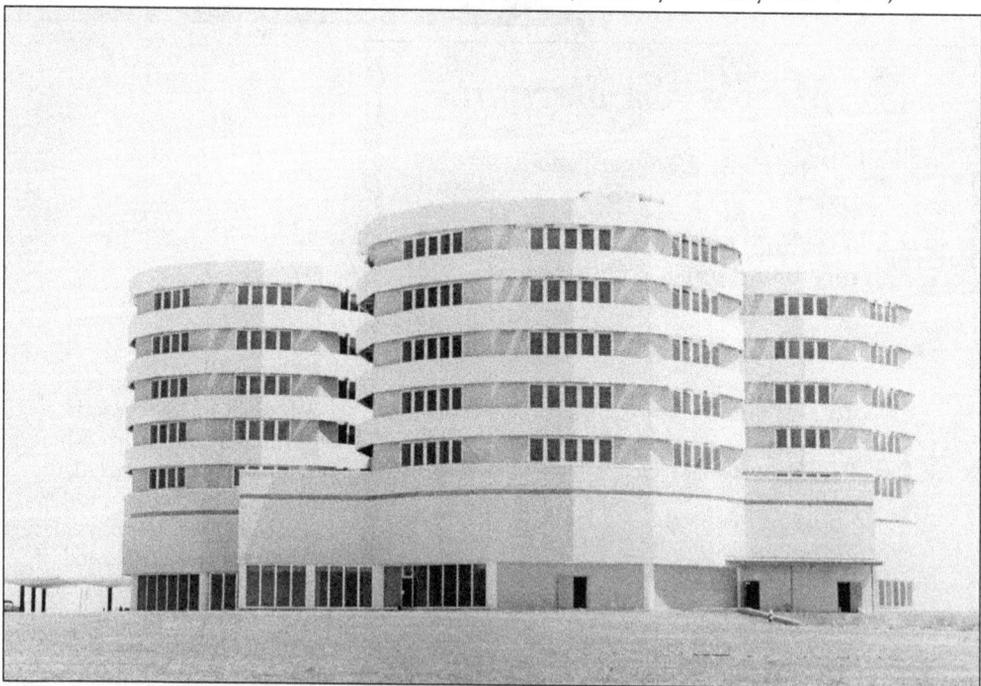

The new $9.2 million Scott and White Hospital, pictured, opened in 1963. It took two years to build. There were 65 specialists and 24 resident physicians in training, and the nursing dormitory consisted of 32 rooms in two-room suites. In the year ending August 1963, more than 53,000 patients registered at Scott and White Hospital. (Courtesy of Kelsey Collection.)

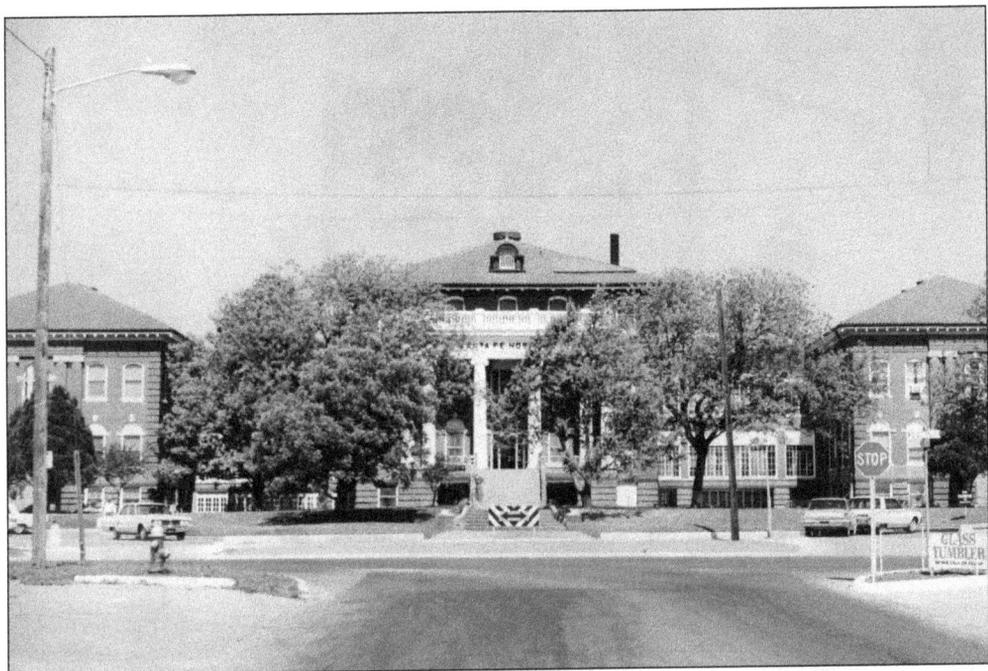

As early as 1887, railroad officials sought a site for medical and surgical care for "those injured or disabled by accident or sickness while on duty." In 1891, five Sisters of Charity and Dr. Wilkinson arrived from Galveston and opened the 20-bed Santa Fe Hospital. The first patient was Robert Robertson, who had an eye injury. This view of the hospital was taken after additions to the 1907 building. (Courtesy of Temple Public Library.)

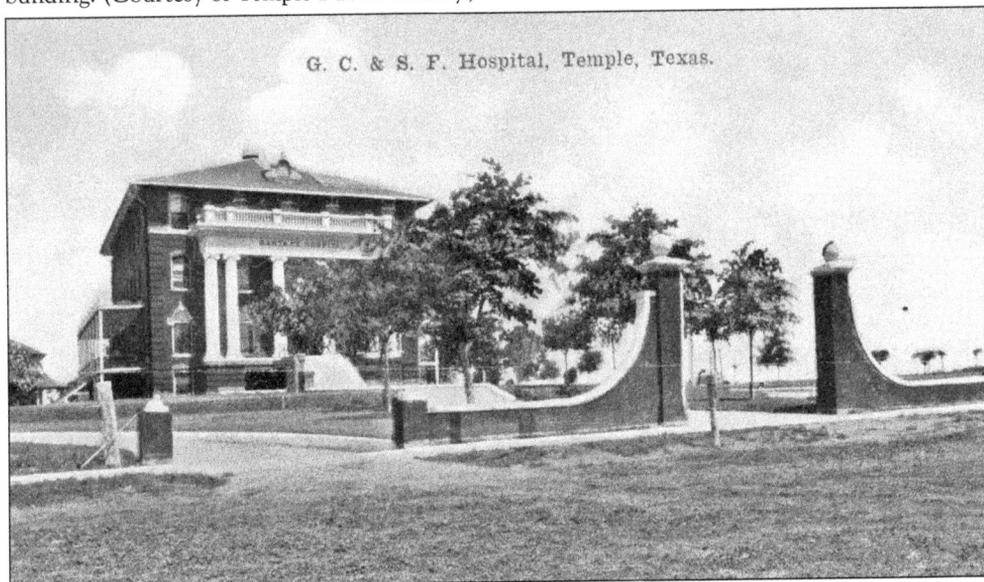

This Santa Fe Hospital, completed in 1907, provided patients and staff with telephone service and electric lights. Dr. J. P. Hawkes became the local surgeon for the railroad in 1890, Dr. A. C. Scott became chief surgeon at Santa Fe Hospital in 1892, and Dr. Raleigh R. White became house surgeon in 1894. Sisters of Charity remained until 1948. At present, Scott and White Hospital utilizes part of the building as an extended care facility. (Courtesy of Kelsey Collection.)

21

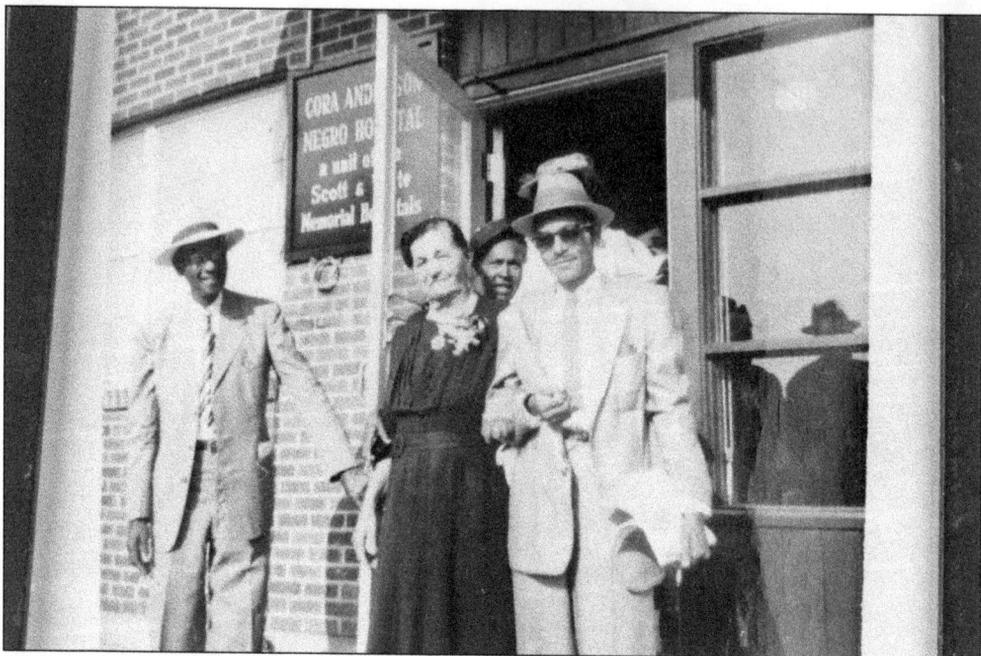

In 1953, Scott and White Hospital opened a $100,000 ten-bed hospital for African Americans on South 9th Street. Scott and White Hospital doctors staffed the hospital and donated their professional fees toward maintenance. The hospital was named in honor of Cora Anderson, shown leaving the hospital. She was a committed worker who helped the black community raise $20,000 for the project. The hospital closed in 1964. (Courtesy of Railroad and Heritage Museum.)

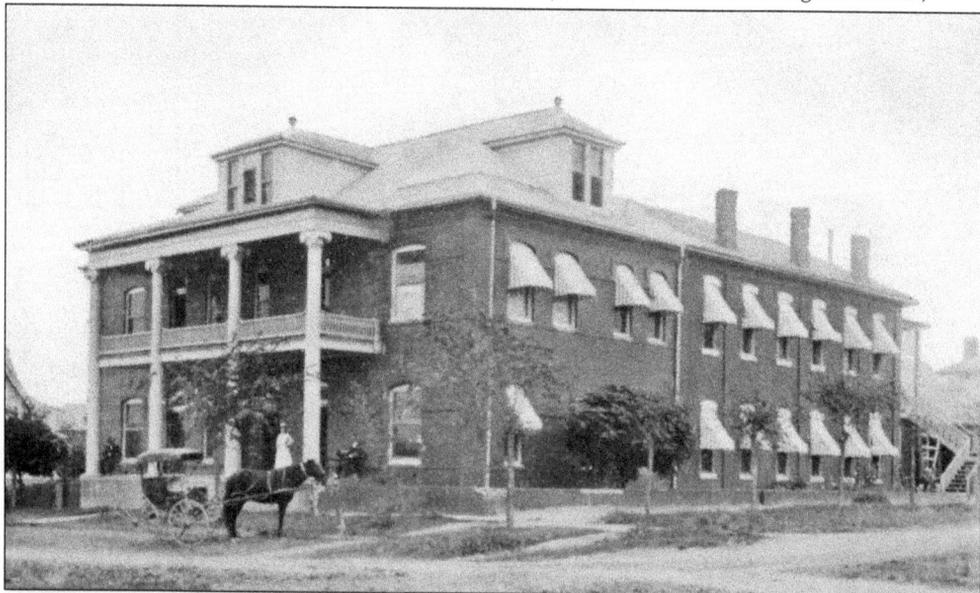

In 1904, Dr. A. C. Scott, Dr. Raleigh R. White, and matron Cornelia Parsons resigned from King's Daughters Hospital. The doctors purchased St. Mary's Sanitarium, built a two-story addition on the front, and established Temple Sanitarium, pictured here. The hospital occupied the same block as St. Mary's Church, rectory, and convent on South 5th Street. (Courtesy of Temple Public Library.)

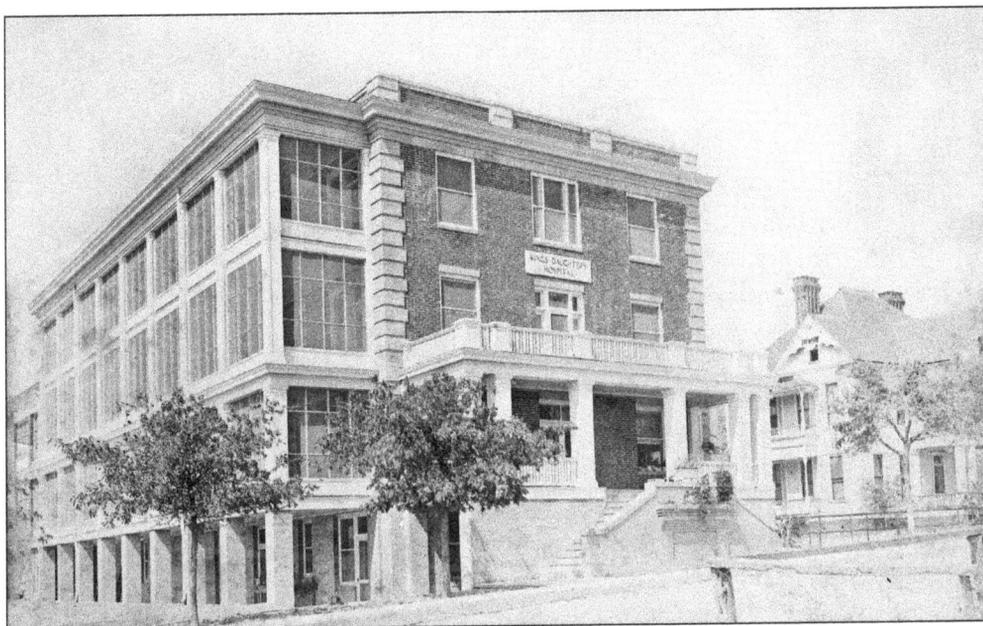

King's Daughters and Sons, a protestant nondenominational organization, founded King's Daughters Hospital in 1897 "to furnish better facilities for treating the sick in frontier towns without hospitals and with meager hotel facilities." A small frame structure housed nurses and afforded a place for medical and surgical staff to care for a small number of patients. The following year, a hospital charter was secured. In 1904, the hospital had money for a 20-bed expansion, and a school of nursing was established. In 1935, nursing graduates wore caps and gowns for the first time. Additions in 1912, 1917, and 1927 expanded the hospital to 110 patient rooms and housing for the nursing school. The photograph below shows the building after the additions. In 1910, there were 725 patients. (Above, courtesy of Kelsey Collection; below, courtesy of Temple Public Library.)

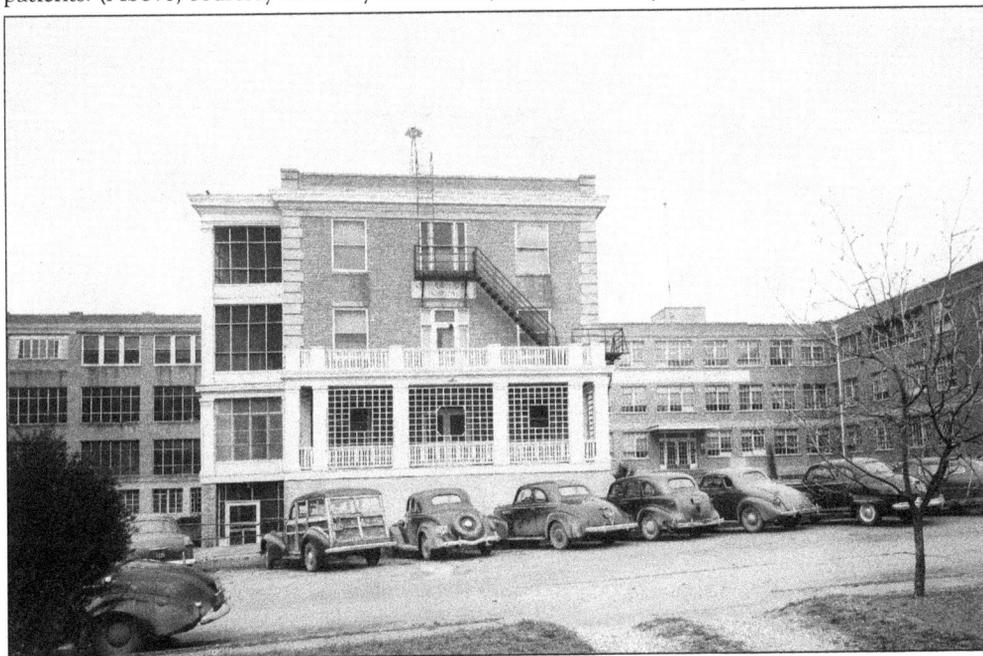

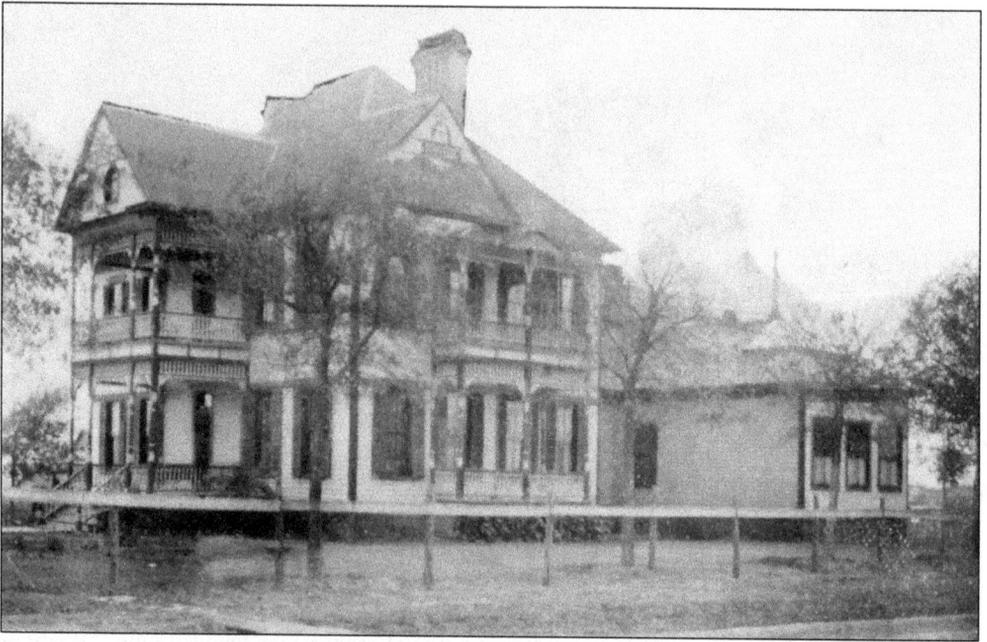

Pictured is the Dr. E. T. Walker house at 304 South 24th Street. His office was at 8 East Central Avenue. The doctor arrived in Temple in 1893 as the appointed surgeon to the International-Great Northern Railroad. He served as surgeon for Empire Mill Company, the electric plant, Temple Compress, and Water Works Company. King's Daughters Hospital acquired his property. (Courtesy of Temple Public Library.)

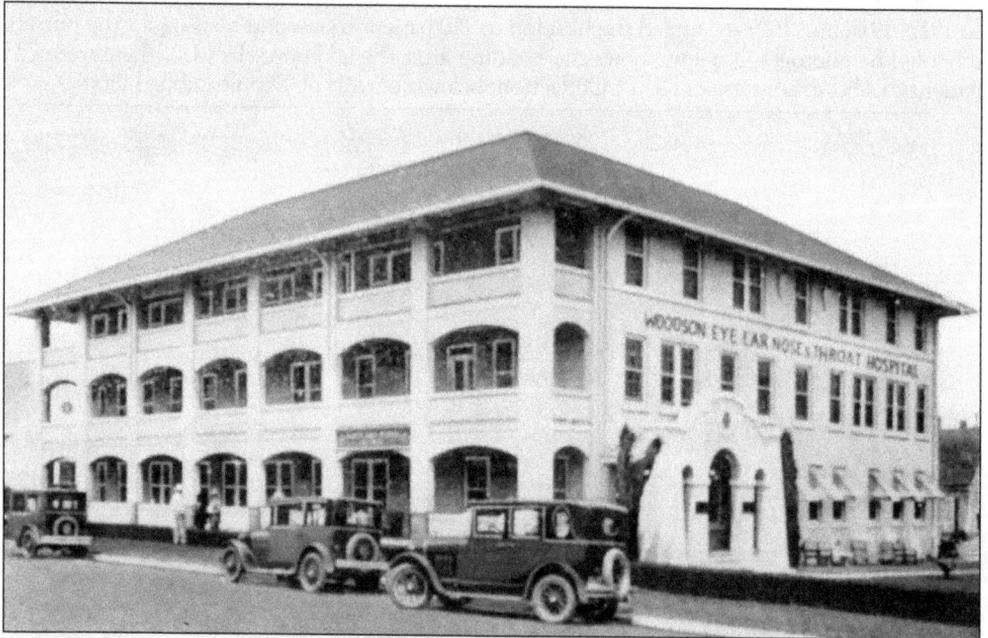

In 1892, Dr. J. M. Woodson succeeded Dr. Henaphy as house surgeon at Santa Fe Hospital. That same year, Dr. A. C. Scott arrived from Gainesville to become chief surgeon, and the two became close friends. Woodson was an eye, ear, nose, and throat specialist. Pictured is the four-story Woodson Clinic, built in connection with Scott and White Hospital. (Courtesy of Kelsey Collection.)

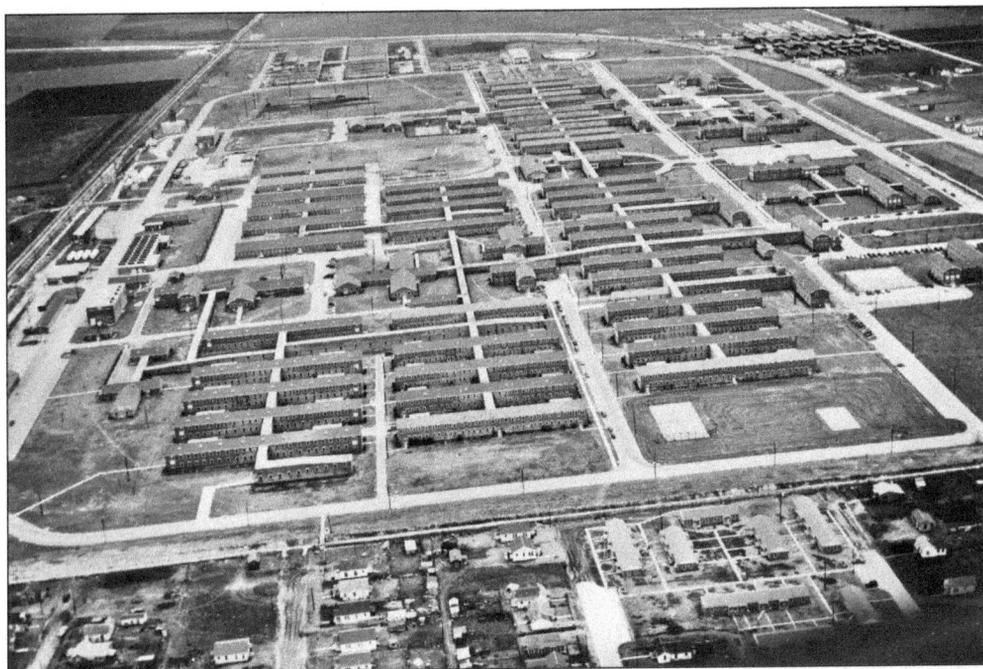

McCloskey General Hospital, a 216-acre military complex, opened in 1942. At the end of the war, the complex of 94 permanent buildings, 96 temporary buildings, nine-hole golf course, swimming pool, tennis courts, and the depot transferred to the Veterans Administration. A 350-bed domiciliary opened in 1949, and a new main hospital building opened in 1999. Currently the hospital is part of Central Texas Health Care System and includes nursing homes, an emergency room, and a 408-bed domiciliary. Pictured above is an aerial view of the hospital complex in the 1950s. In 1944, Temple campaigned vigorously for a state memorial honoring the 36th Division of the Texas Army National Guard. McCloskey General Hospital patients and veterans of the 36th Division are shown below participating in finding an appropriate site for the proposed memorial. (Courtesy of Temple Public Library.)

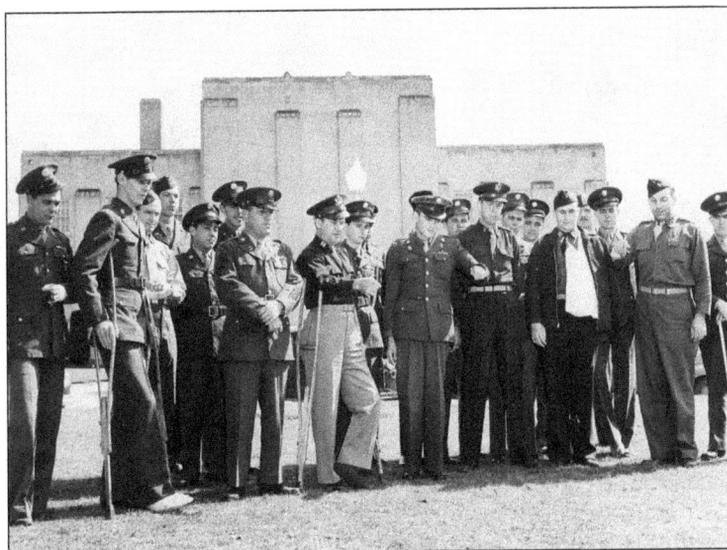

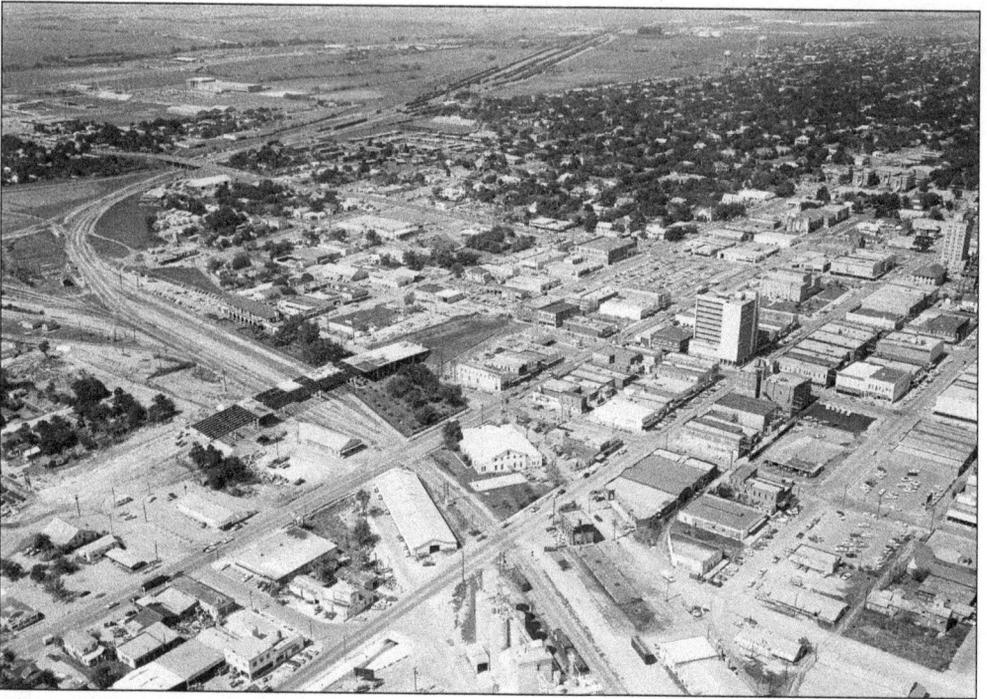

This aerial view shows construction of the South 3rd Street overpass. Long delays, created by trains passing at critical crossings, hindered emergency vehicles and necessitated overpasses such as this one. The Gulf, Colorado and Santa Fe Railway North Yard and the Adams Street overpass are visible in the background. (Courtesy of Temple Public Library.)

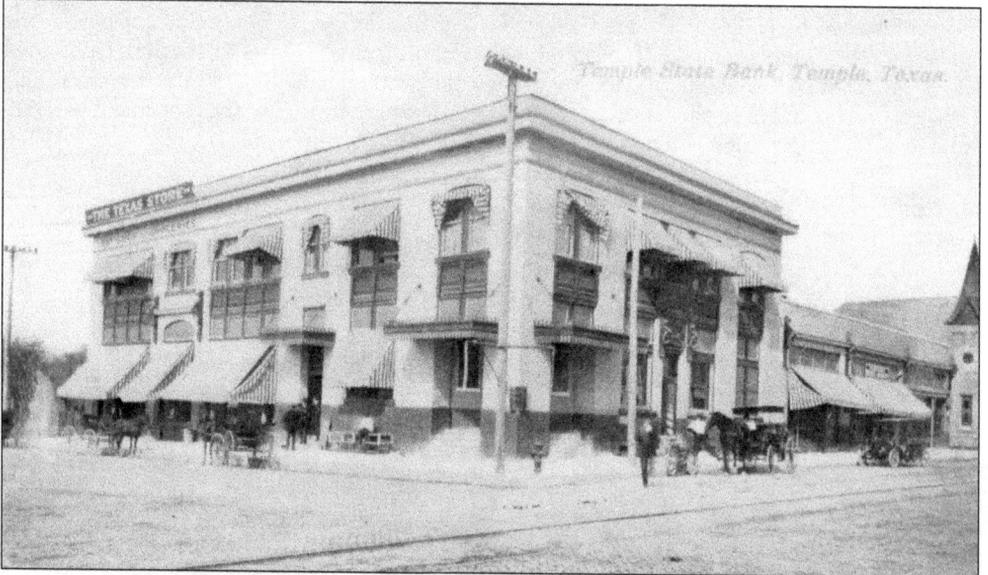

Offices for physicians and surgeons Lee Knight, J. S. McCelvey, George S. McReynolds, R. W. Noble, L. W. Pollock, C. L. Power, Robinson, and L. R. Talley were in the Temple State Bank Building at the northwest corner of Adams Avenue and North Main Street. In the photograph, Dr. Talley and Dr. Knight's names are visible on the lintels. J. E. Ferguson built the bank building in 1912. Although severely altered, the building still stands. (Courtesy of Kelsey Collection.)

Two

DOWNTOWN SCENES AND BUSINESSES

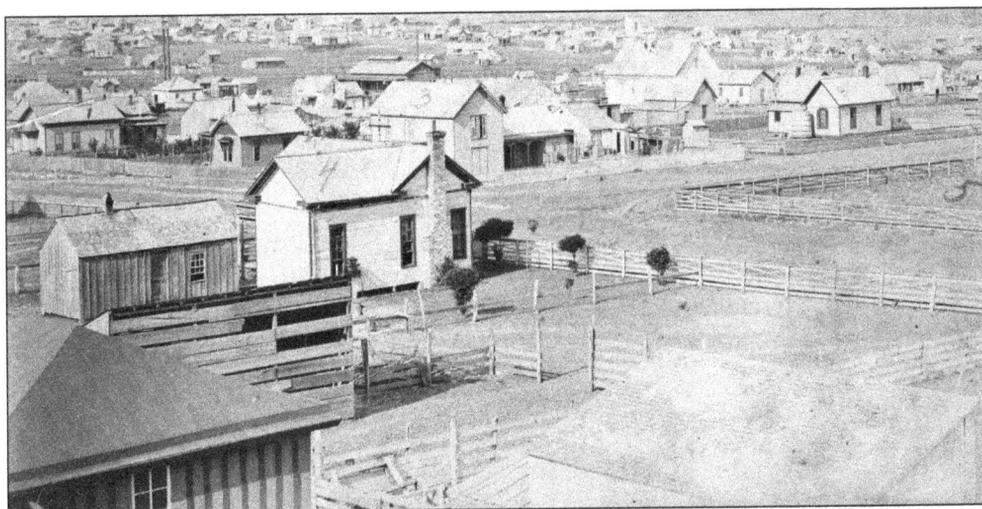

This early view, looking southeast from South 1st Street, shows Temple as it appeared about 1888—a barren, treeless, arid prairie. Notice the large wooden cistern beside the house at right. An inadequate source of water required the early citizens of Temple to rely on wells or cisterns for their water needs. The Killingsworth water wagon was a frequent sight on the streets in the early days. In 1907, after years of bickering and experimenting with various schemes to improve the water system, the town finally had the foresight to place the waterworks under a city-owned municipality. A $150,000 bond election was held to purchase the Waterworks Company. The citizens approved the bond by a vote of 370 for and 30 against. The house in the foreground with the number four written on the roof was the home of Dr. Smith. Also pictured is the German Evangelical Church. Fences not only kept in the homeowner's livestock but also served to keep out stray livestock. (Courtesy of Railroad and Heritage Museum.)

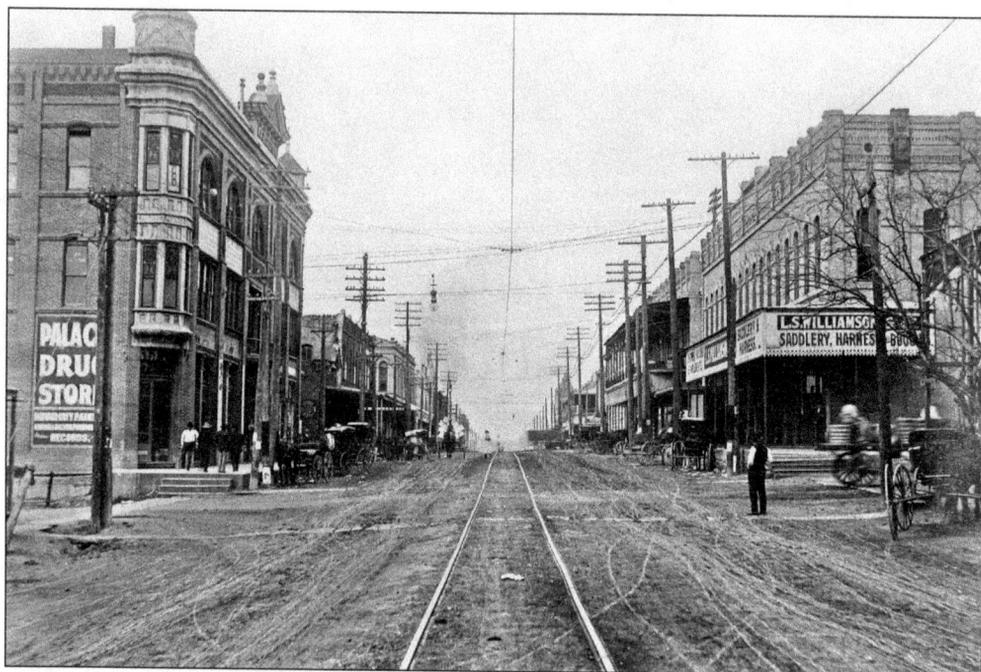

This scene is of Avenue A looking west, about 1909. On the left, Palace Drug occupied the lower floor of the Wilkerson Building at the southwest corner of Avenue A and South 2nd Street. Lewis S. Williamson's harness, saddlery, and implement business is on the right. The trolley track is visible in the street. (Courtesy of Temple Public Library.)

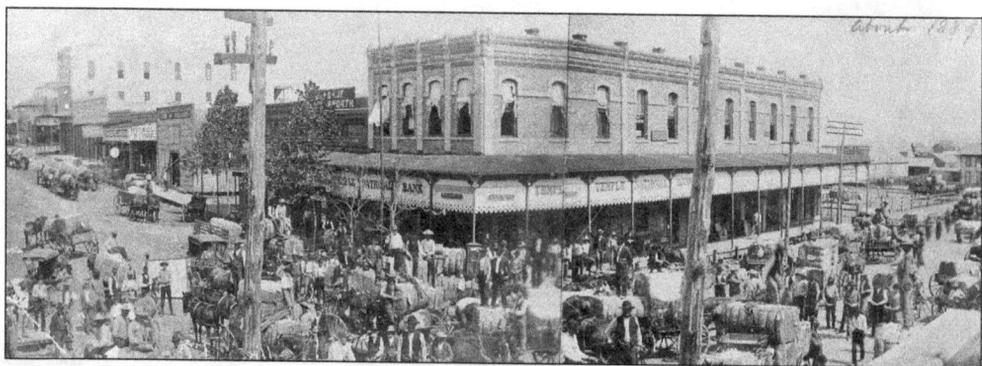

This panoramic view of Avenue A and South Main Street was taken about 1889. The two-story building in the center is the Temple National Bank. Businesses to the left include Lee and Talley and the Nickel Store. The cotton yard is at the end of the bank building, at right. The wagons in the street are carrying cotton bales. (Courtesy of Temple Public Library.)

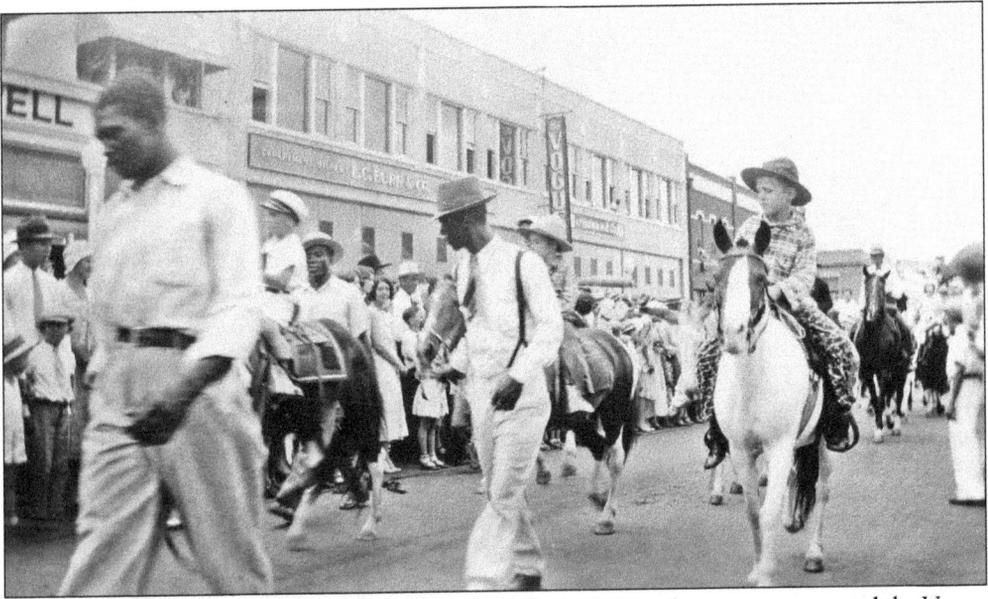

This photograph shows a parade passing in front of the L. C. Burr department store and the Vogue on North Main Street. The parade is going north on Main Street. It is unknown what the occasion for the parade was or the year the photograph was taken. (Courtesy of Kelsey Collection.)

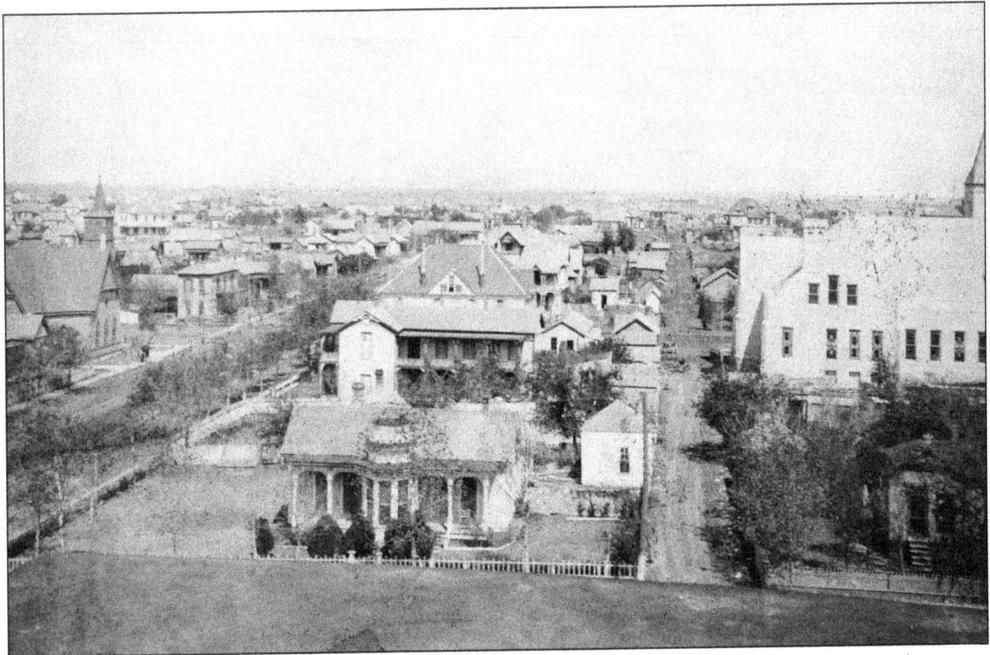

This view, taken from the opera house, looks north from the city square. The First Presbyterian Church at North 1st Street and Barton Avenue is visible at left, and First Baptist Church at Barton Avenue and Main Street is at right. The house in the center foreground, facing Adams Avenue, is the L. R. Wade home. (Courtesy of Temple Public Library.)

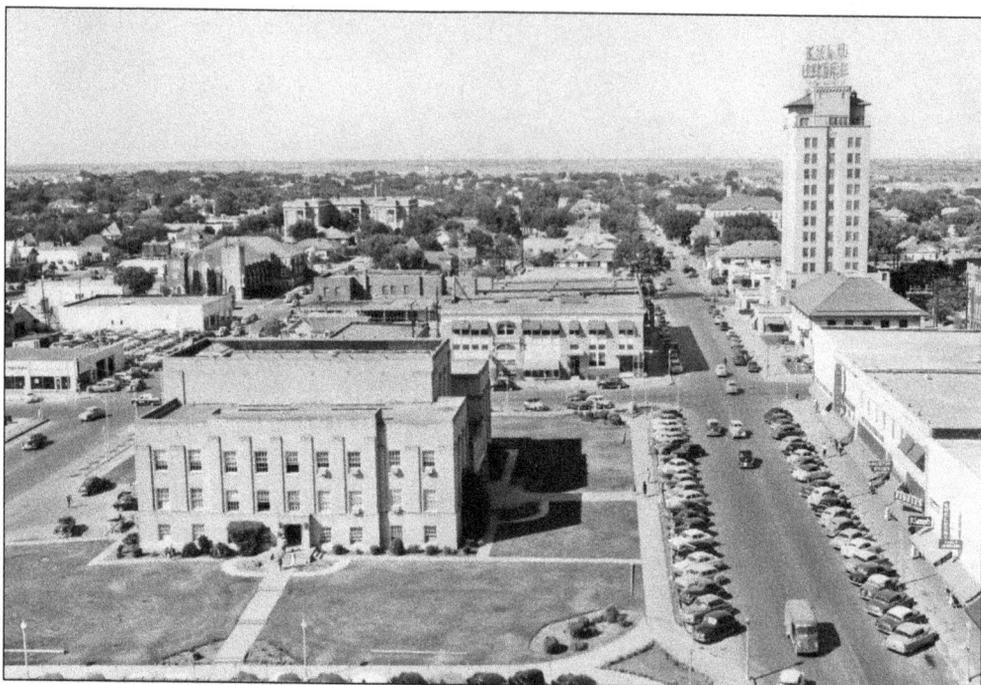

Seen in this aerial view, the art deco Municipal Building, center, was erected in 1929. City offices, a large auditorium, library, civic center quarters, the office of city veterinarian Dr. W. F. Hackney, and the police department occupied the building. City offices are still located there. (Courtesy of Temple Public Library.)

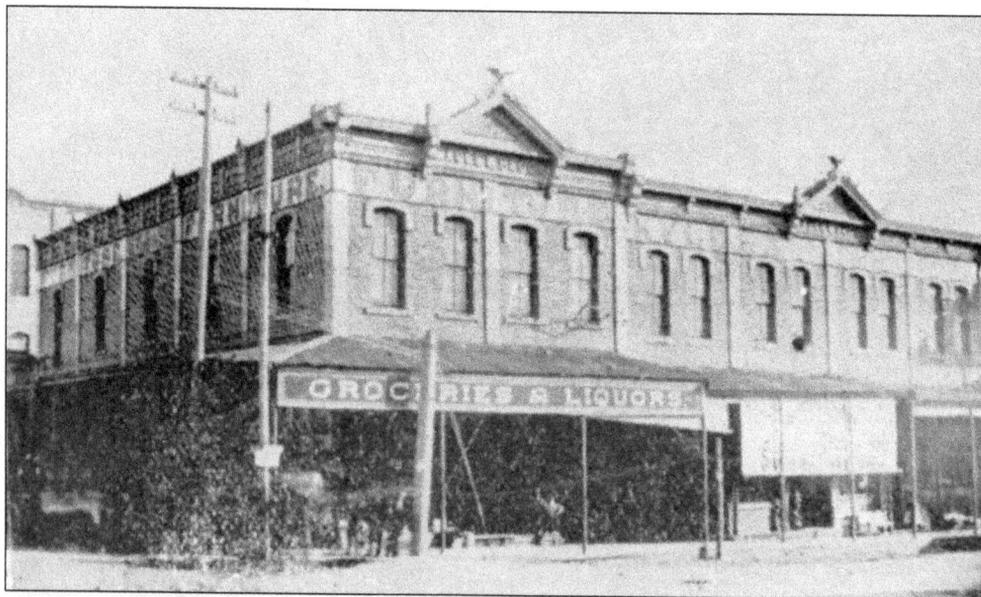

In 1887, a development of businesses known as the Eagle Block opened at South Main Street and Avenue A. The buildings received their name from the decorative eagles that adorned the cornices. Wilkerson and Goolsby Eagle Saloon, Golden Eagle clothing store, and the firm of Moyer, Swink, and Lewis occupied the building. S. and Nate Block owned and operated Golden Eagle clothing store. (Courtesy of Temple Public Library.)

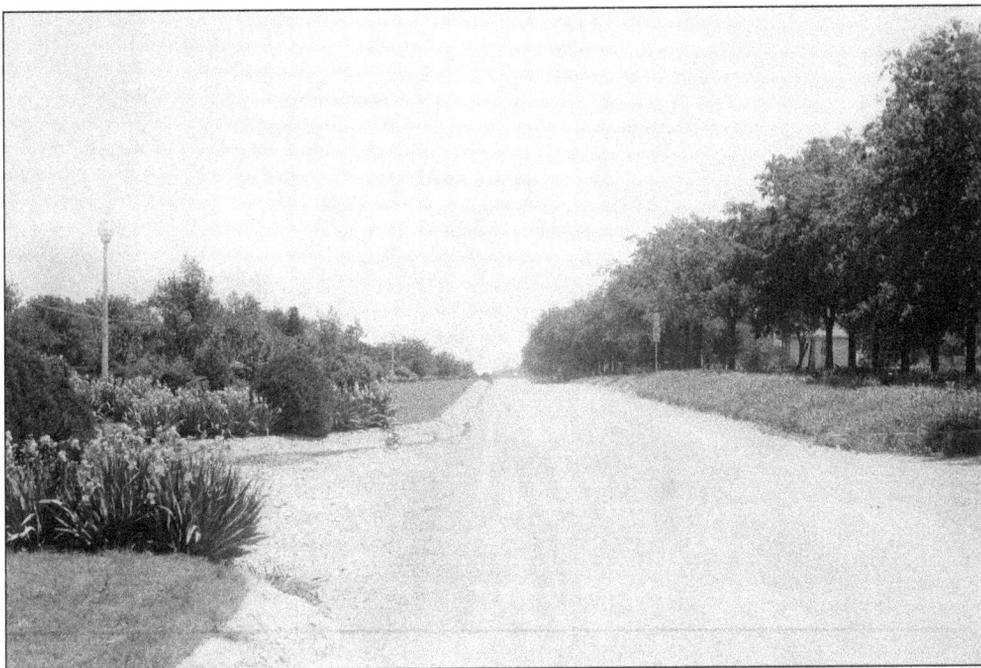

Avenue H, pictured, often referred to as "the Boulevard," acted as the main route entering or leaving Temple. It became a part of Highway 2 and Highway 81. The Temple–Belton trolley ran along Avenue H. In 1931, J. A. Talley and the City Federation of Women's Clubs led an effort to beautify and landscape a 16-block section. The avenue was paved in 1936. (Courtesy of Temple Public Library.)

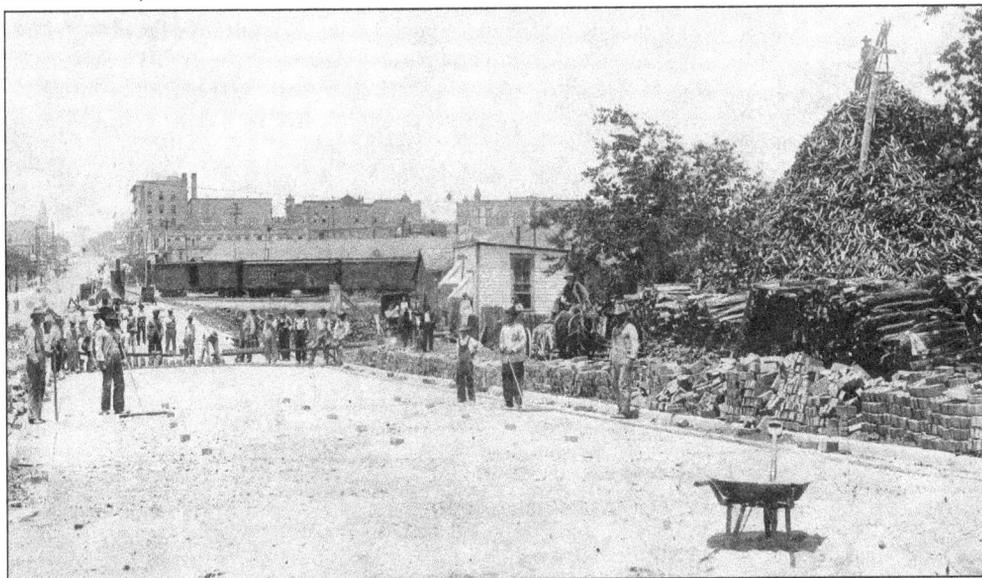

Temple waited 28 years for streets to be paved. On October 7, 1909, ground was broken for the first bricking of streets, starting with South 1st Street. It was bricked from the Gulf, Colorado and Santa Fe Railway track north to Adams Avenue. By 1912, the entire business district was paved with vitrified brick. Shown are workers bricking South Main Street. (Courtesy of Temple Public Library.)

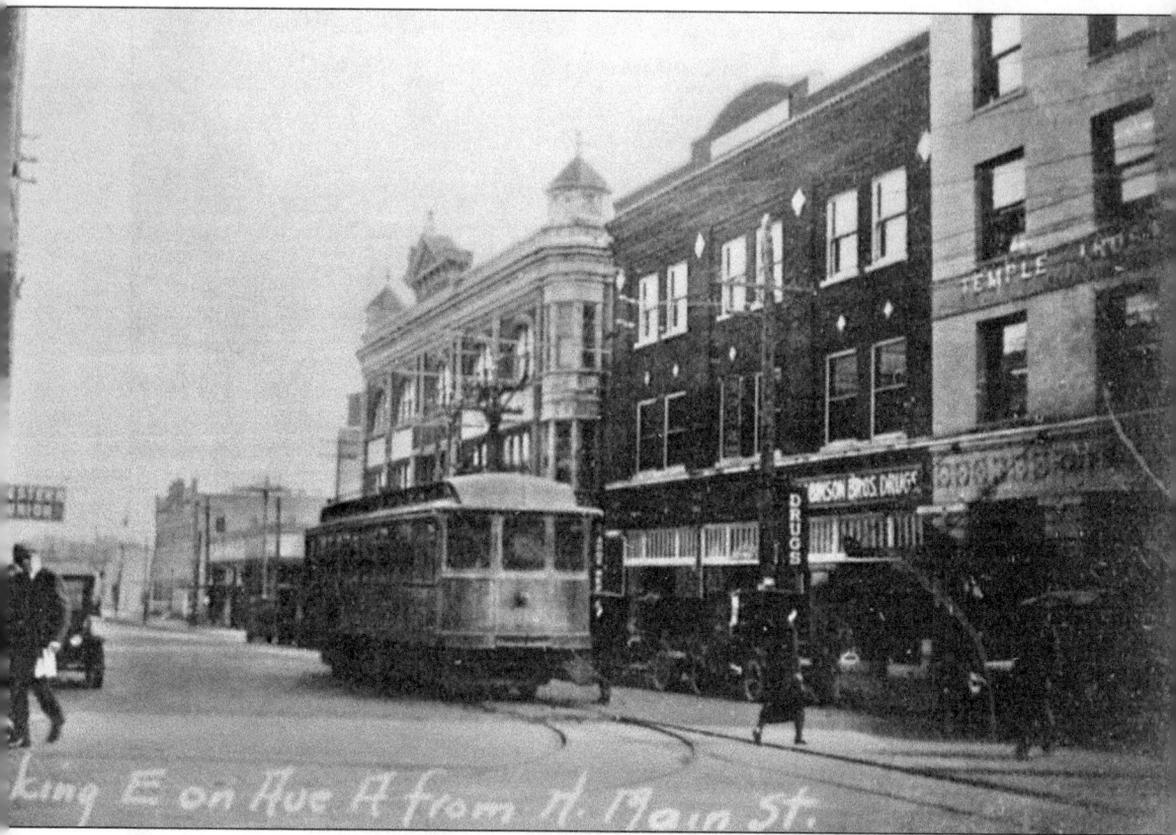

king E on Ave A from N. Main St.

Pictured is the trolley on Avenue A. The trolley line, completed in 1904, operated between Temple and Belton. The route took in Santa Fe Hospital and parts of Avenue H, Avenue G, 8th Street, Avenue A, 5th Street, Central Avenue, 9th Street, and French Avenue. Car barns for the trolley were on 8th Street. A generating station that furnished power for the line was located at Midway, a point halfway between Temple and Belton. W. G. Haag built the "north-loop" of the trolley lines along French Avenue in 1905, when it was "way out in the country" and there were only three houses along the avenue. During the summer, weeds were cut away from the tracks so that the cars could operate. Widespread use of the automobile doomed the Temple–Belton Traction Company. In 1910, the company fell into federal receivership and bondholders took over. In 1911, Temple investors purchased the company and renamed it Southwestern Traction Company. It became insolvent about 1923. (Courtesy of Temple Public Library.)

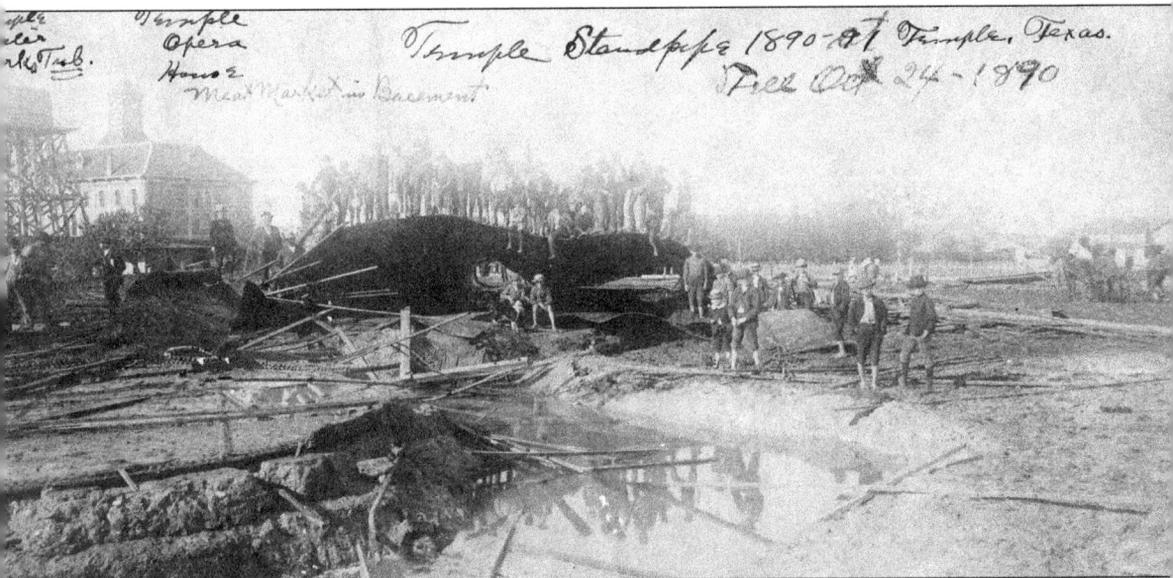

Temple Opera House *Meat Market in Basement* — *Temple Standpipe 1890 at Temple, Texas. Fell Oct 24-1890*

The recently constructed standpipe on North Main Street, north of the old post office and next to the Methodist Church, collapsed on the night of October 24, 1890. The emitted force of the 280,000 gallons of water destroyed E. B. Greathouse's barn and outbuildings across the street, and the house of Virgil Tucker was completely moved off its foundation. In the tragedy, a lamp burning by the sick bed of Mrs. O. F. Rigdon fell over and broke, setting fire to both the bed and to her husband's clothing and producing severe burns that resulted in his death later that morning. Some of the fencing at the Baptist Church swept away. A 110-foot high, 18-foot diameter standpipe was built in the same location. This standpipe was determined to be unsafe and was torn down in 1914. Ironically, when the 1890 standpipe was built, the *Temple Times* boasted that the standpipe would tower 125 feet and hold "water enough to flood the town." (Courtesy of Railroad and Heritage Museum.)

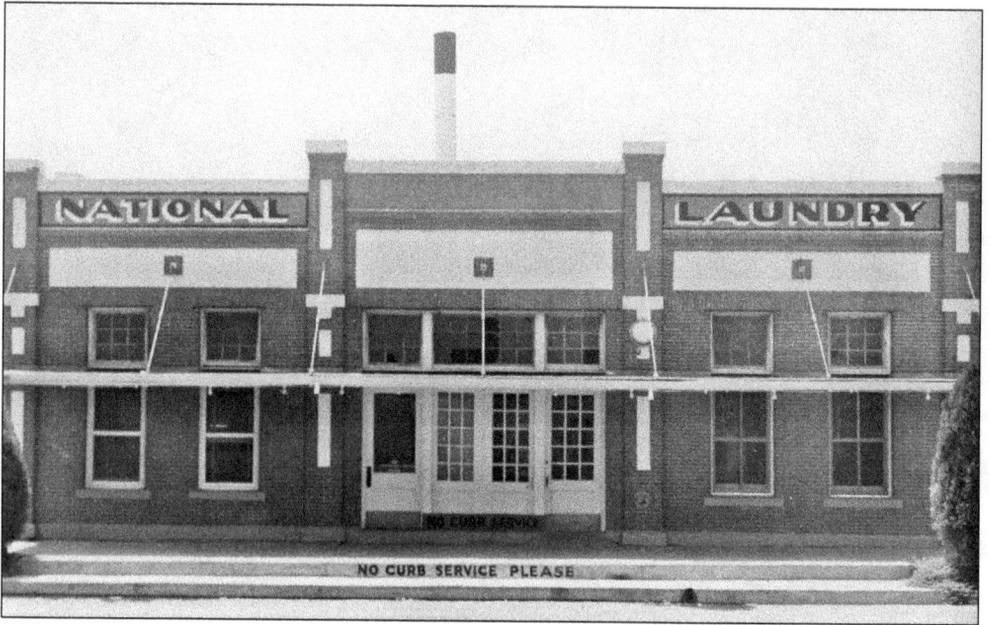

In 1927, C. E. Callaway acquired one-half interest in National Laundry. Callaway operated the business in partnership with C. R. Simmons of Sweetwater. In 1937, he purchased Simmons's interest. The building, at 102 South 5th Street, was torn down when the police station was built in the early 1990s. (Courtesy of Temple Public Library.)

Andrew Berry and his son Barnell (Barney) Berry established Zenith Laundry and Dry Cleaning in 1946. Andrew began his career in the laundry business in 1923 at National Laundry. In 1926, he established Belton Steam Laundry in Belton. The Belton laundry was disposed of in 1946 when the Berry family established Zenith Laundry in Temple. The building at 304 North 3rd Street still stands. (Courtesy of Temple Public Library.)

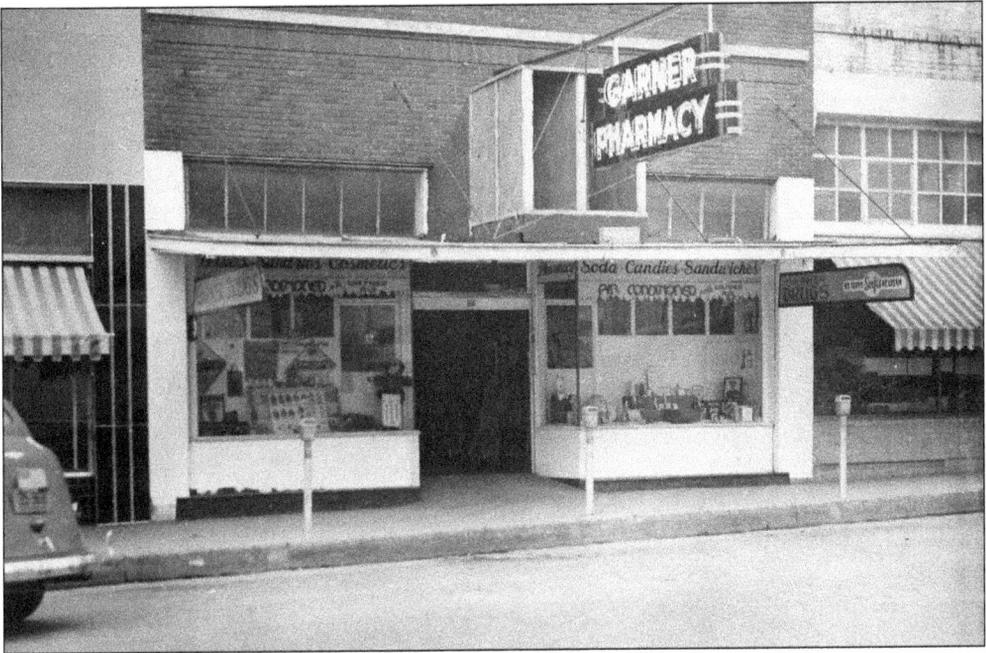

Calvin and Teresa Garner owned and operated Garner Pharmacy at 24 South 1st Street. In addition to filling prescriptions, they sold gifts, provided fountain service, served lunch, and specialized in banana splits and malts. Perfume, Whitman candies, and Mulford veterinary supplies were popular items sold in the store. (Courtesy of Temple Public Library.)

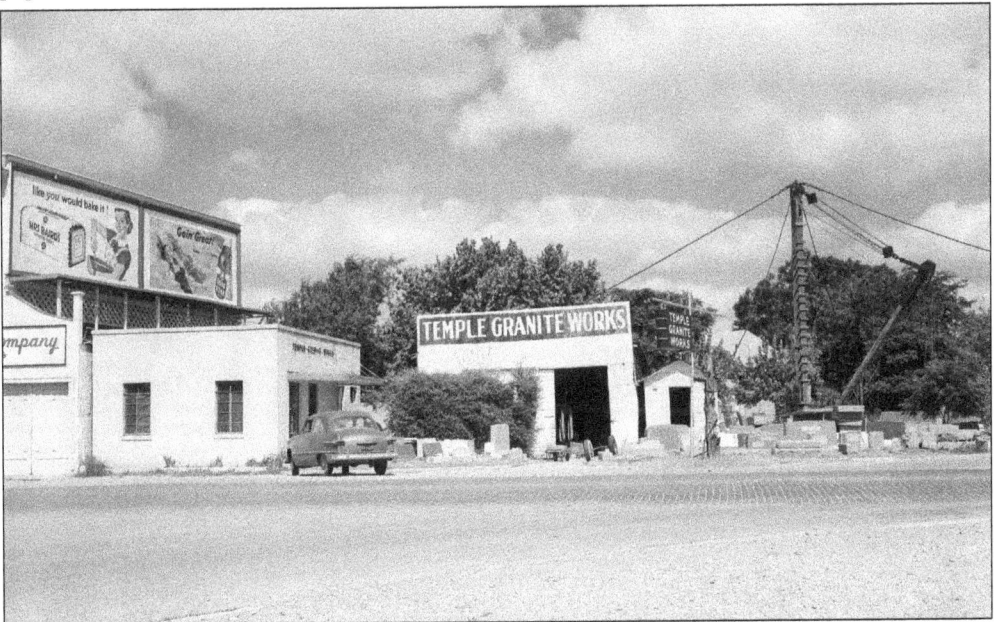

F. S. Walker, a stonemason, emigrated in 1911 from Scotland to Vermont. He worked at a quarry but later moved to Texas to escape the harsh New England winters. In 1946, he bought Temple Granite Works at 310 South Main Street. He was an excellent stonecutter, and examples of his work are displayed in Central Texas cemeteries. He patented a curbing design for cemetery plots. (Courtesy of Temple Public Library.)

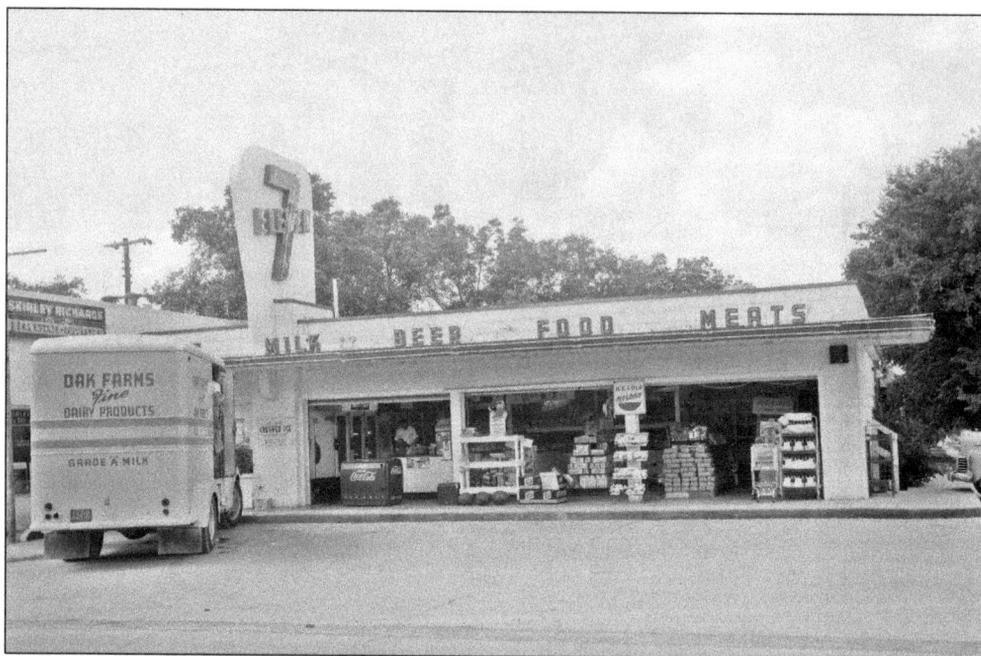

Southland Company supplied 7-Eleven stores with ice from the plant at South 9th Street near the Gulf, Colorado and Santa Fe Railway tracks. In 1946, the first 7-Eleven convenience store opened at 217 North 3rd Street. Pictured is the second 7-Eleven store, opened in 1947 at 604 West Avenue G. Ice and food were sold there. (Courtesy of Temple Public Library.)

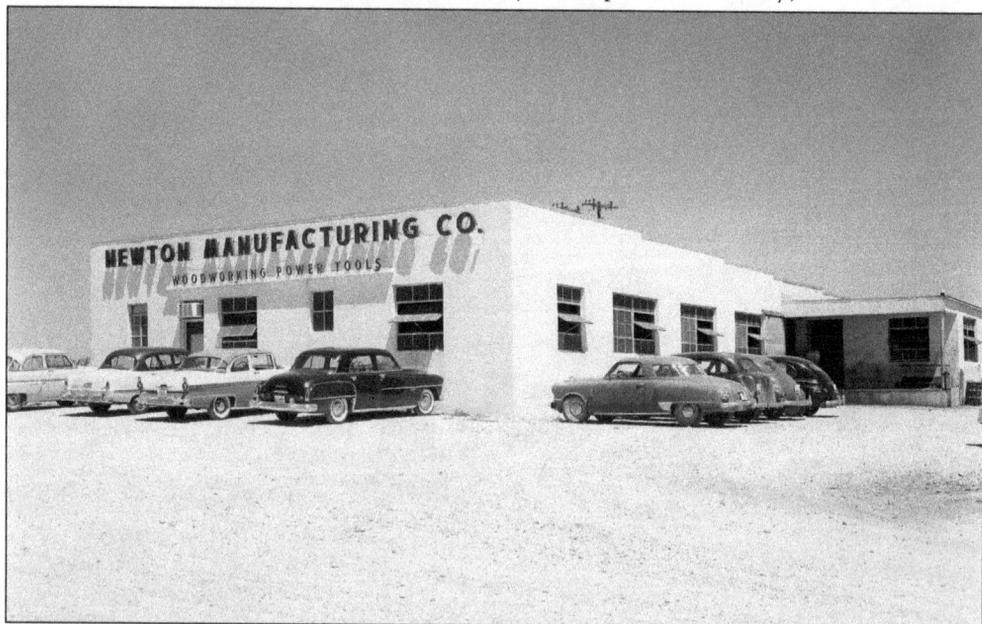

Herman S. Newton, a 1926 graduate of Georgia Tech, established Newton Manufacturing in 1941. The company, located at 1019 East Adams Avenue, manufactured woodworking power tools. By 1953, the company employed 16 persons. Newton designed a dowel-boring machine and an edge sander that became the mainstays of Newton Manufacturing. (Courtesy of Temple Public Library.)

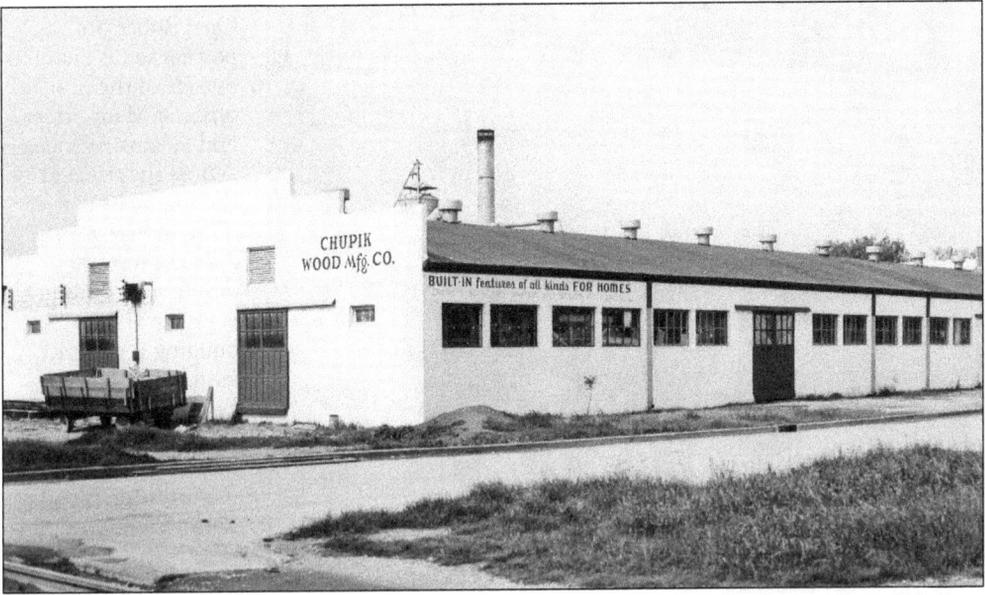

Chupik Wood Manufacturing started in business in 1929. In 1942, the company purchased Viaduct Planning Mill. The company grew and in 1947 moved into a new building at 611 East Avenue A. Products included built-in features for homes, kitchen cabinets, mantels, tables, store fixtures, frames, windows, doors, and moldings. (Courtesy of Temple Public Library.)

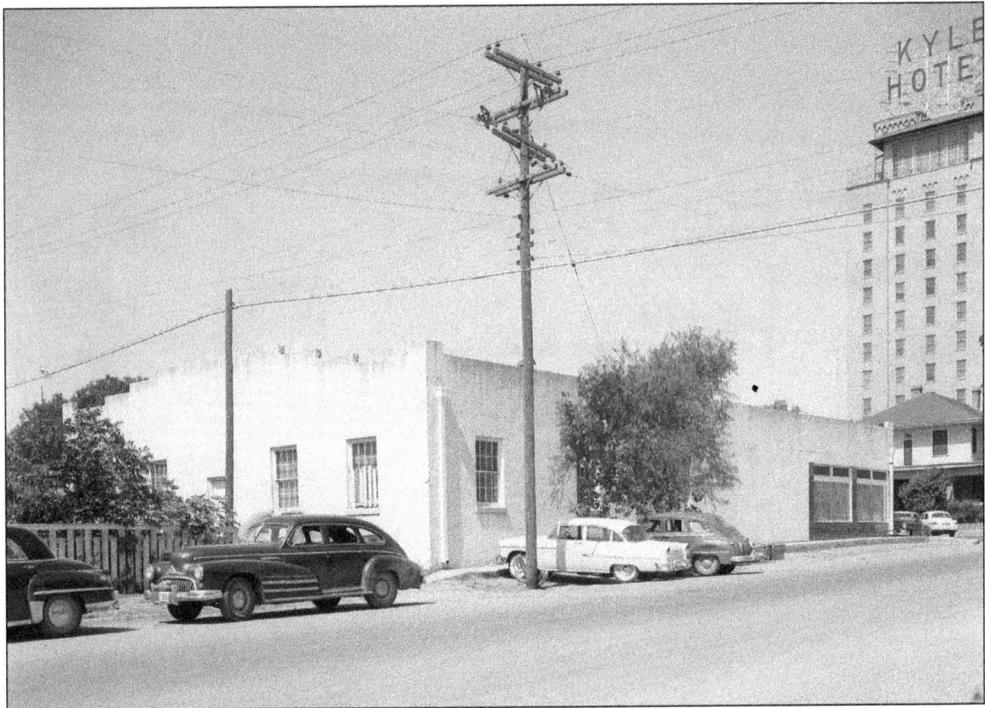

Bell County native William B. Shaw acquired a Chrysler and Plymouth dealership in 1927. This business was at 115 South Main Street. By 1929, Shaw moved the agency to 103 East Avenue A. Pictured is Shaw Motor Company at the corner of North 2nd Street and Barton Avenue, the location it moved to in 1946. (Courtesy of Temple Public Library.)

Opal Roberson, postmaster, is pictured outside of the post office at Main Street and Adams Avenue. Across the street at the southeast corner of Main Street and Adams Avenue, Stavinoha Hardware is visible. This building is currently used by Temple Business Incubator. Roberson lived at the nearby Kyle Hotel. (Courtesy of Temple Public Library.)

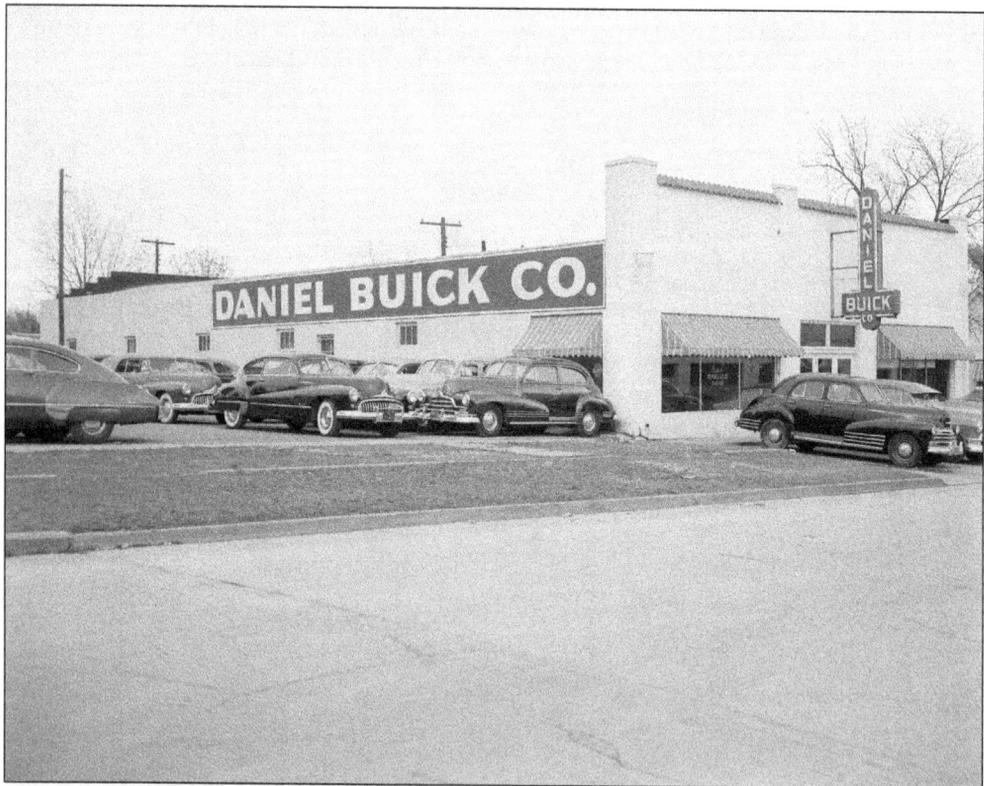

Francis H. Daniel, a native of Dallas and graduate of Southern Methodist University, founded Daniel Buick Company in 1948. Daniel established the automobile agency at 206 East Adams Avenue. The agency was a dealer for Buick and Opel automobiles. He later formed a partnership with Howell Hundley. (Courtesy of Temple Public Library.)

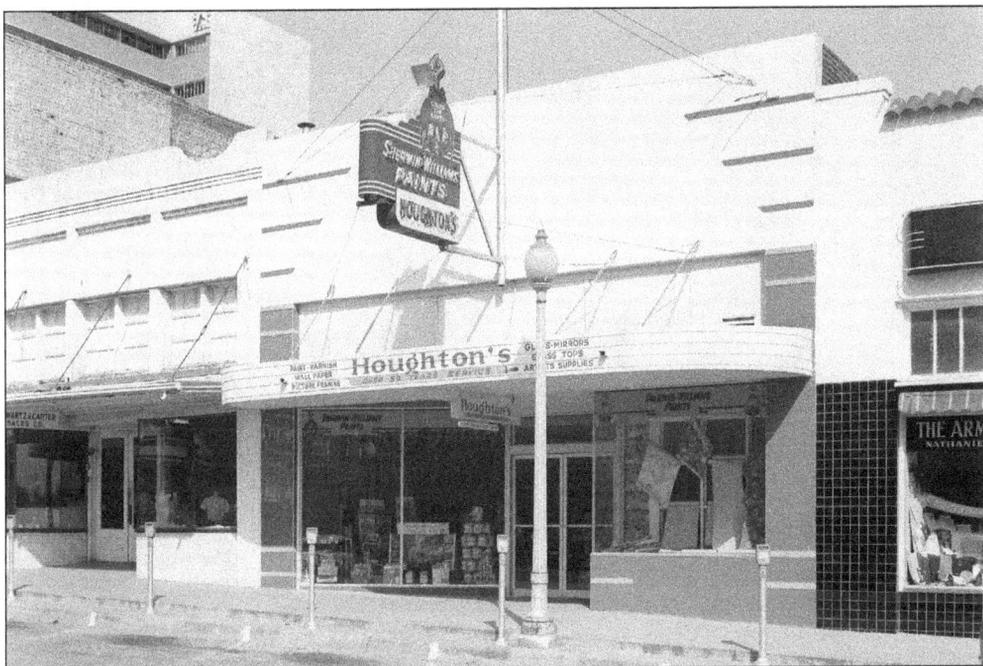

Brothers George and John Houghton, natives of Canada, owned and operated Houghton's paint and wallpaper store at 109 South 1st Street. John married Willie Coldwell Patterson, the widow of E. W. Patterson. After John's death in 1942, Willie and her son by her first marriage ran the store. Willie died in 1957. (Courtesy Temple Public Library.)

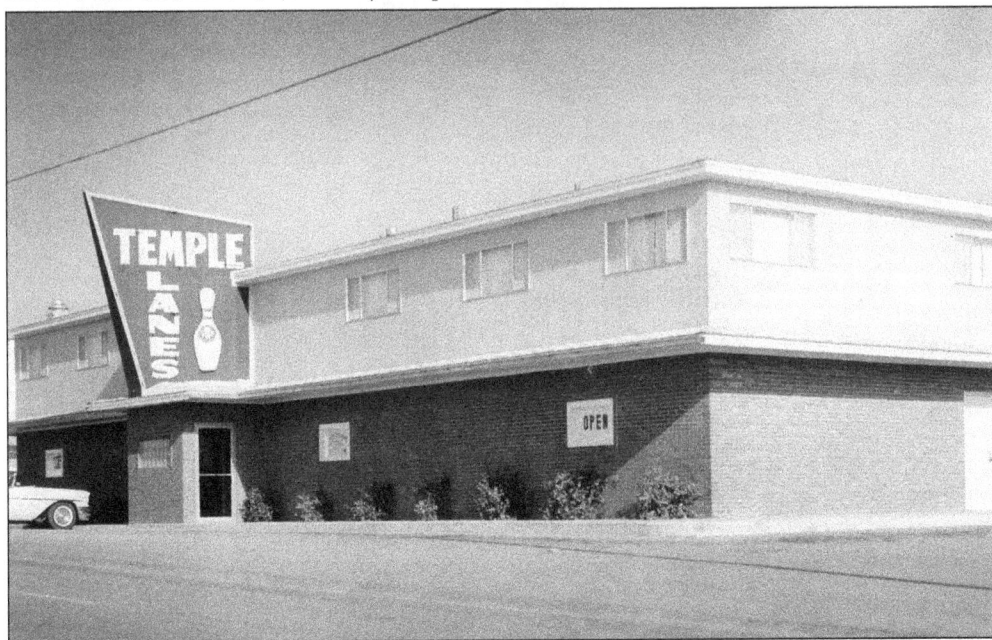

Two bowling alleys opened in the late 1950s—J's Bowl on North 3rd Street and Temple Lanes at 2905 South General Bruce Drive. Temple Lanes, pictured, was popular with league bowlers. Currently, Grammy award winner and Tejano entertainer Little Joe Hernandez occupies the building for his museum and office. (Courtesy of Temple Public Library.)

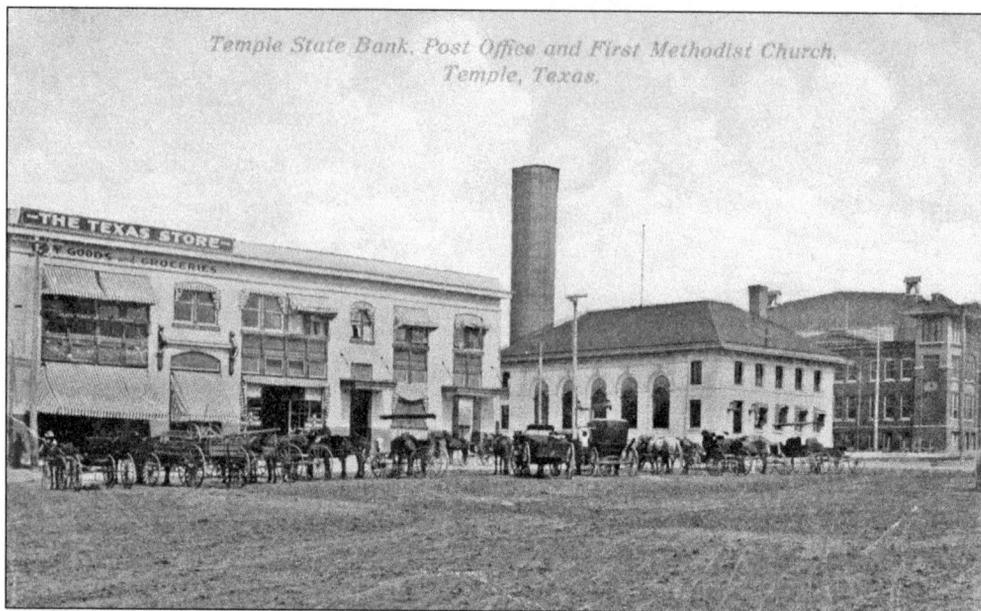

Temple State Bank, Post Office and First Methodist Church, Temple, Texas.

Pictured are the Temple State Bank Building, post office, and Methodist Church. When the bank building was completed in 1912 at Adams Avenue and North Main Street, John McKay established The Texas Store. James E. Ferguson built the two-story bank building before he became governor. The post office was also built in 1912. The standpipe is visible over the post office. (Courtesy of Temple Public Library.)

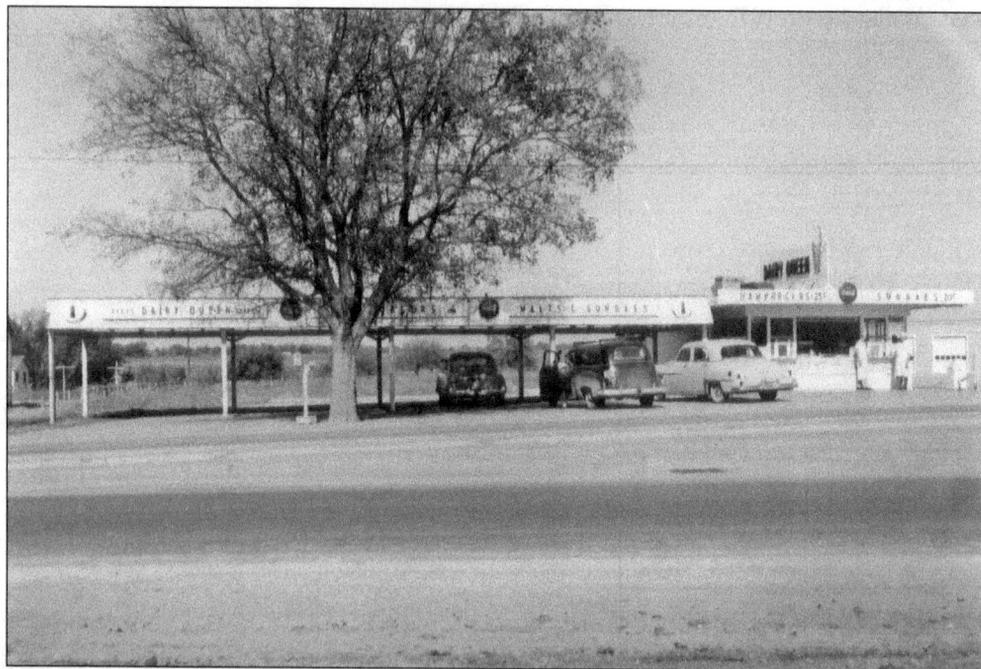

Wenzel Zabcik (left) and Frank Zabcik are in front of Dairy Queen at 2819 West Avenue H. James Anderson and Frank Zabcik owned this Dairy Queen, one of the first in Texas. The motto of Dairy Queen was "the cone with the curl on top." An ice-cream cone is visible in the sign on the building. Hamburgers were 25¢ and sundaes were 20¢. (Courtesy of Calvin Zabcik.)

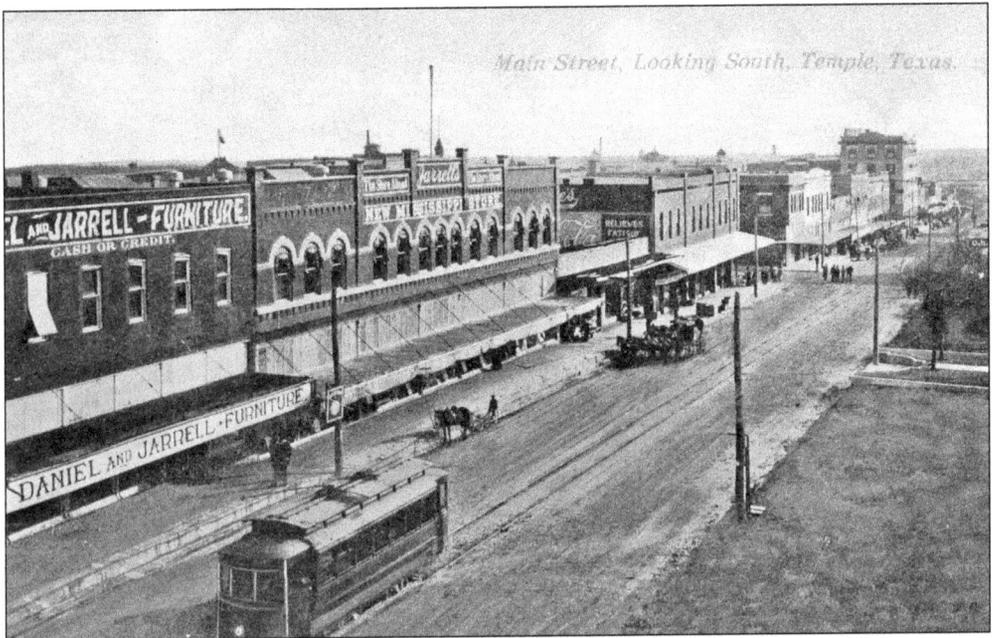

The Mississippi Store, part of a chain of 17 in the state, opened in 1890 on South Main Street. Following a fire in 1911, the store moved to this 20,000-square-foot building on North Main Street. By 1920, there were more than 50 employees working in 14 departments. The Mississippi Store carried a large stock of dry goods, boots and shoes, hardware, and tin ware. (Courtesy of Temple Public Library.)

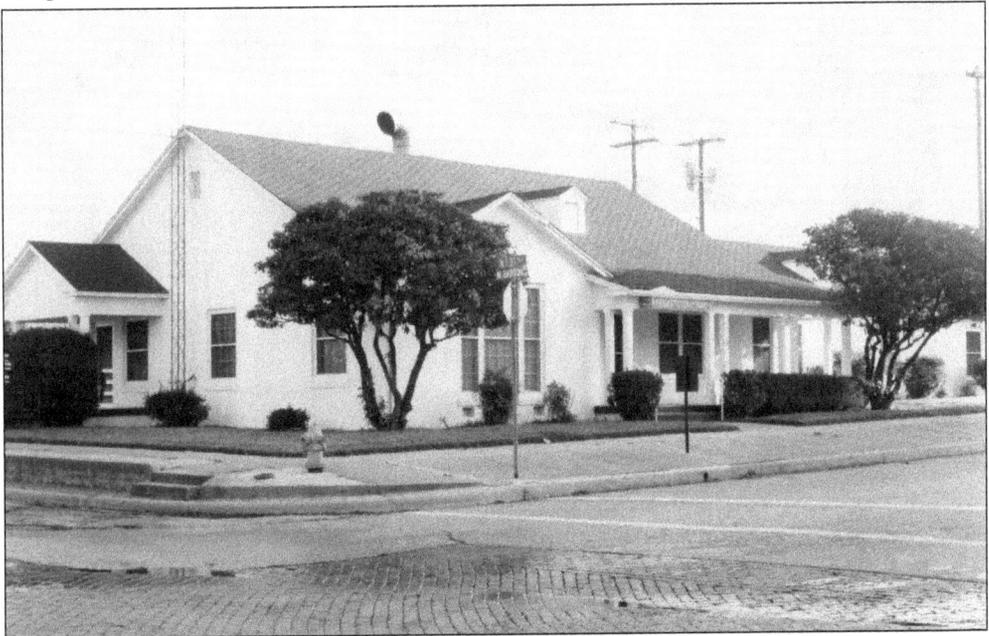

In 1942, Hewett Funeral Home moved to a new $20,000 building at 14 West Barton Avenue, pictured in this 1986 photograph. Tile and stucco were added to the building in 1955, and improvements to the office were made in 1959. Funeral sales for 1957 totaled $185,701.09, and for 1958, they were $175,562.55. (Courtesy of Kelsey Collection.)

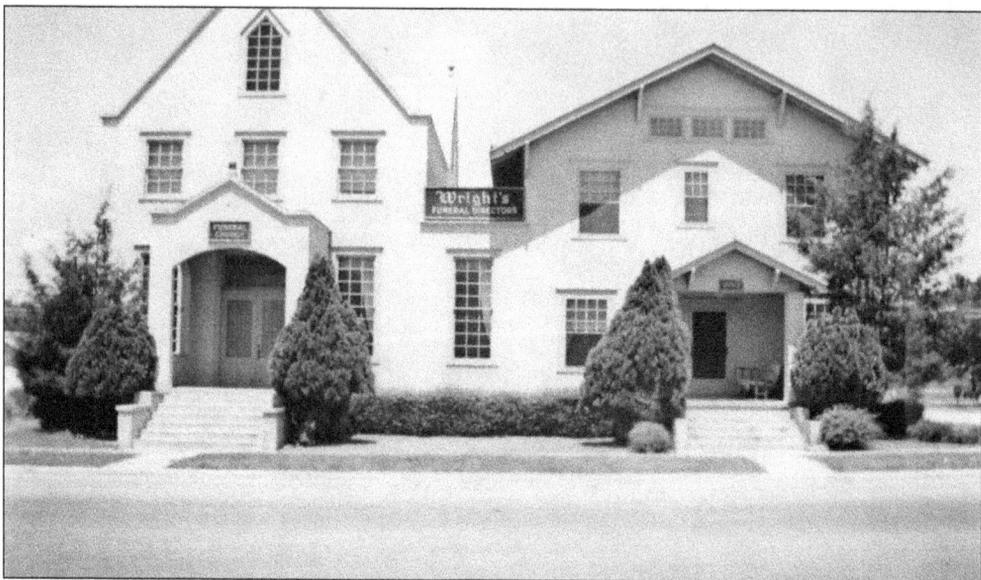

The Wright family operated Wright's Funeral Home on North 3rd Street for many years. Capt. T. C. Wright and J. E. Moore established XIT livery stable in 1881. In 1895, Wright erected a brick building on the lot where the livery stable was located. The business grew to include Wright's Undertaking Company. His son John became the first licensed embalmer in Texas. (Courtesy of Temple Public Library.)

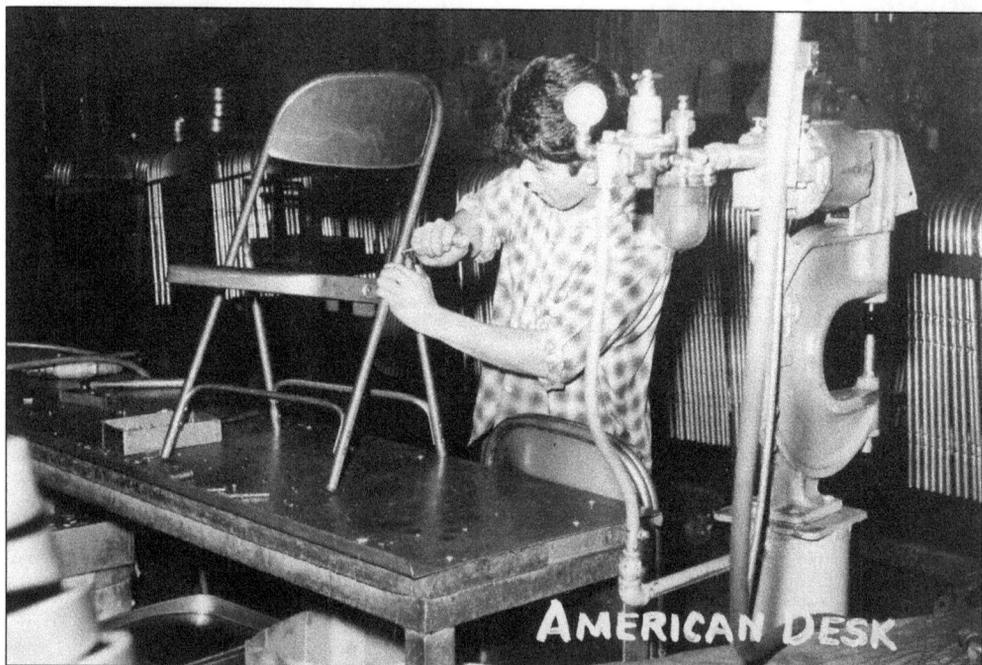

In 1923, W. C. Jackson and A. P. Brashear founded Texas School Equipment, which grew to become American Desk. By 1929, schools throughout the country were purchasing American Desk furniture. The manufacturing plant employed between 30 and 50 people. In 1960, American Desk and Best-Rite Chalkboard built a 40,000-square-foot building. Pictured is a worker at the American Desk plant. (Courtesy of Temple Public Library.)

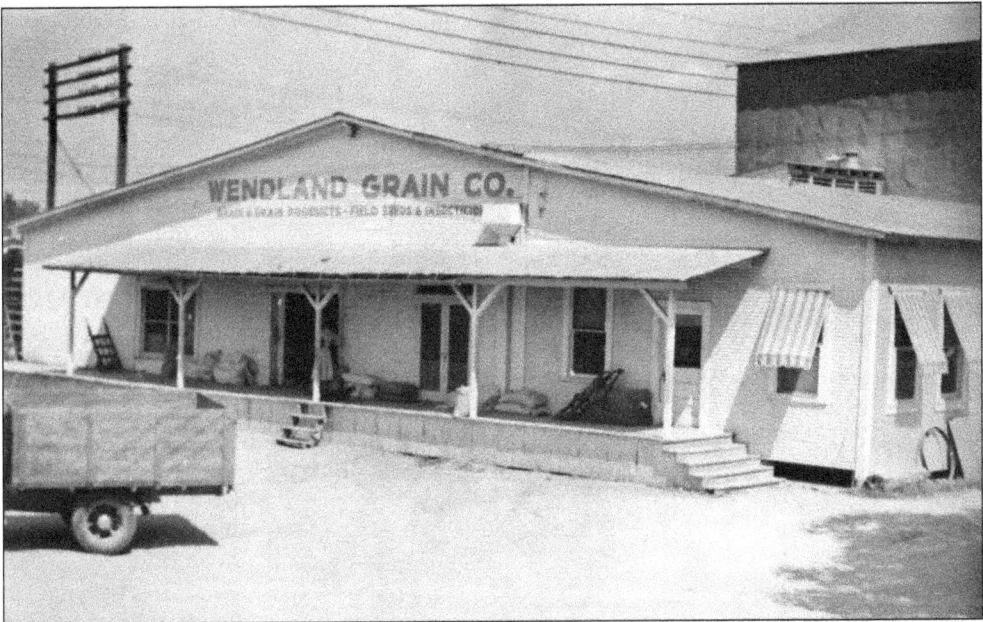

The Wendland family established Wendland Grain in Killeen in 1915. The plant moved to Temple in 1928. By 1934, the company manufactured more than 75 products grown in Central Texas. The average number of employees was 20. A 1954 expansion program increased grain production. Grain storage capacity increased to 187,000 bushels, corn increased to 12,000 bushels, and the average number of employees increased to 50. (Courtesy of Temple Public Library.)

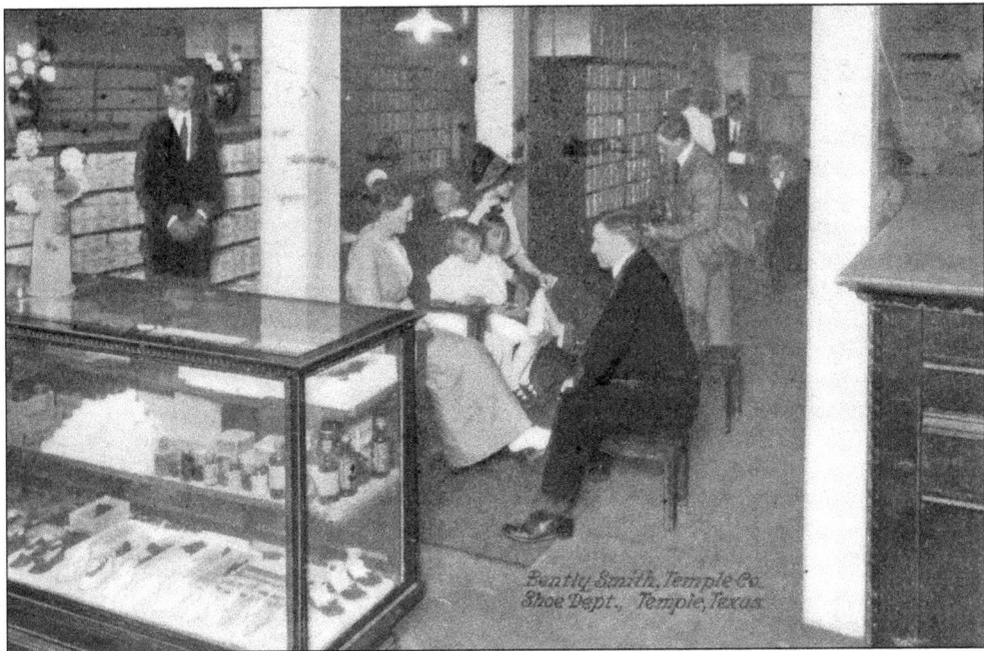

Officers of the Bentley-Smith-Temple department store were A. F. Bentley, president; H. H. Smith, vice president; and R. Mac Temple, secretary. F. D. George worked in the ladies' department and James B. Bishop was a salesman. Bentley also owned Bentley Dry Goods. He came to Temple from Belton in 1883 and opened a grain business. (Courtesy of Kelsey Collection.)

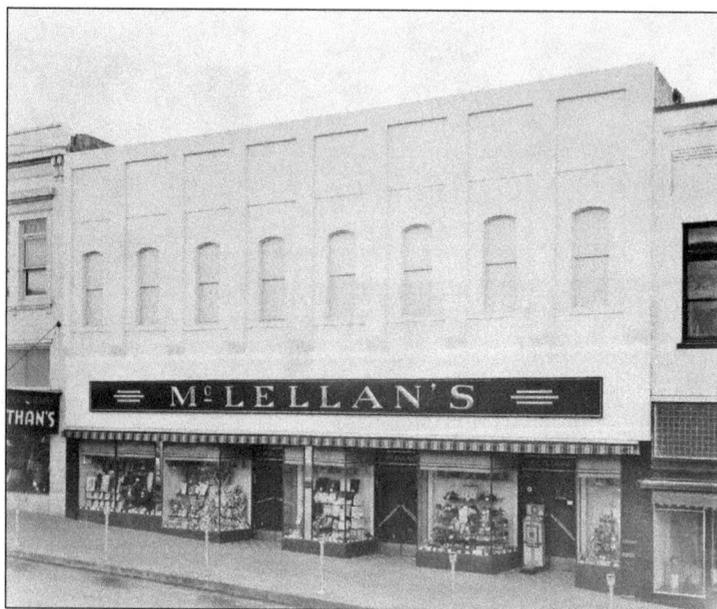

McLellan's store opened in 1927. The chain store specialized in inexpensive items in the 5¢ to $1 range. W. E. Holmes of San Antonio was the first store manager. Later O. M. Reilly became manager. The McLellan store operated for many years on South Main Street. In the Mood Ballroom has occupied the building since 1999. (Courtesy of Temple Public Library.)

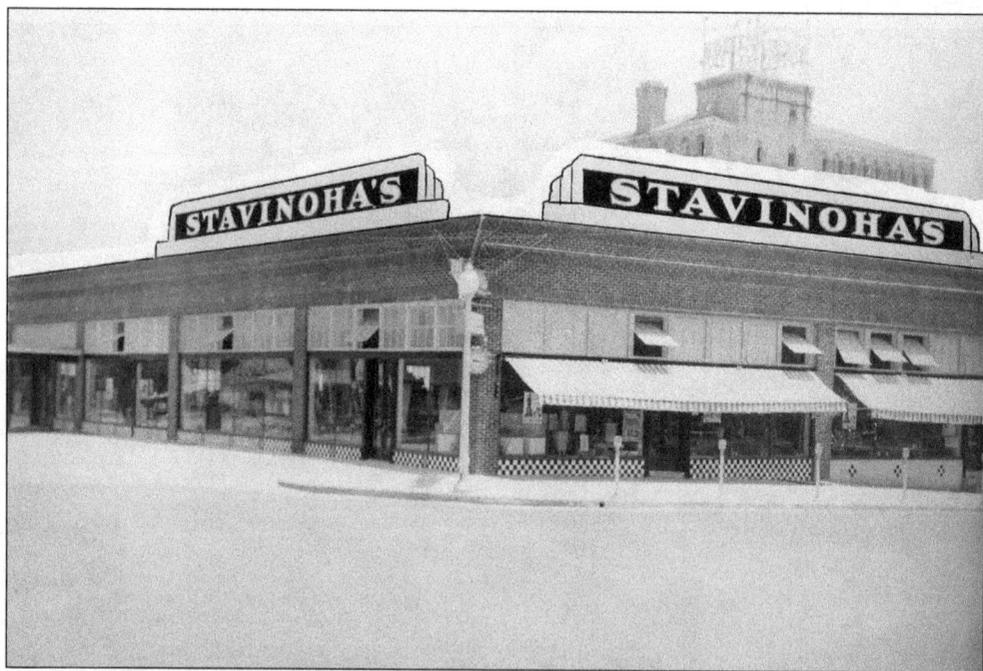

Brothers John and Henry Stavinoha of Fayette County founded Stavinoha's Hardware in 1906. John's son Robert joined the company in 1932 and was in charge of purchasing steel and wire goods. The business moved in 1936 to this 75-by-110-foot building with a basement at 2nd Street and Adams Avenue. (Courtesy of Temple Public Library.)

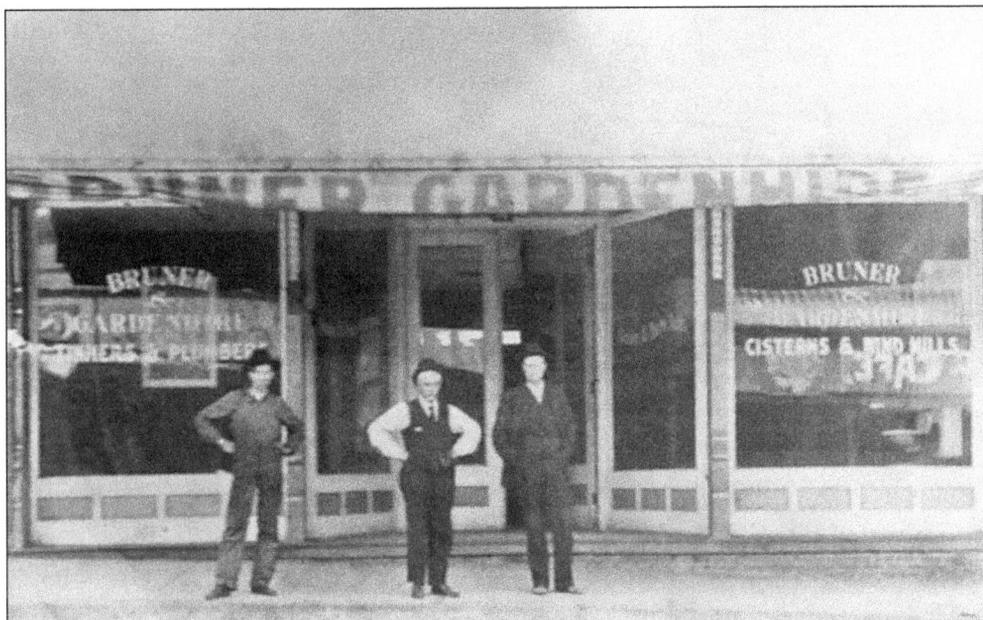

Charles Earl Bruner and G. Walter Gardenhire, who were tinners, steam fitters, and plumbers, formed a partnership in 1897. They specialized in the making of windmills and cisterns. Bruner and Gardenhire was located at 15 South 1st Street. The Bruner family came to Temple in 1881 and lived at 1120 South 8th Street. Gardenhire lived on East Avenue A. (Courtesy of Kelsey Collection.)

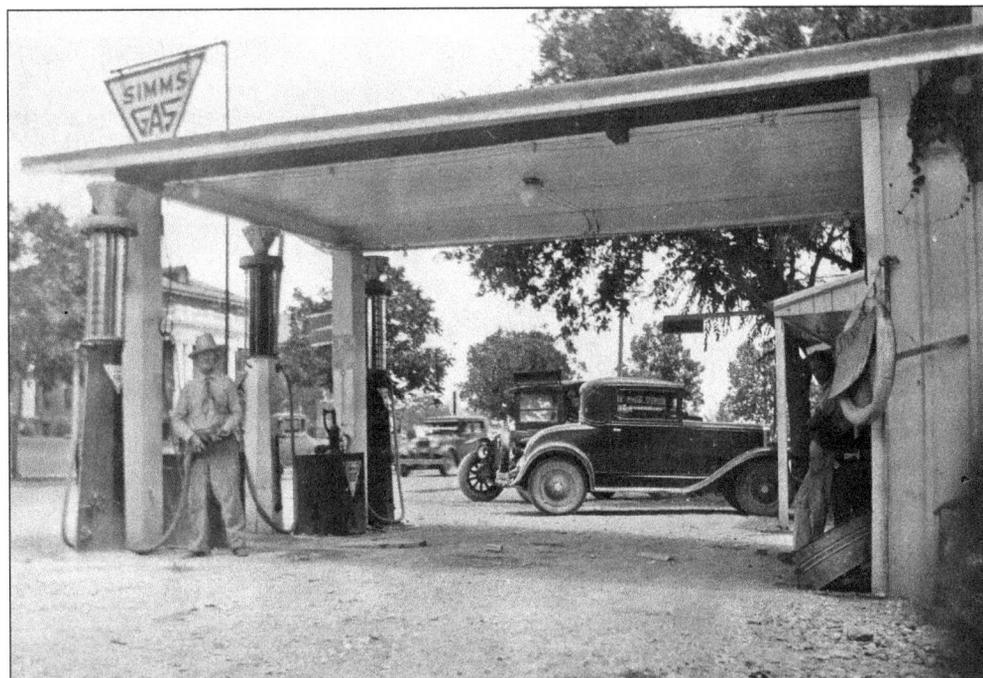

W. Y. Cummings, pictured, and his wife owned and operated a small grocery and service station across from Santa Fe Hospital near the busy intersection of South 25th Street and Avenue H. He sold the grocery in 1914 but soon reacquired it. In 1917, he built an eight-room residence near the store. The house stood for many years. (Courtesy of Jeannie Peteete.)

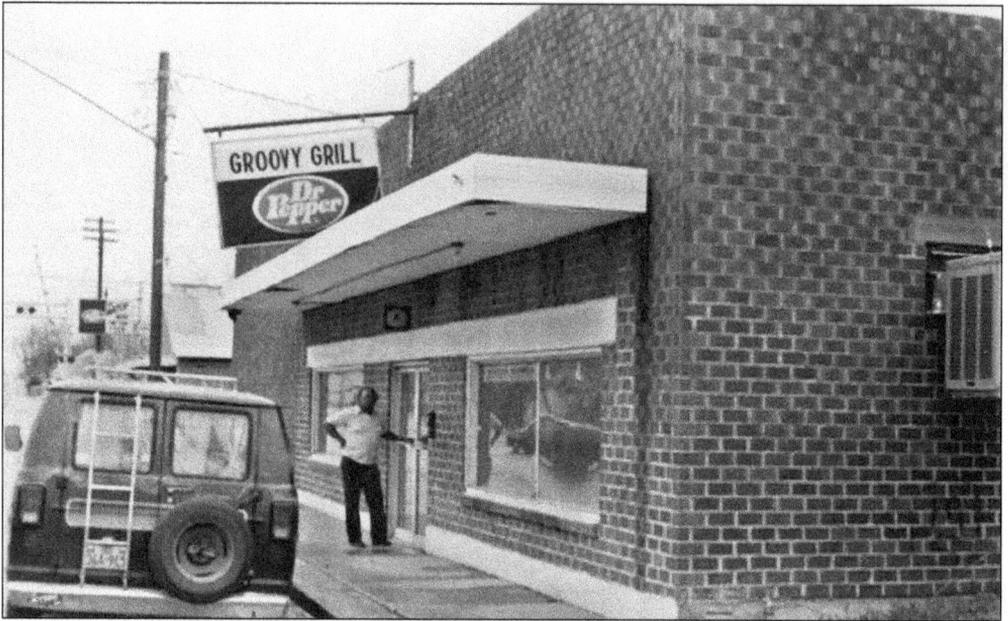

Rawlings Grocery and Market, a neighborhood store, was in this building at 420 South 8th Street. In 1972, after operating it for 40 years, Wade and Delia Rawlings sold to Joseph Shilo, who changed the name to Groovy Grill. Shilo did so well that he was able to pay Rawlings two note payments a month. As a small child, the Rawlings's grandson Mark Fellabaum helped in the store. (Courtesy of Kelsey Collection.)

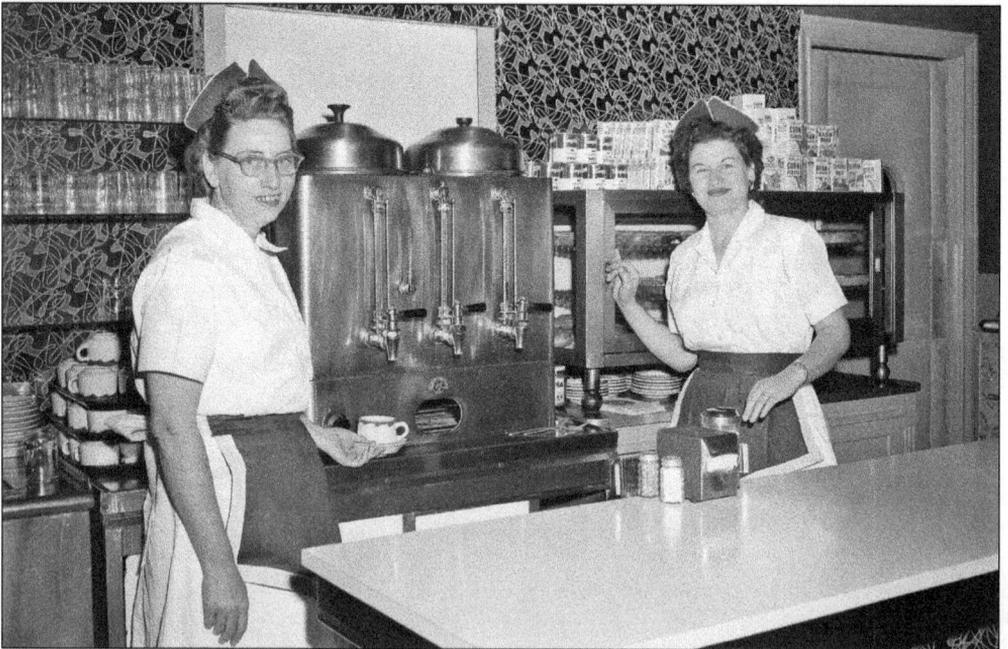

Michael Attas and his son-in-law Dean Creasey successfully ran the La Fonda Restaurant, which specialized in foods ranging from Mexican to Italian. At one time, Creasey owned the V and J Holiday Lounge on West Avenue A. Pictured in 1956 are two waitresses at La Fonda. (Courtesy of Temple Public Library.)

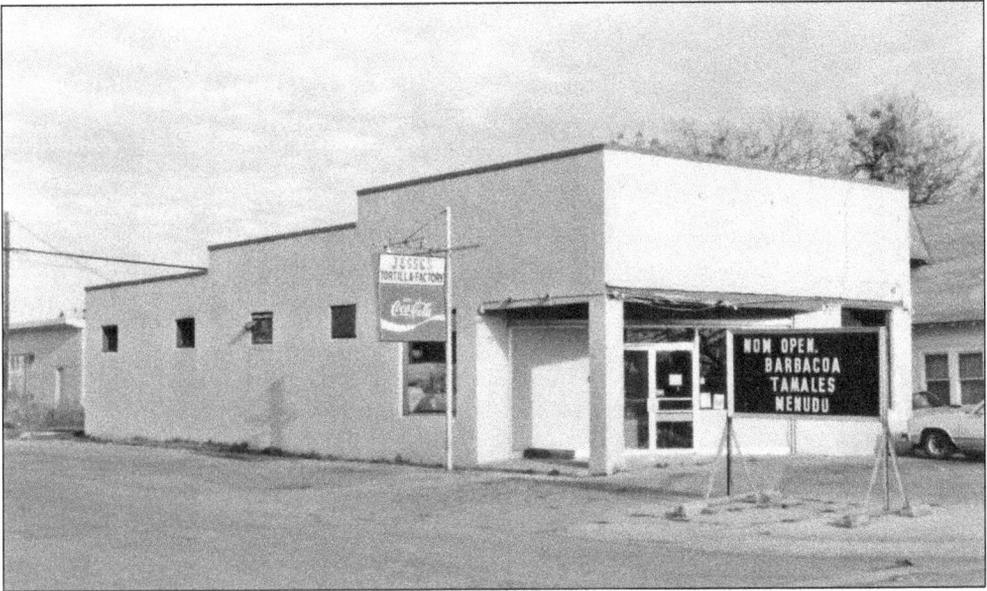

Ben Cuba owned and operated a neighborhood grocery for many years on the northwest corner of South Main Street and Avenue G at 620 South Main Street. Jesse's Tortilla Factory, which sold pastries, barbacoa, tamales, and menudo, occupied the building at the time of this photograph in 1987. In the late 1950s, Cuba owned and operated a grocery on South General Bruce Drive. (Courtesy of Kelsey Collection.)

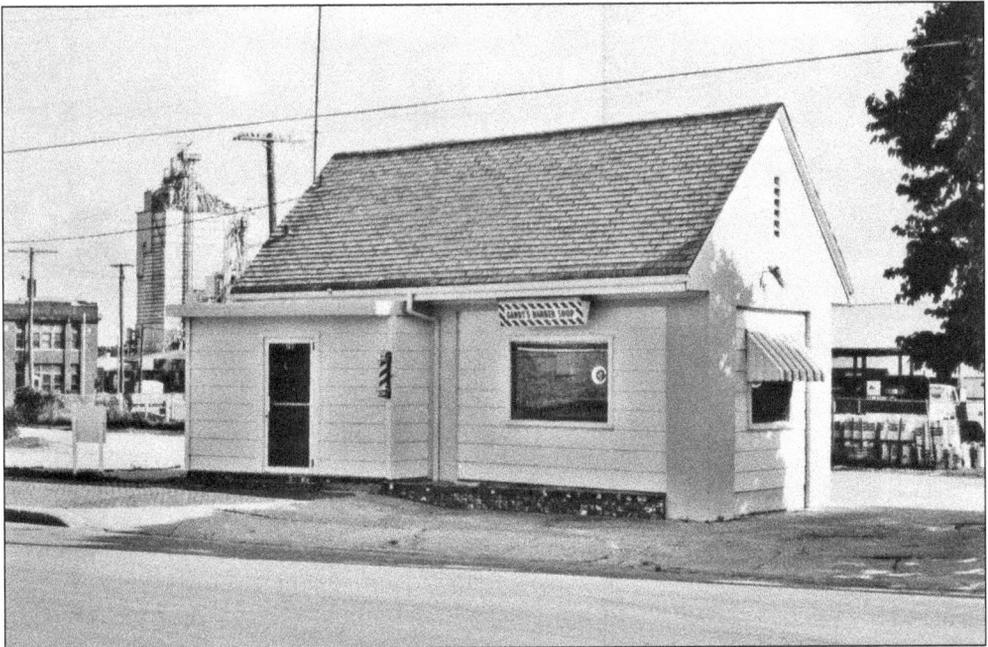

Pictured is the building that housed Gandy's barbershop in 1986, located at 201 South 1st Street. The building still stands and has been used as Gandy's barbershop since 1979. The lot was reputed to be the first sold in the town of Temple in 1881. J. H. Butcher of Galveston bought it. The Gulf, Colorado and Santa Fe Railway freight depot and Wendland Grain are visible at left. (Courtesy of Kelsey Collection.)

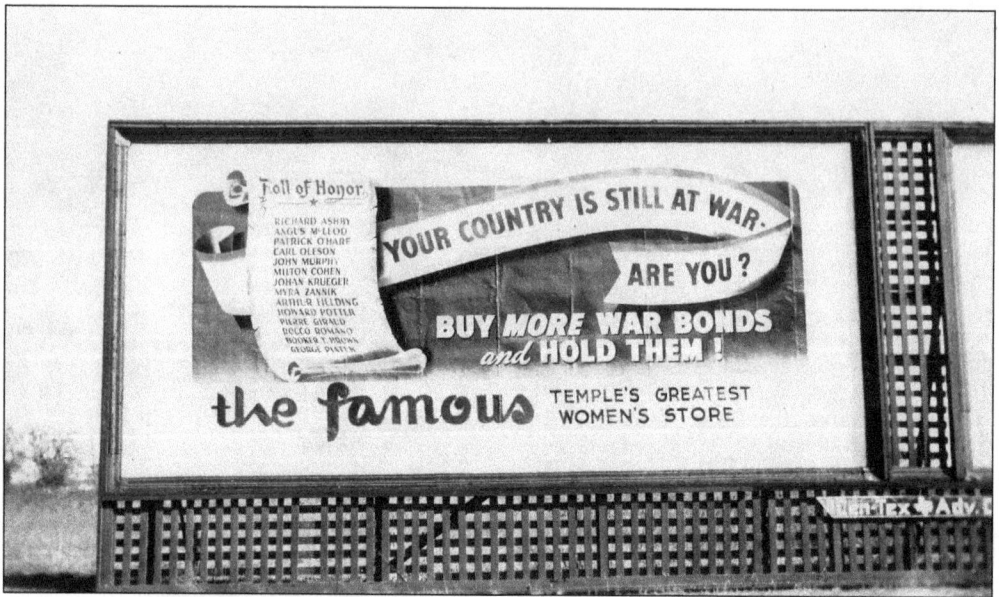

In 1925, Harry L. Weinblatt of Mart, Frank Handelman, and Jake Kroll formed a corporation known as The Famous. The business sold a variety of merchandise. In 1928, Weinblatt came to Temple and established The Famous. Remodeling took place in 1931. The air-conditioned New Famous opened in 1940 at 13 South Main Street. This 1948 photograph is of an outdoor advertising sign for The Famous. (Courtesy of Kelsey Collection.)

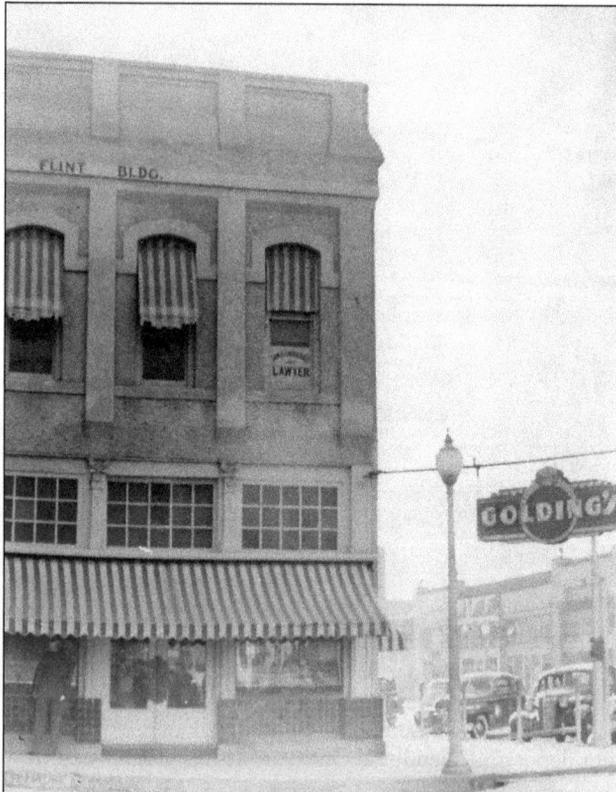

Golding's is pictured in the Flint Building at 19 South Main Street. Harvey Golding of Austin opened a jewelry store in 1928. Prior to his arrival in Temple, he worked for his father, M. Golding, in the jewelry business in Waco. Golding purchased Oppenheimer Jewelry and later acquired his father's store. He was a fourth-generation jewelry businessman. The Flint Building still stands. (Courtesy of Temple Public Library.)

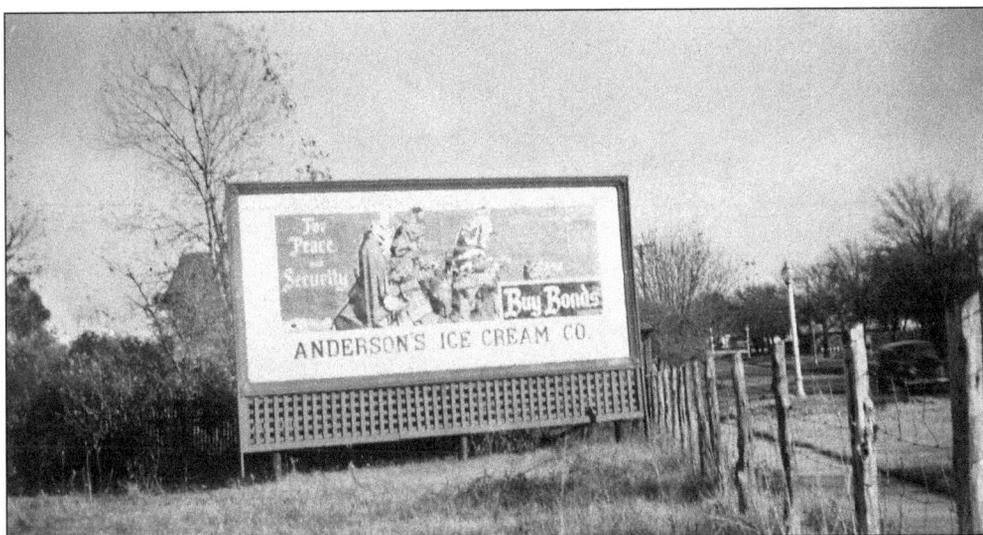

Paul C. Anderson founded Temple Dairy Products in 1935, operating in a small building on South 4th Street, with one truck for deliveries. The name changed in 1942 to Anderson Ice Cream Company, and ice cream became the only product. In 1946, the company had a yearly production of a half-million gallons of ice cream. This 1948 photograph is of an outdoor advertising sign for Anderson. (Courtesy of Kelsey Collection.)

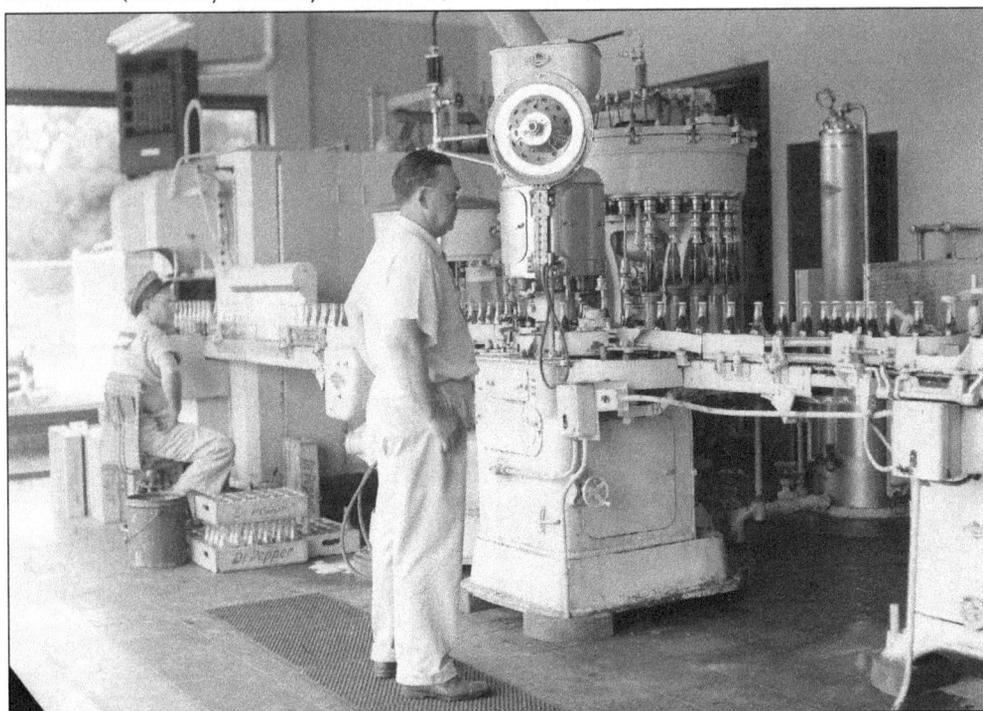

Sam Floca (right) inspects the bottling machinery at the Dr. Pepper plant. The Temple plant, located at 402 South Main Street, turned out 30,000 bottles daily. Three brothers, Sam, Theodore, and Buster Floca, formed the company. When this photograph was taken in 1955, the king-size can sold for 10¢, the small can sold for 7¢, and there were 20 employees in the plant. (Courtesy of Temple Public Library.)

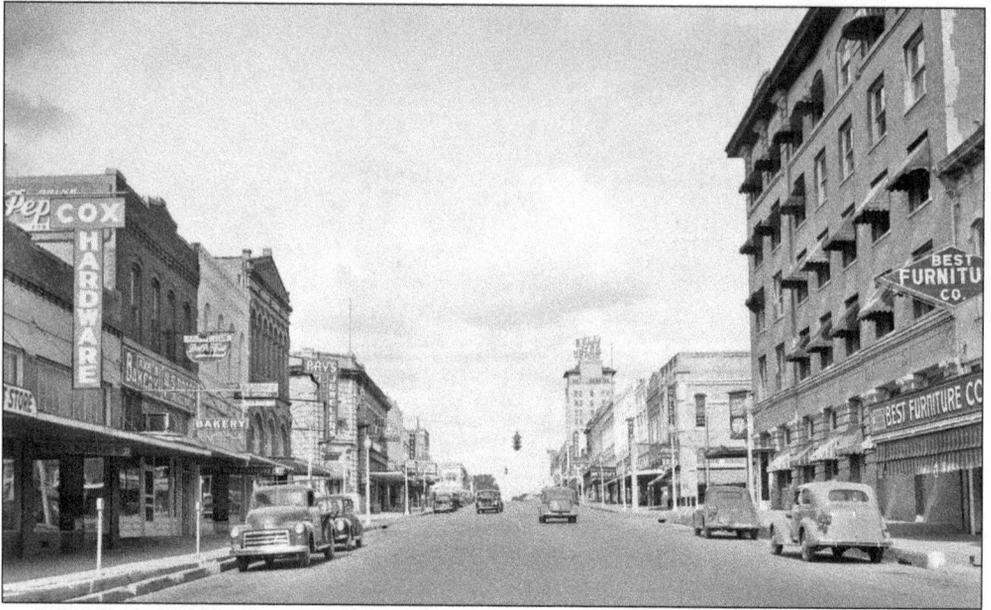

Shown here is Main Street looking north. The businesses on the left are Cox Hardware, Axe's Bakery, W. S. Nance Jewelers, Dixie Furniture, Mackey's Drug, and First National Bank Building; on the right are Kyle Hotel (tall building in the background), Texas Power and Light, Roddy's ladies ready-to-wear, Nathan's, Buttrey's, Golding's Jewelry, and Temple National Bank. Ray's Jewelers is in the Nunneley Building. Notice the original brick paving of Main Street. (Courtesy of Temple Public Library.)

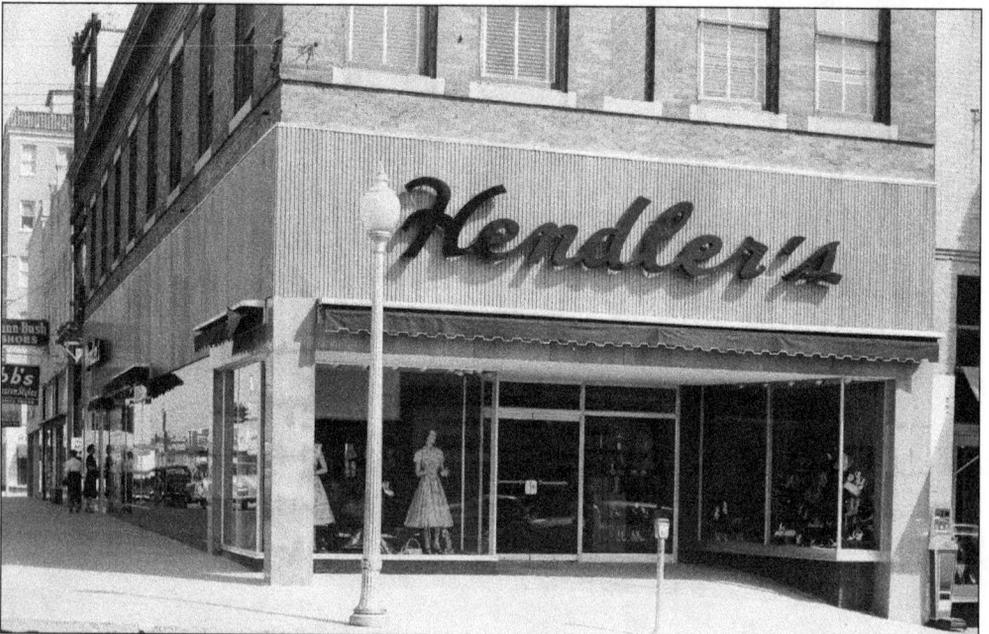

Hendler's, one of Temple's popular women's apparel stores, occupied the southeast corner of South Main Street and Central Avenue. Samuel Kalman Hendler, a native of Lithuania, owned and operated his store for more than 40 years. At the age of 17, he ventured to the diamond fields of South Africa as a prospector, and in 1913 and 1914, he acquired his financial start. The building still stands. (Courtesy of Temple Public Library.)

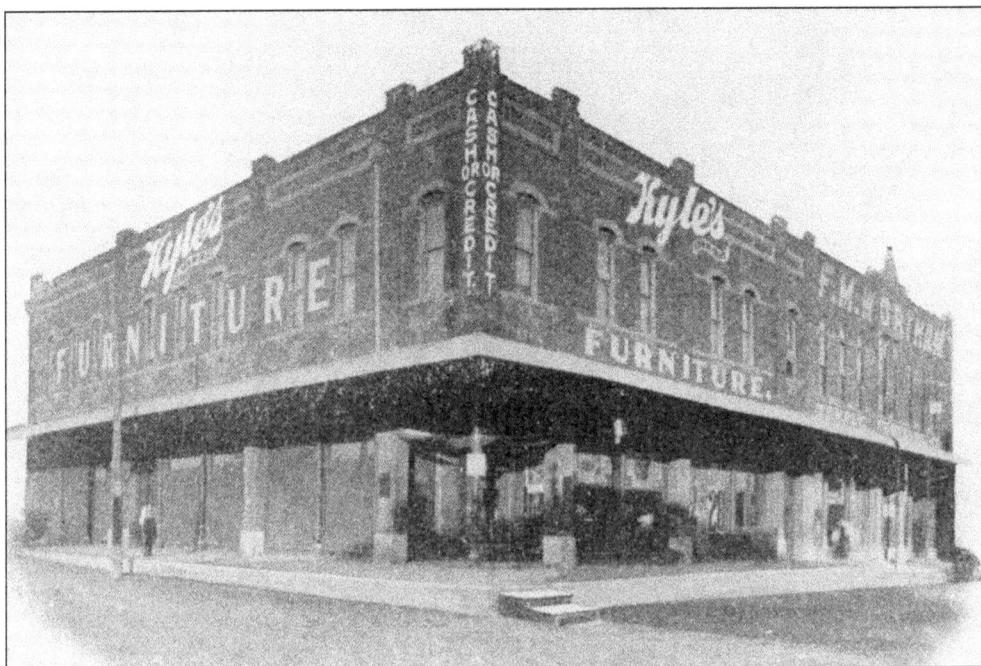

The most prominent of the early furniture dealers was Kyle's Furniture. Kyle's was established in 1889 on South Main Street between Avenue A and Avenue B. It was here that the early citizens of Temple purchased furniture, refrigerators, matting, linoleum, shades, and a multitude of other household items. In 1891, the company added an undertaking department and hired an embalmer. J. W. Kyle retired in 1914. (Courtesy of Kelsey Collection.)

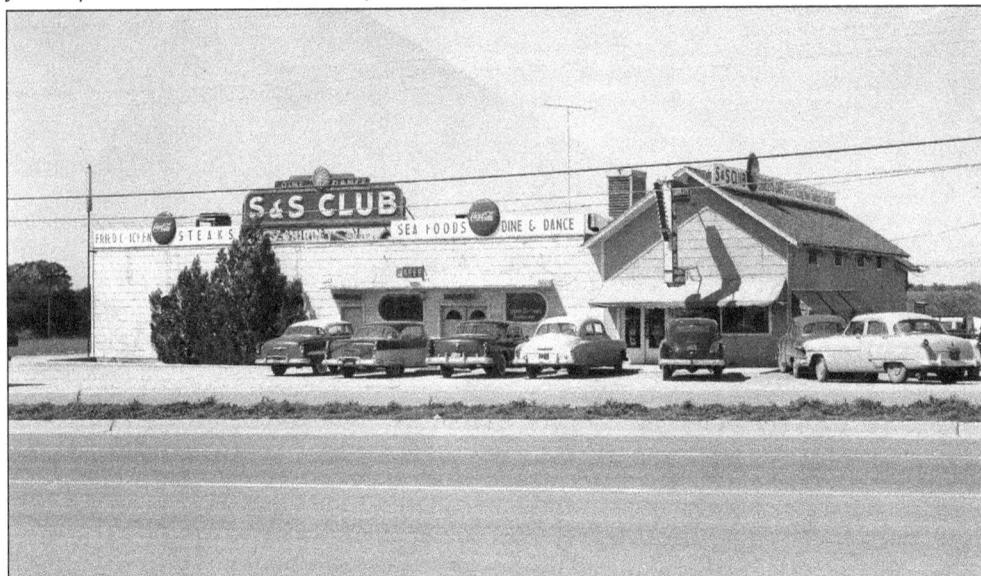

The S & S Club, established in 1946, was a popular supper and dance club. It was at the extreme end of West Avenue H on the old Temple to Belton Highway. Soldiers from nearby Fort Hood frequented the club, which was named for Henry Stefka and Lawrence Sladovnik. Sladovnik and Stefka were brothers-in-law. Sladovnik first managed the S & S Club, followed by L. S. Shirley. (Courtesy of Temple Public Library.)

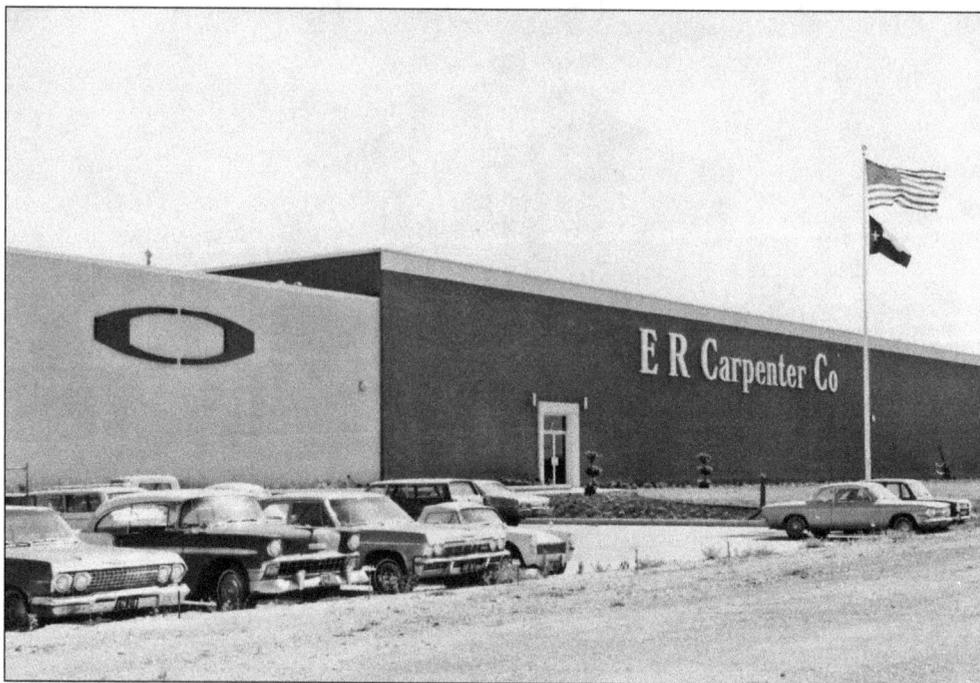

E. R. Carpenter Company, with corporate offices in Richmond, Virginia, opened a manufacturing plant in Temple in 1966. The company manufactured 58 different kinds of foam products. When it opened, the 150,000-square-foot plant expected to employ about 100 and to have an estimated payroll of $7.5 million. The Carpenter Foundation generously donates money to the local community. (Courtesy of Temple Public Library.)

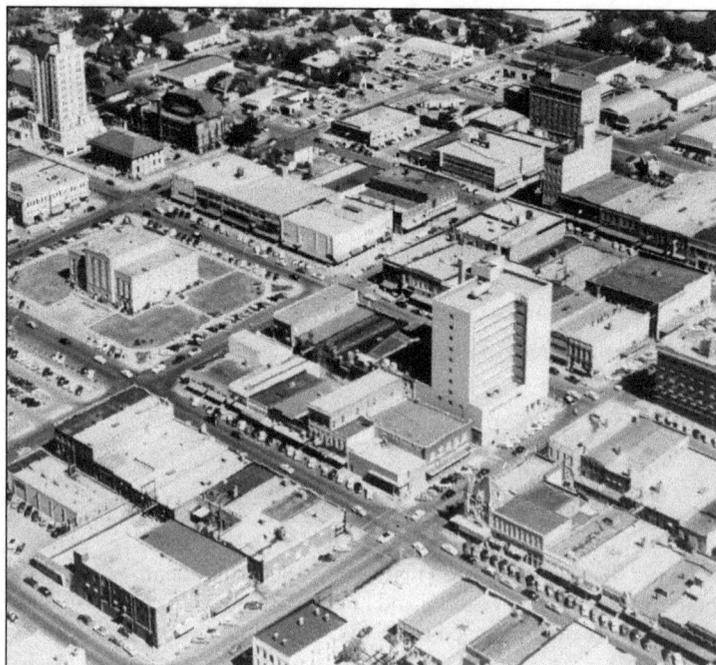

This aerial photograph of downtown Temple in 1960 appeared in a City of Temple brochure that explained the functions of city government. At this time, Keith Dodgen was city manager and Jay S. Williams was purchasing agent. The fire department was composed of 3 stations and 27 men. During 1959, the police department answered 10,529 calls. (Courtesy of Temple Public Library.)

Temple Candy Company was established in 1901 on South 1st Street in a single storeroom with five employees. Business growth compelled a move to larger quarters. Pictured is the new two-story brick building with a basement and elevators at South 4th Street and East Avenue A. By 1913, the company had 100 employees and manufactured 250 varieties of candy and gum. In 1924, the state awarded a contract to Temple Candy Company to supply candy and gum to state institutions. A popular confection produced by the Temple Candy Company was OSally, a candy with a vanilla fudge center dipped in caramel, rolled in roasted peanuts, and covered in chocolate. Shown below are employees of Temple Candy. (Above courtesy of Kelsey Collection; below courtesy of Ray VonRosenburg.)

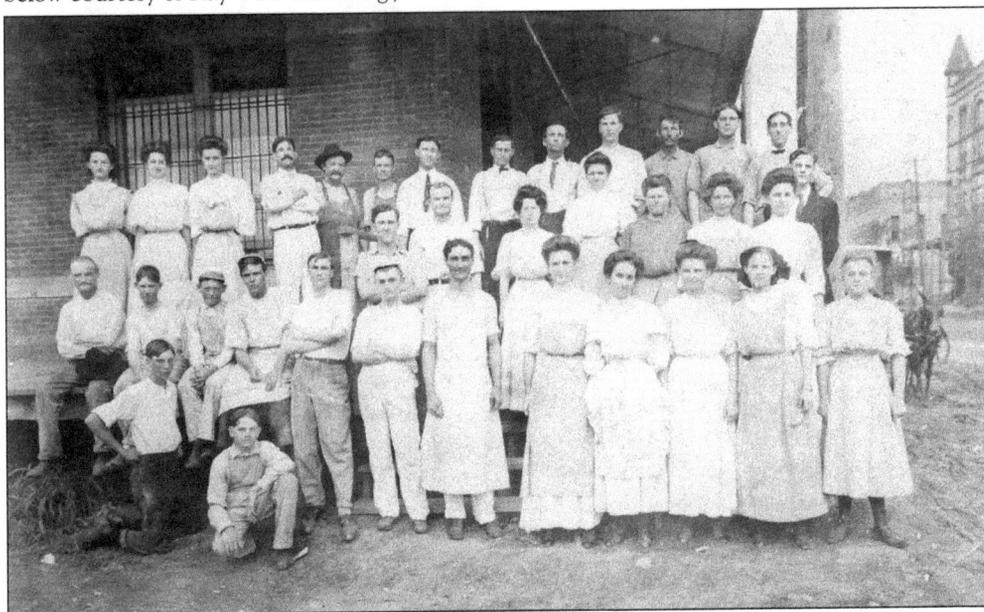

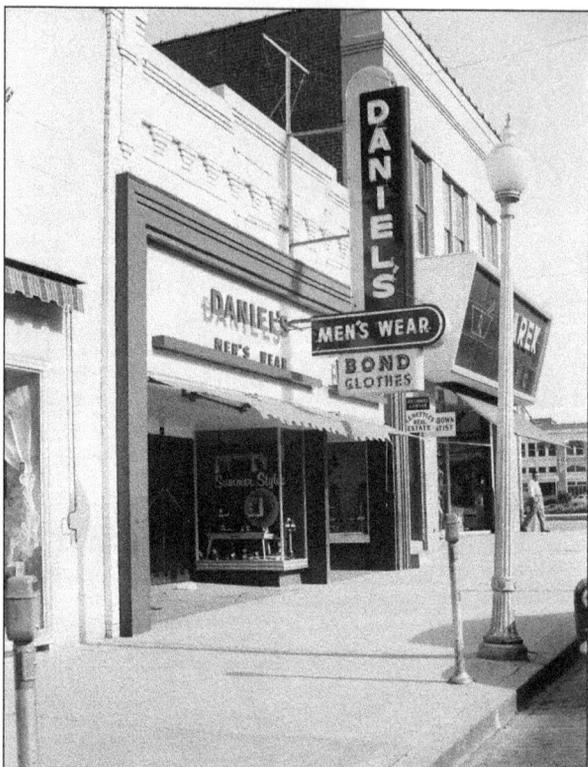

J. H. Daniel owned and operated Daniel's Men's Wear. His store occupied the building at 4 South Main Street next door to Marek Drug, pictured below at 2 South Main Street. Floyd's Booterie, owned by Forrest W. Floyd, occupied the same building as Daniel's. (Courtesy of Temple Public Library.)

Louis J. Marek established a drugstore in the Professional Building in 1938. In 1953, Marek Drug moved to a new location at 2 South Main Street at the corner of Central Avenue and South Main Street. In addition to filling prescriptions, the drugstore sold stationery, magazines, pipes, cosmetics, electric razors, and school supplies. (Courtesy of Temple Public Library.)

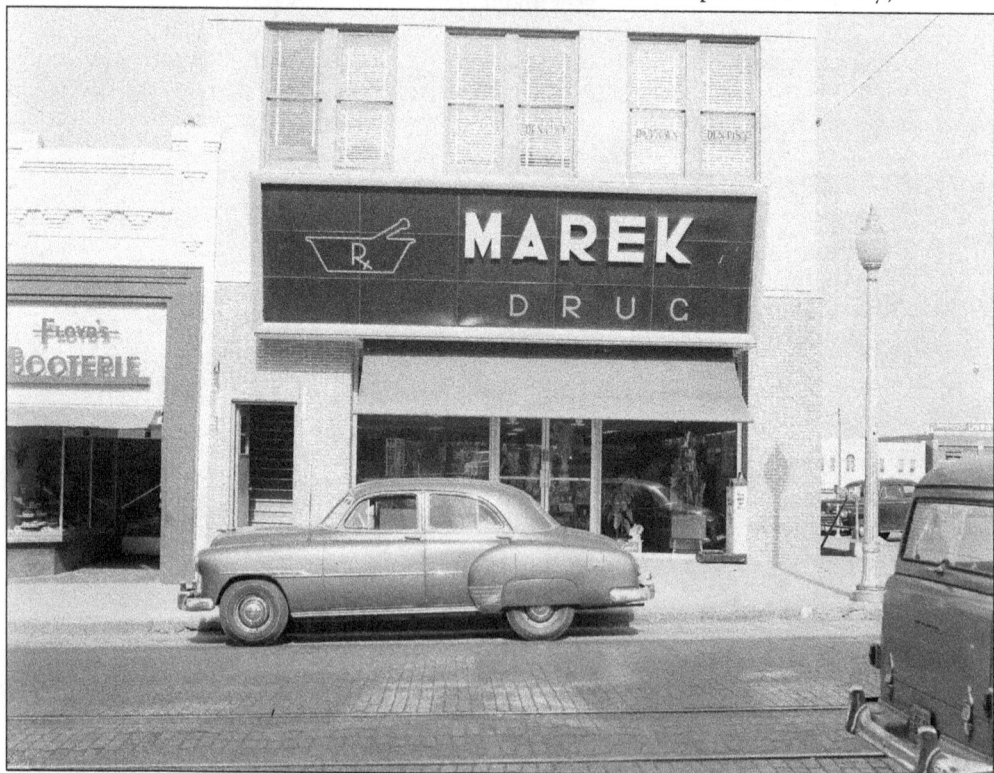

At the time this photograph was taken, Home Furniture was owned by Lillian Kasten Bredthauer, the widow of W. C. Bredthauer, who established Home Furniture in 1932. The store was located at 106 North Main Street. The company sold nationally advertised merchandise. The Home Furniture sign has remained displayed on the building. (Courtesy of Temple Public Library.)

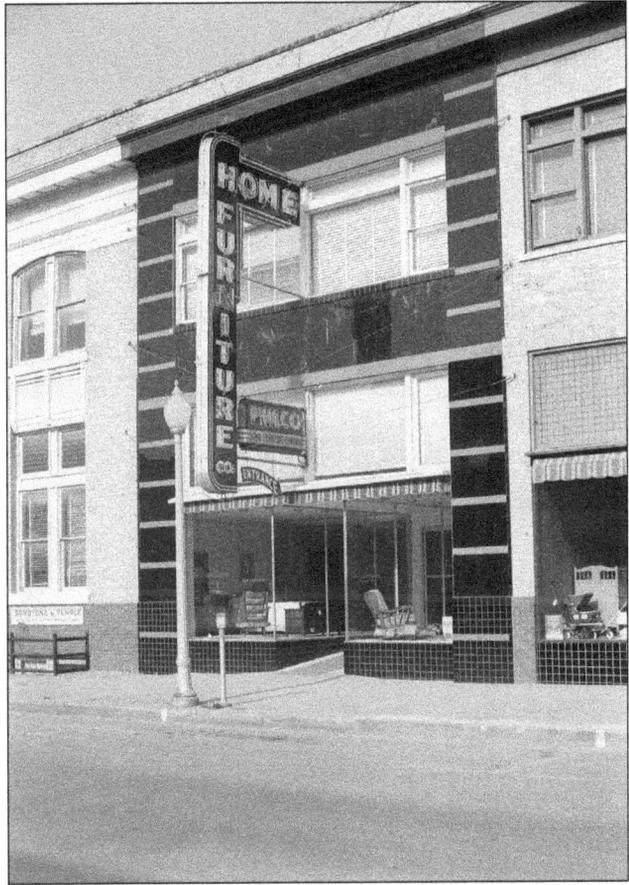

Lionel L. Campbell, Bruce Campbell, and James W. Marrs established Campbell-Marrs Lumber Company in 1938. The business was at Avenue A and South 4th Street. The company also owned a lumberyard at Killeen. The Campbell family established their lumber business in 1916 in Moody. Lumberyards were also established at Waco, Eddy, Rosebud, and Groesbeck. (Courtesy of Temple Public Library.)

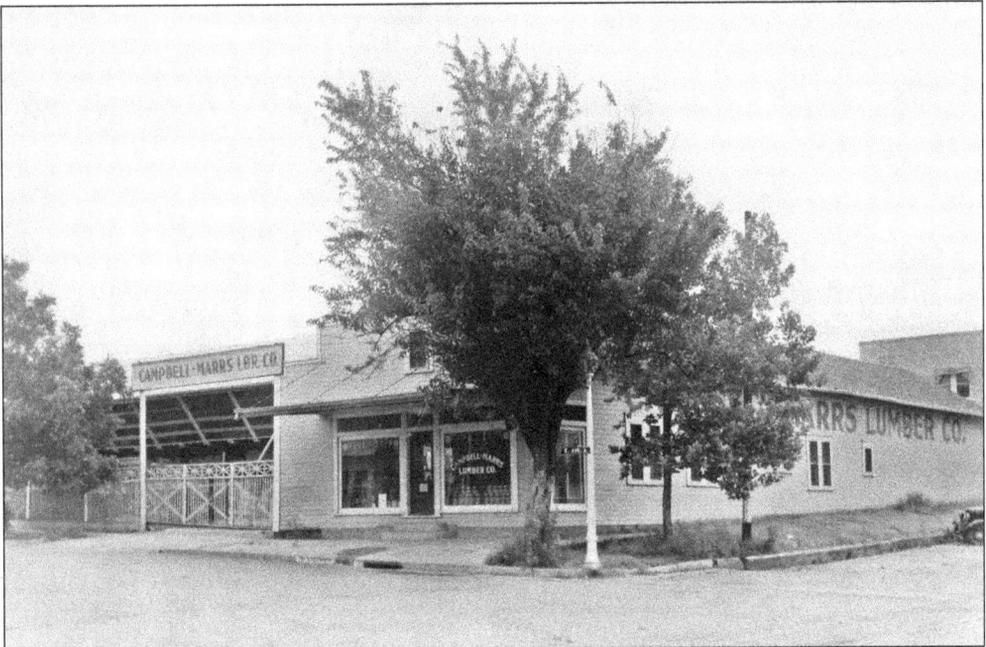

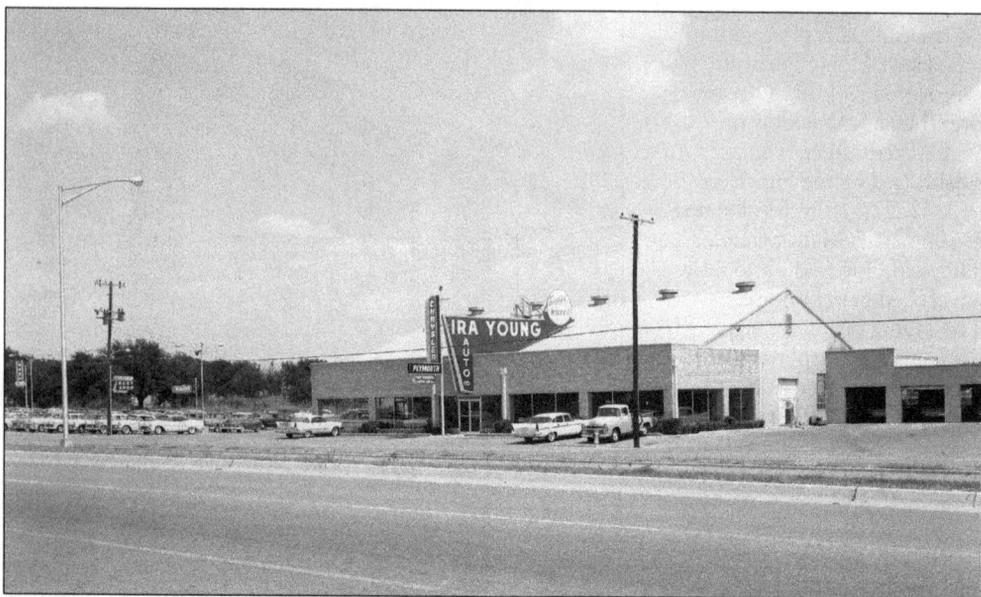

Pictured is Ira Young sales agency on South General Bruce Drive, which sold Chrysler and Plymouth automobiles. He opened his first automobile lot on South 1st Street in 1936 and this automobile lot in 1952. In 1962, he built Youngstown Shopping Center at 2901 South General Bruce Drive. The shopping center is partially still in use. (Courtesy of Temple Public Library.)

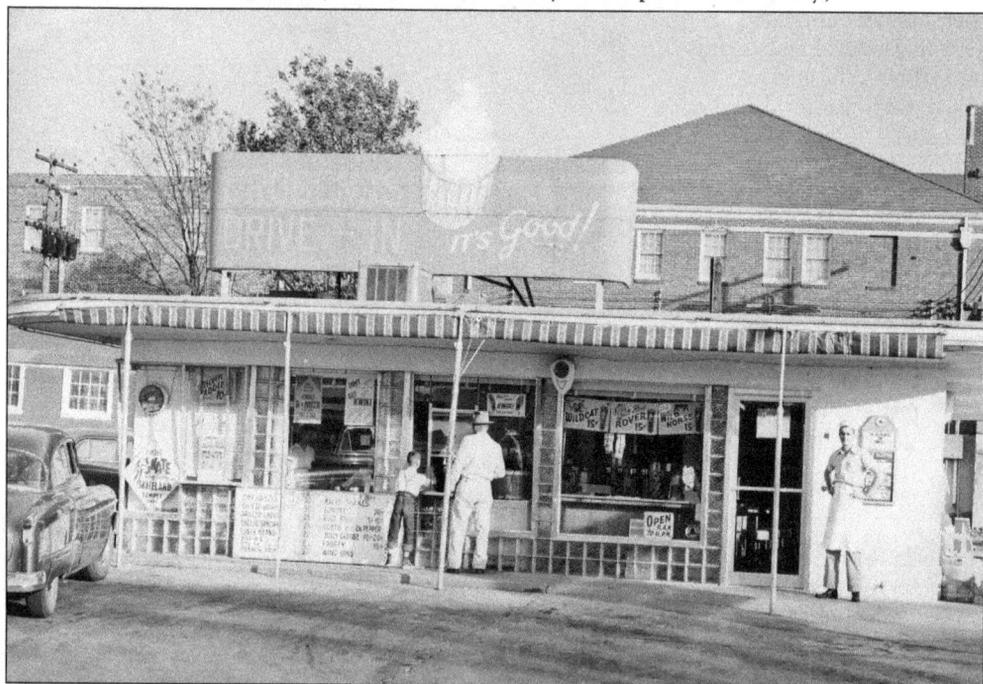

Drobena's Drive-In, located near the old Temple High School on North 3rd Street, was popular with students. At first, the small drive-in offered only counter and curb service, but later a dining room was added. Cheeseburgers sold for 35¢. Declining sales brought on by the relocation of Temple High School and construction of Interstate 35 resulted in the ultimate closing of the drive-in. (Courtesy of Sam Houston.)

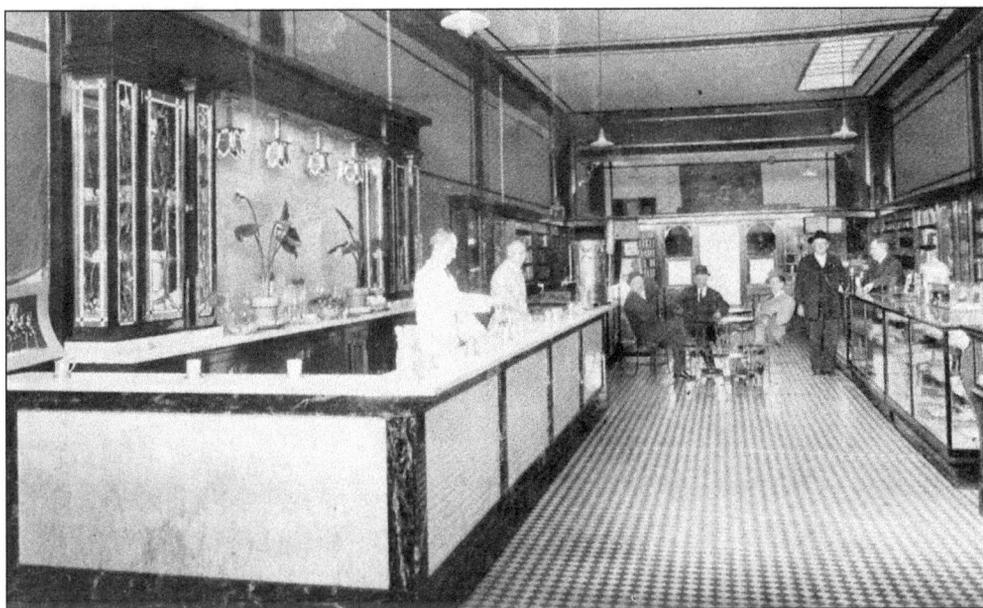

Shown is the Willis and McLain Drugstore. W. E. Willis came to Temple in 1886. His drugstore business was in several locations before he moved in 1929 to the Kyle Hotel and occupied the northwest corner of the building. Ennis Calhoun was a soda jerk in the new location. Willis was one of the first druggists to install a soda fountain. (Courtesy of Sam Houston.)

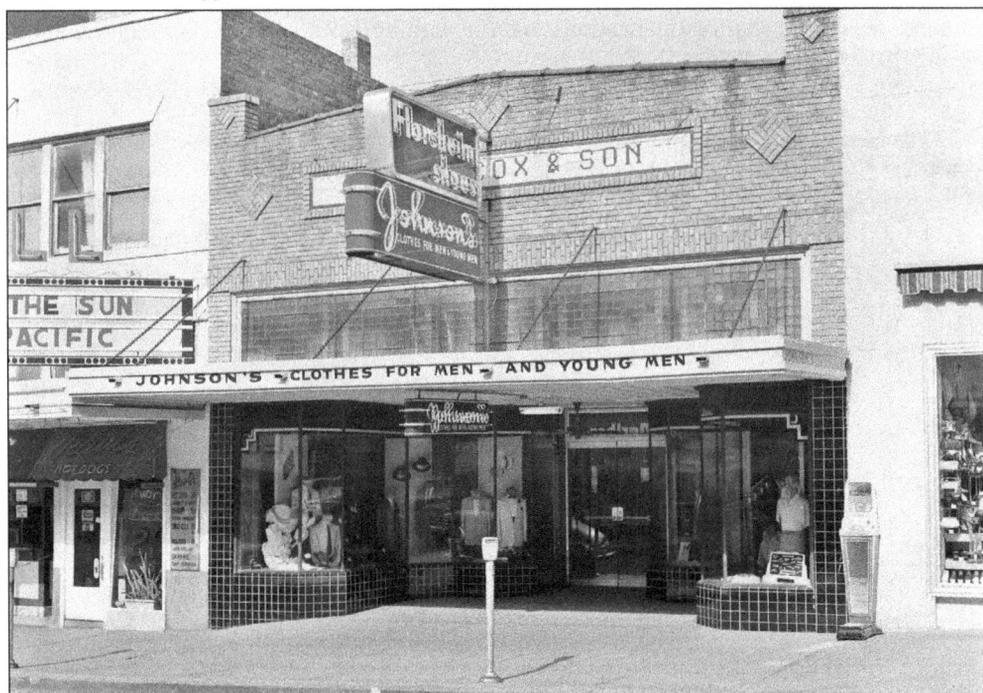

Johnson's sold apparel for men and young men, including Florsheim shoes. Lawrence M. Johnson owned the South Main Street business, which occupied the Charles Cox & Son Building. Johnson opened the business about the time this photograph was taken. Bell Theatre and Paul's Place were to the south. (Courtesy of Temple Public Library.)

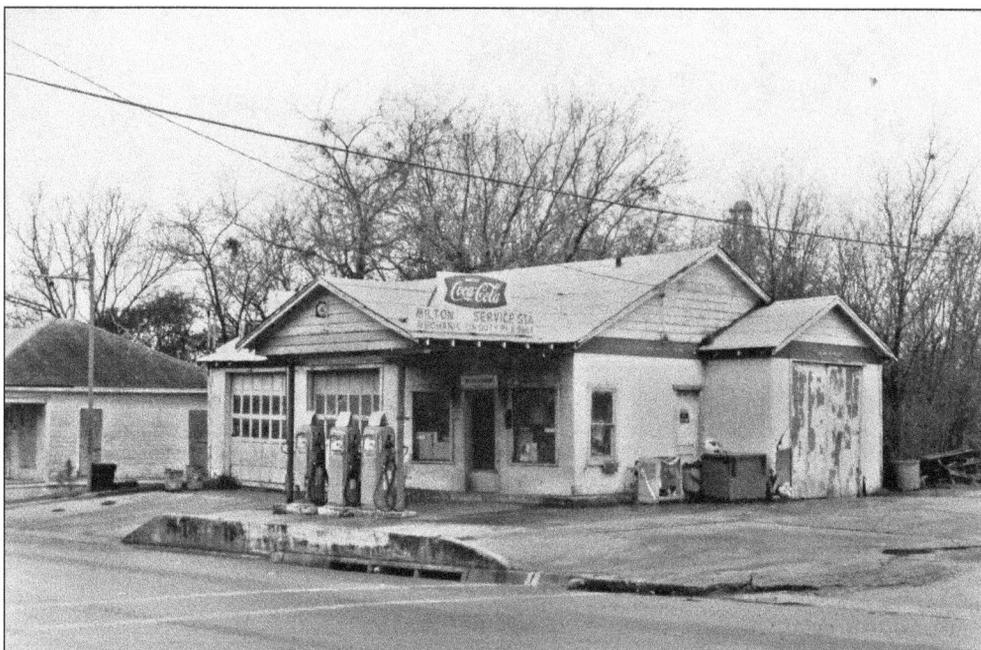

Pictured here in 1986 is the Milton Phillips 66 service station. Milam County native Milton Stephen owned and operated the station for 26 years. The three-pump gasoline station was at 402 South 8th Street. In addition to the sale of gasoline products and batteries, Stephen provided a mechanic for minor repairs, oil changes, lubrications, and car washing. (Courtesy of Kelsey Collection.)

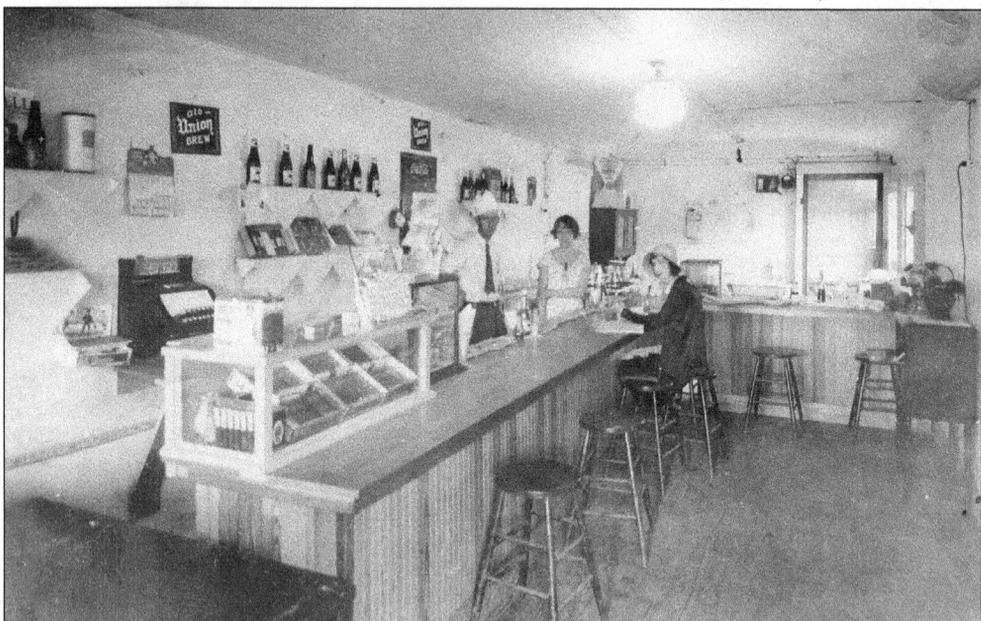

Chief's Café stood across from Santa Fe Hospital. A. S. and Lottie Cummings Peteete managed the café. Lottie's father, W. Y. Cummings, was the owner. Peteete descendants passed down family lore that Bonnie and Clyde ate at Chief's Café when Doyle Johnson was killed by the gang. The café was a familiar site to travelers on old Highway 81. The photograph is from the 1930s. (Courtesy of Jeannie Peteete.)

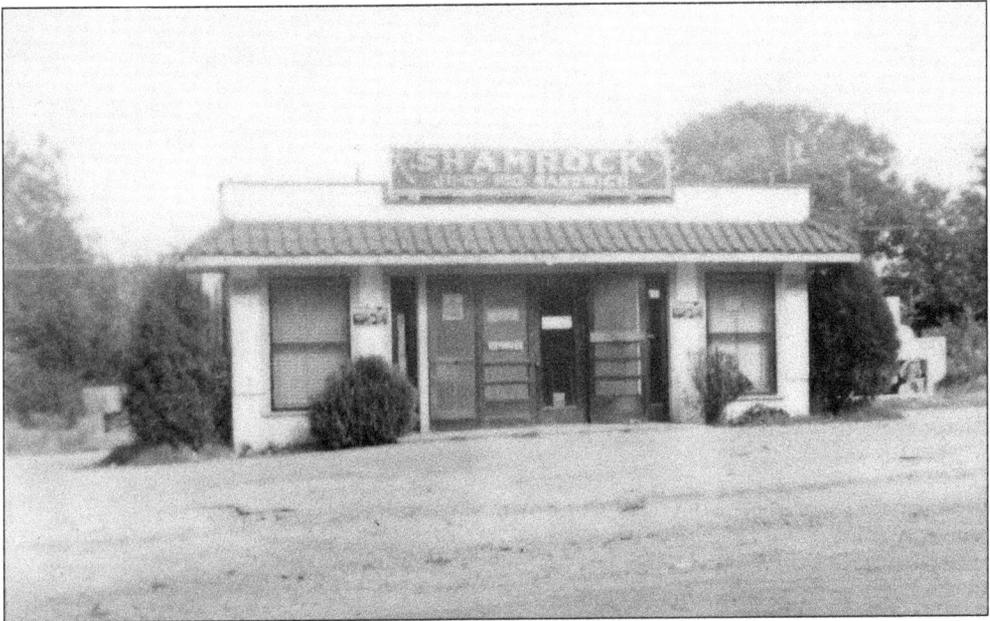

About 1935, T. R. Wolf established Shamrock Café at 615 North 3rd Street. It was under Frank Roberts's ownership that Shamrock waitresses were required to wear green and white checkered uniforms, reflecting an Irish origin. The café became famous for its pig sandwiches and Wednesday ritual of homemade tutti-frutti ice cream. Popularity extended beyond the chef's culinary skills, as in the rear of the café was a slot machine. (Courtesy of Sam Houston.)

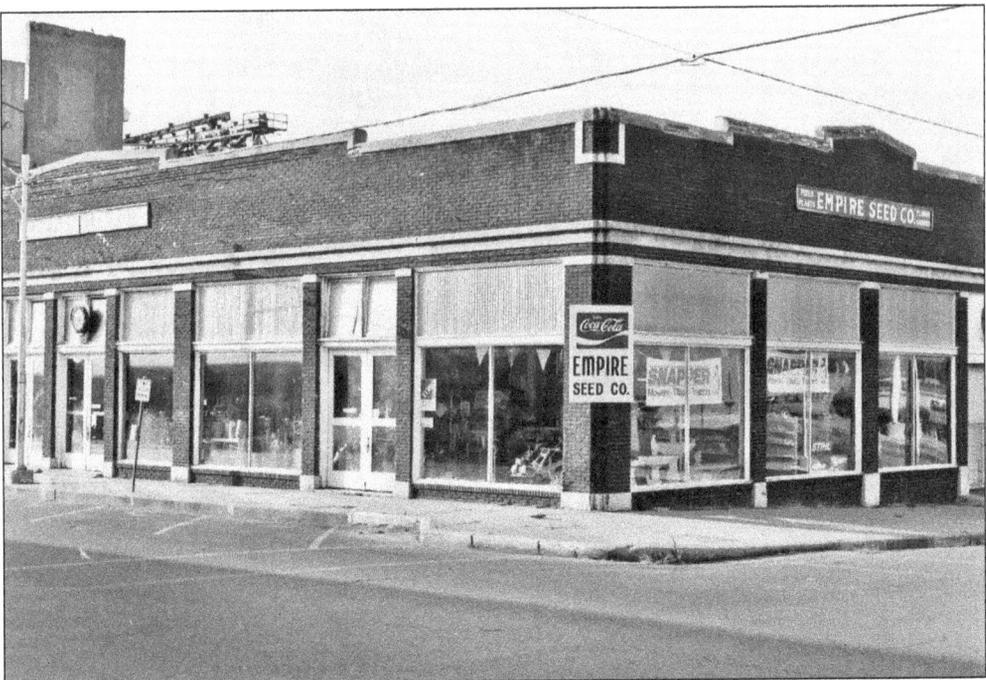

C. H. Robertson and George F. Brooks established Empire Seed Company in 1936. It carried a wide variety of seed, fertilizers, and garden plants. Empire Seed, located at the corner of Avenue A and South 2nd Street, is still in business. It is pictured here in 1986. (Courtesy of Kelsey Collection.)

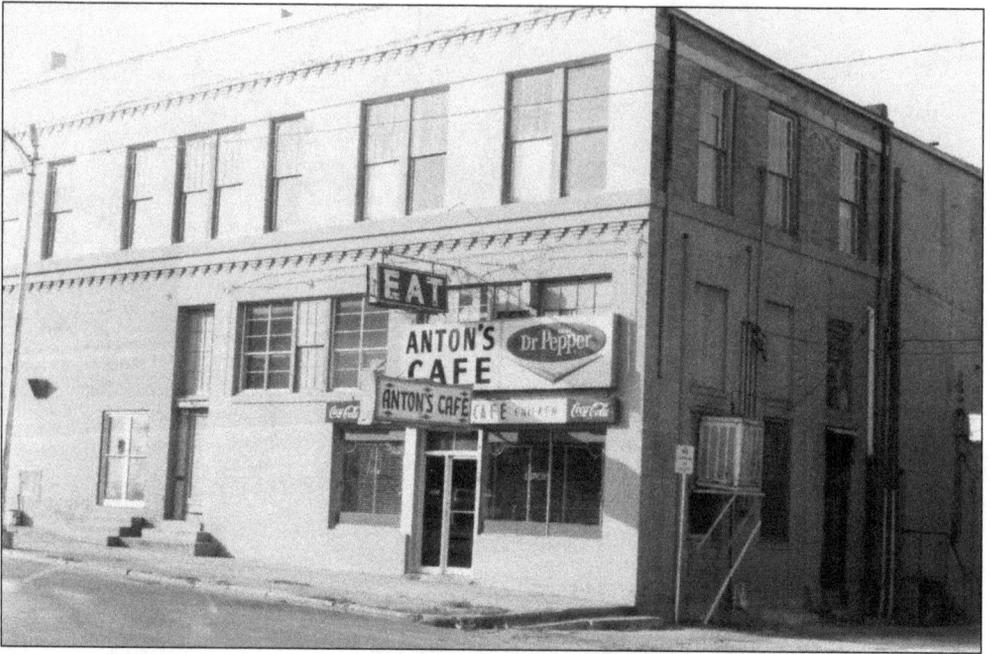

Anton Bravenec had a long career in the restaurant business. He entered the business in 1935 with the establishment of Anton's Café and Delicatessen. After World War II, he opened Anton's Café at 109 West Central Avenue and operated it until his retirement in 1965. The café is pictured here in 1986. The building still stands and houses a restaurant. (Courtesy of Kelsey Collection.)

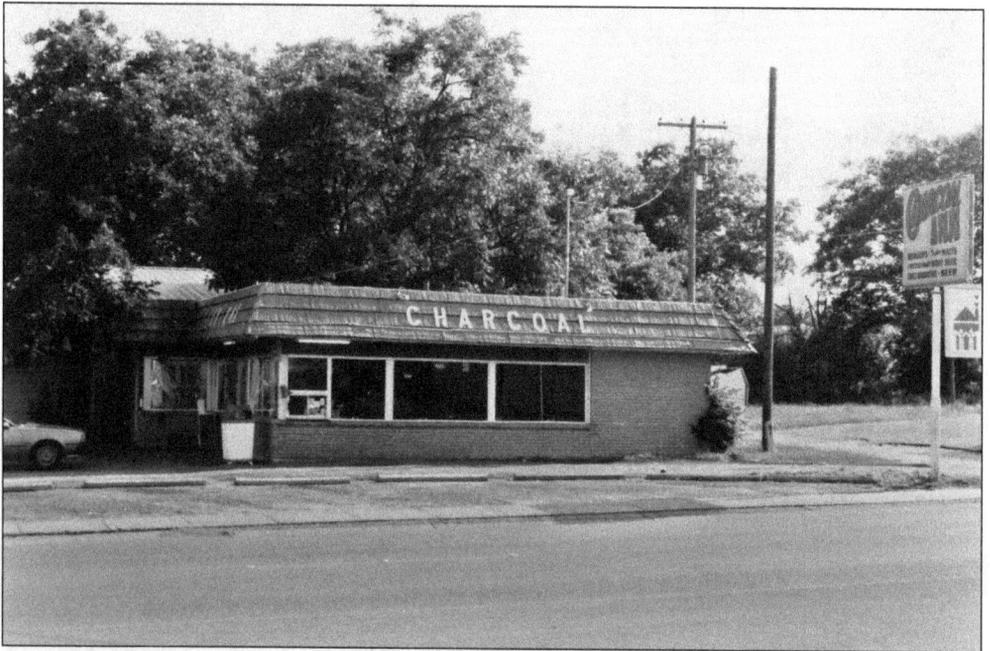

Established by Raymond C. Mikeska, the Charcoal Inn opened in 1953 on East Adams Avenue. The drive-in served flame-grilled hamburgers, a specialty that made the restaurant famous. At one time, Charles W. Houston was the owner. The building was torn down in the 1990s when East Adams Avenue was widened. (Courtesy of Kelsey Collection.)

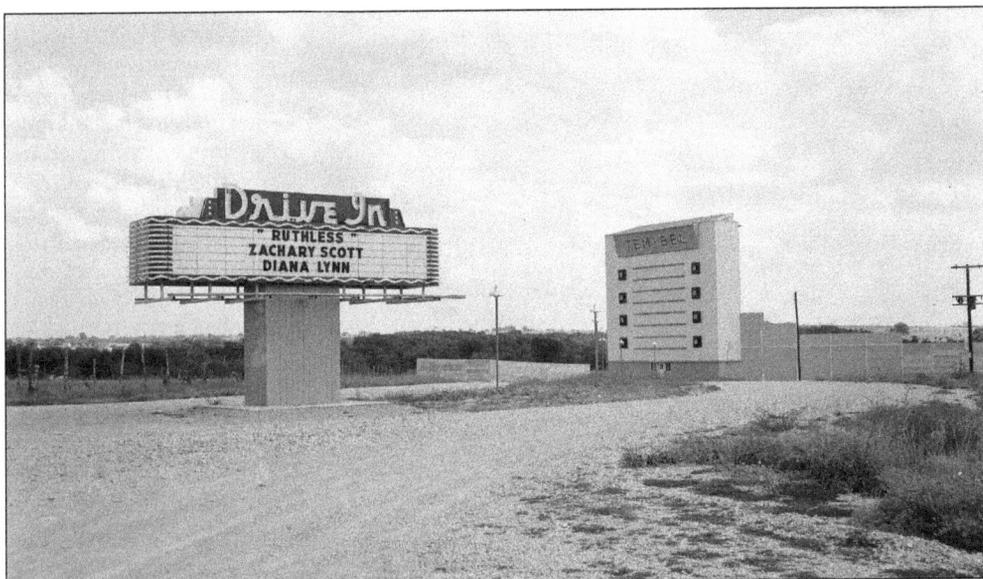

Several drive-in theaters made their appearance after World War II. Tem-Bel Drive-In opened in 1948 with the showing of *This Time for Keeps*, starring Esther Williams. Adults were charged 40¢ for admission, children 9¢. Tem-Bel Drive-In stood on a hill overlooking the location where K-Mart later was located at the southeast intersection of Interstate 35 and Loop 363. (Courtesy of Temple Public Library.)

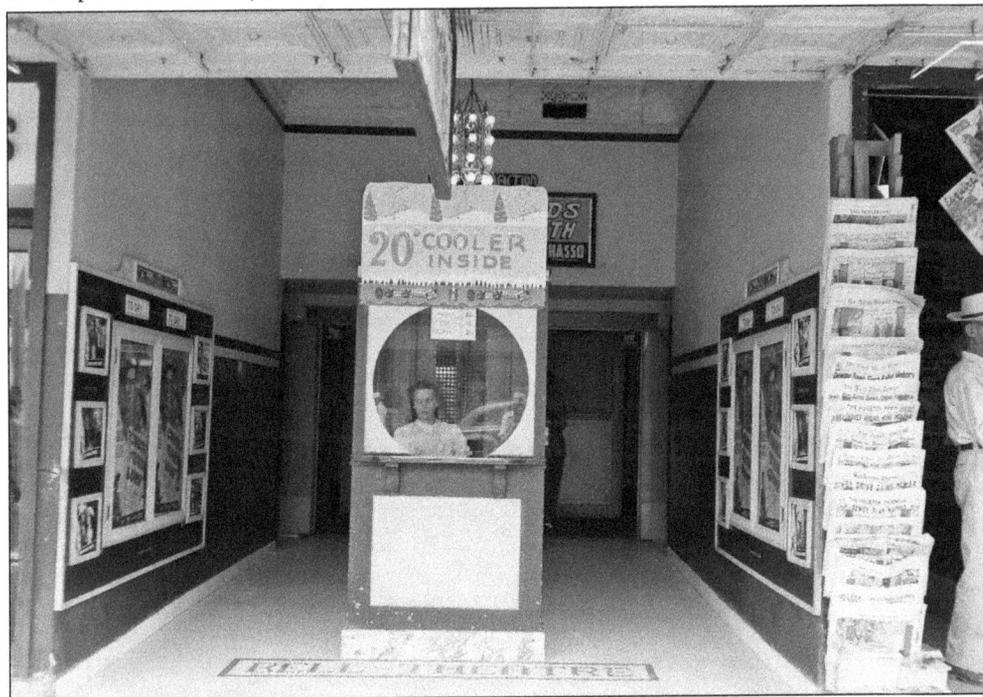

Bell Theatre, at 10 South Main Street, opened its doors on December 23, 1933. The first movie shown was *Laughing at Life*, starring Victor McLaglen and Regis Toomey. Price of admission was 15¢ for adults and 5¢ for children. Tillman Bond managed the theater. (Courtesy of Temple Public Library.)

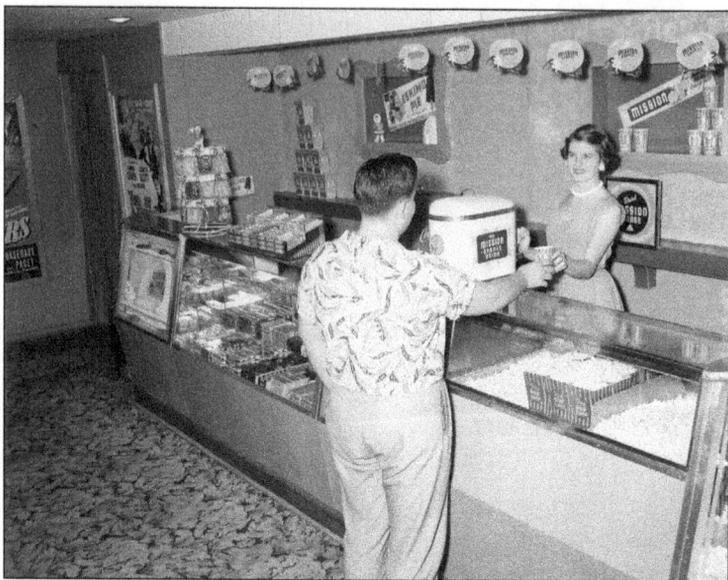

Texas Theater held its grand opening on November 27, 1941, in the building formerly occupied by the Moss Rose Café on South 1st Street. The first movie in the new theater was *Maryland*. The balcony was capable of seating 165. The Texas replaced the recently closed Little Theater. (Courtesy of Temple Public Library.)

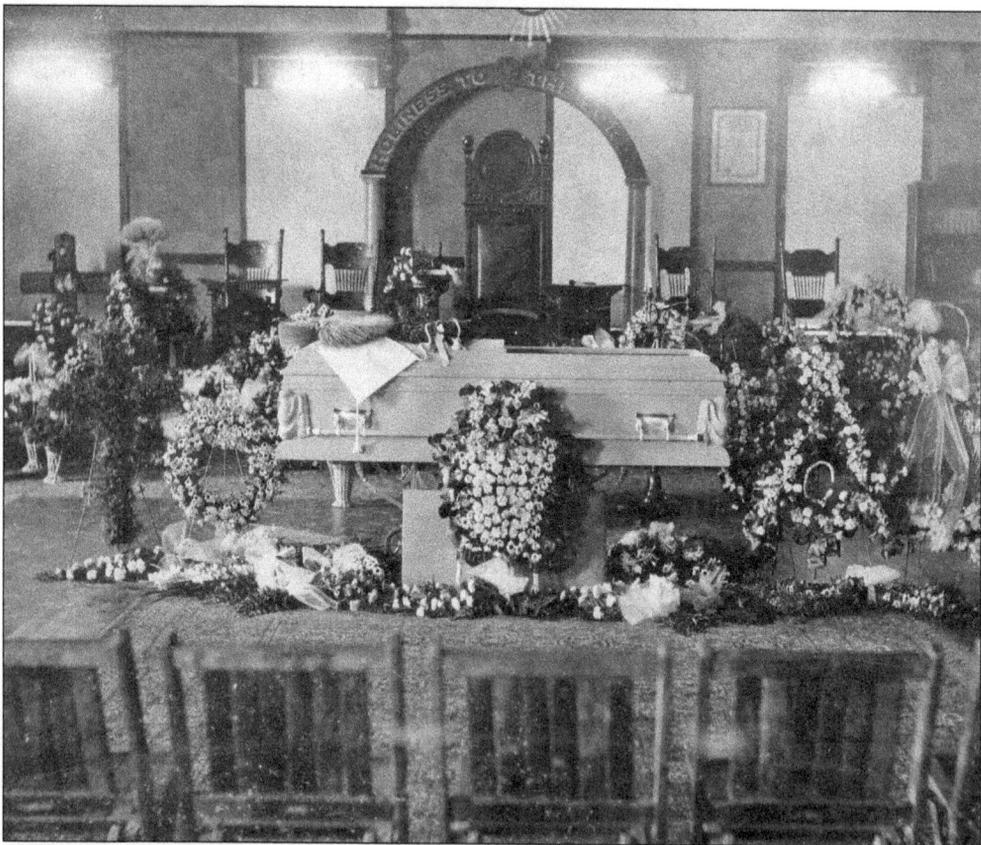

This photograph is a rare interior view of Knob Creek Masonic Lodge taken probably at the Masonic funeral for Dr. Murray L. Chapman in 1928. It depicts what the lodge hall looked like before the 1987 fire. Nine months before his death, Chapman had a stroke that paralyzed him on his right side. A Masonic apron is placed on the casket. (Courtesy of Kelsey Collection.)

Three

STRUCTURES

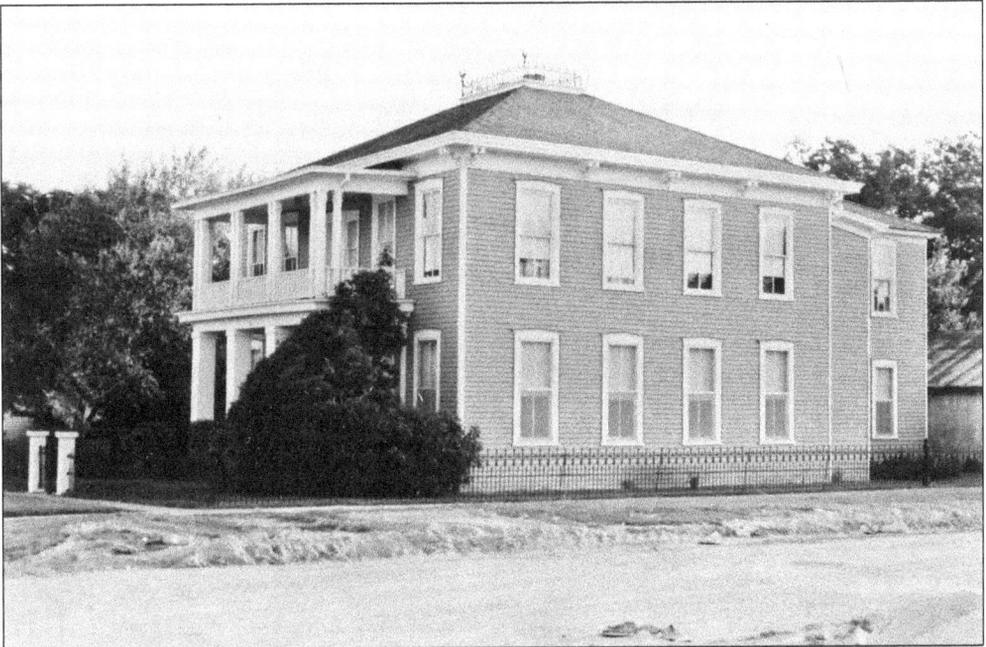

Erected in 1882 at 4 South 9th Street, the Purifoy Insurance building is among the oldest residential structures in Temple. In 1904, the Fisher family lived in the house. Daughter Curtis, age 10, was given a diamond ring by her brother. To prove it was a diamond, she wrote her name on the window, and "Curtis Fisher" remains on a front windowpane. The building has a Historic Temple medallion. (Courtesy of Kelsey Collection.)

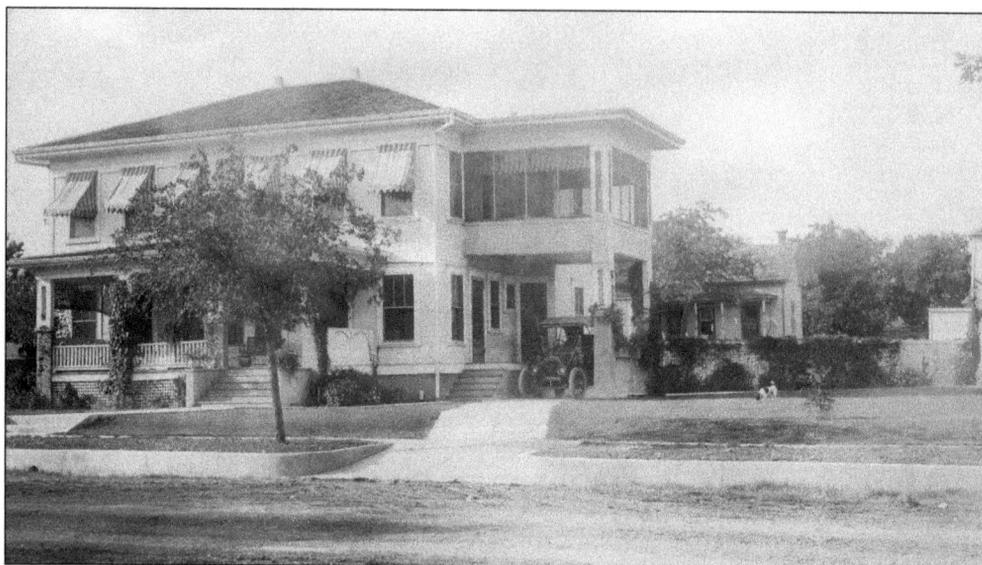

Frank and Callie Denison moved into this home at 314 West Downs Avenue about 1916. She was an avid collector of dolls, and the small house in the rear was for her collections. The screened-in porch extending over the carport was for sleeping on hot summer nights. The house still stands but has gone through several alterations. (Courtesy of Temple Public Library.)

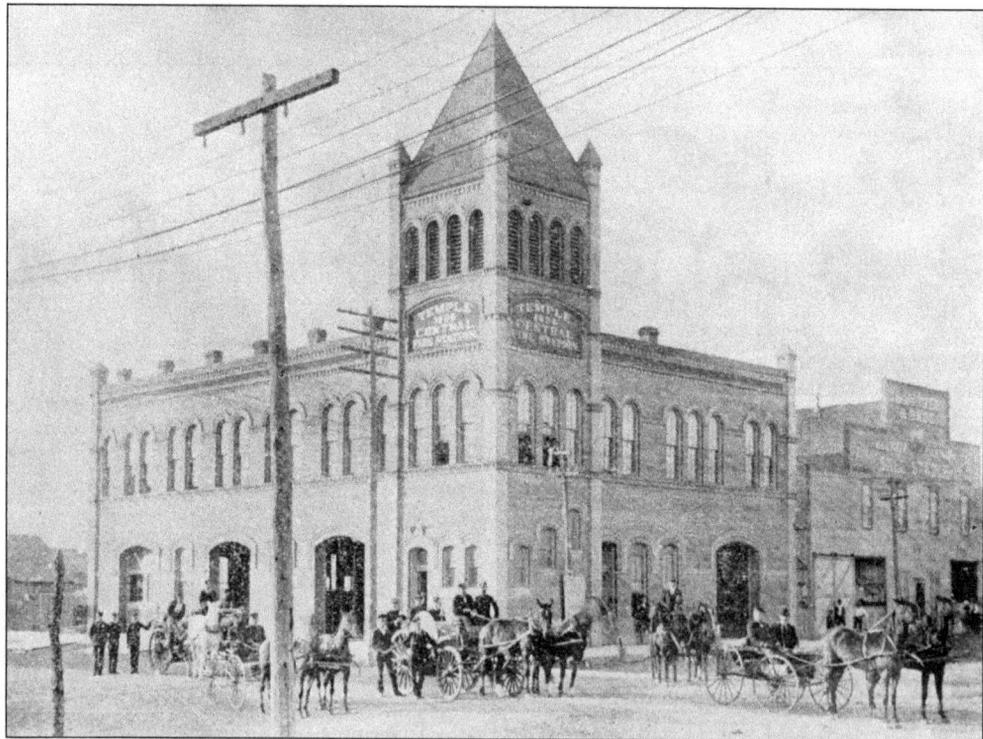

Central Fire Station, a two-story brick structure built in 1896, became the first fire station officially constructed for the city of Temple. Located at 206 West Avenue A, the station went through renovation in 1940 when the brick exterior was plastered with white stucco. A new Central Fire Station was built on North 3rd Street in 1964. (Courtesy of Temple Public Library.)

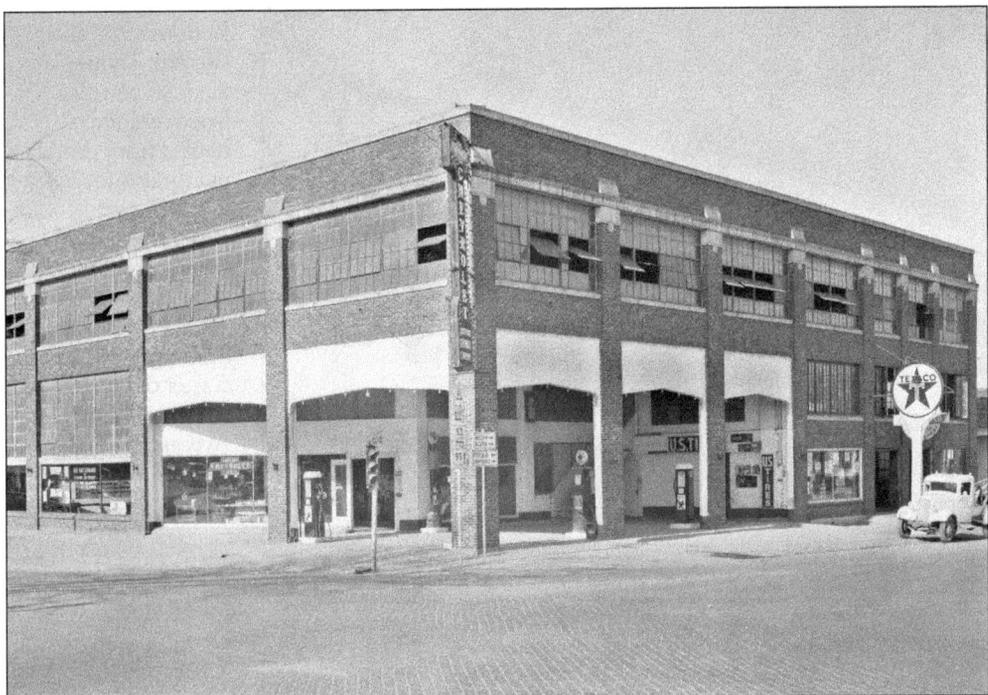

Johnson Chevrolet moved to the Doering Building in 1934 and is seen there in this 1950s photograph. Frank Doering erected the art deco automobile sales building in 1921 on the corner of Adams Avenue and 3rd Street. Frank Matush relocated his automobile supply business to the new building, and Aldrich Real Estate offices were there for many years. Notice the Texaco gasoline pumps. (Courtesy of Temple Public Library.)

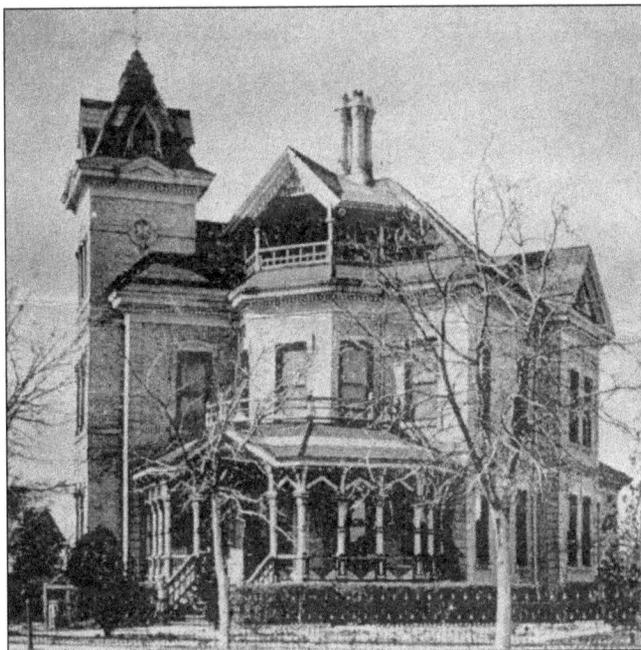

Built in 1887, the elegant three-story brick house of Capt. George Willcox was on North 9th Street. A. G. Watson designed the house, and Ben D. Lee of Belton was the contractor. At the time of its construction, the house was said to be the finest on the Gulf, Colorado and Santa Fe Railway between Houston and Fort Worth. (Courtesy of Temple Public Library.)

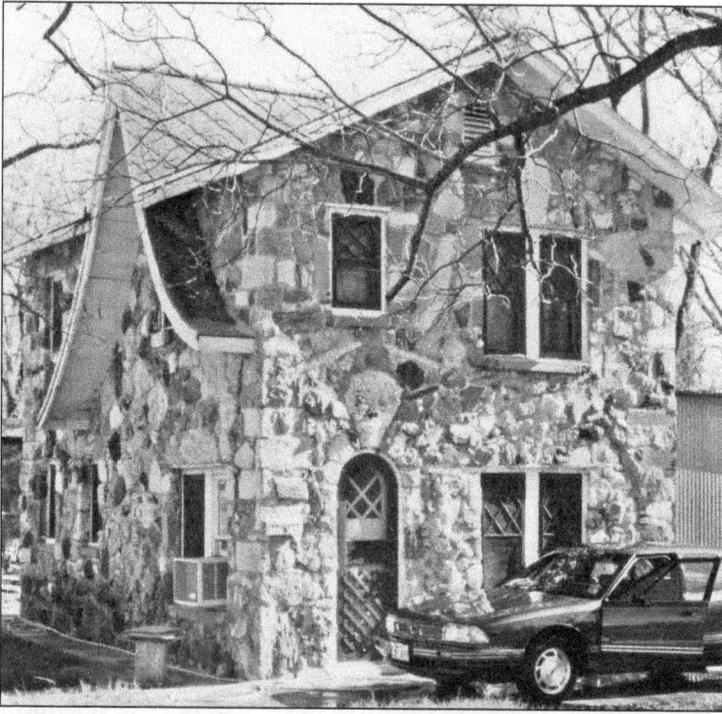

Built in 1929, this two-story house is made of petrified wood and rocks hauled from the mountains of West Texas. Several colors of petrified wood were incorporated in its construction. The house sits back from the southeast corner of North Main Street and East King Avenue. (Courtesy of Kelsey Collection.)

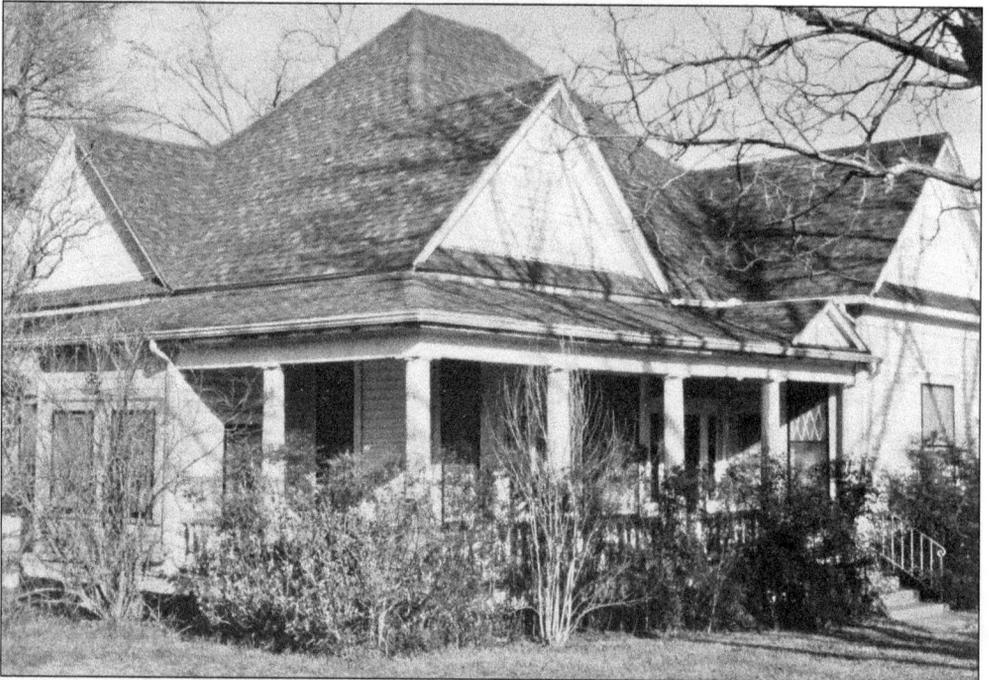

Pictured in this 1999 photograph is the house at 804 North 13th Street, built in 1895 for Larkin Strange and his first wife, Mary Elliott Strange. After his death in 1929, his second wife, Olive Barnett Strange, converted the house into three apartments, renting two and reserving one for herself and daughter Olive Strange. Mother and daughter were teachers and were well remembered by Temple students. (Courtesy of Kelsey Collection.)

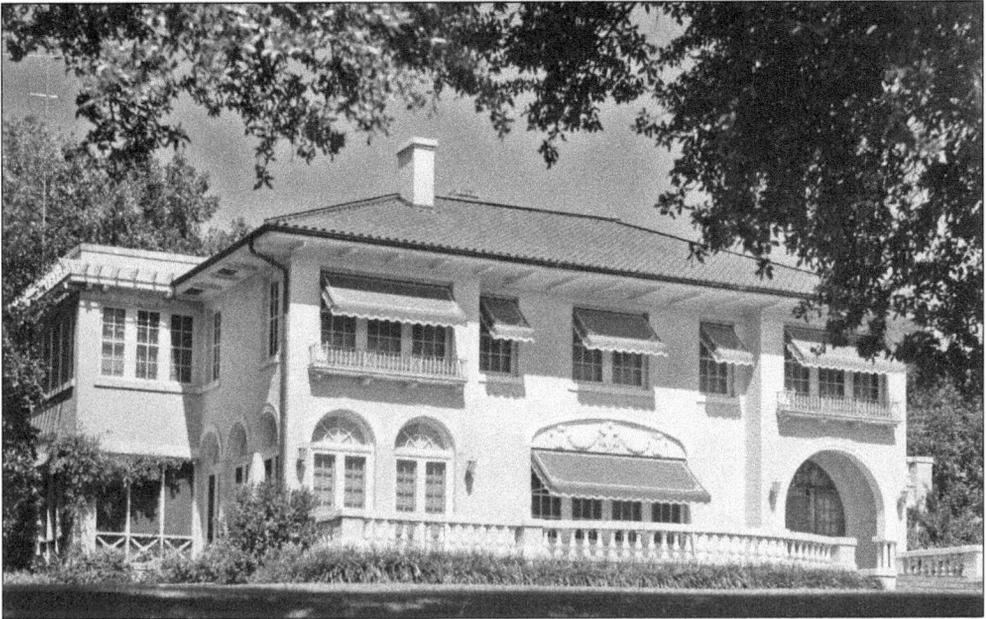

Built in 1925, the house at 1314 North 9th Street originally belonged to the family of O. L. Fletcher, who was the proprietor of Temple Fuel and a cotton buyer. The house is American with Georgian Colonial modifications. John McAlexander installed maple floors in 1928. The house still stands. (Courtesy of Temple Public Library.)

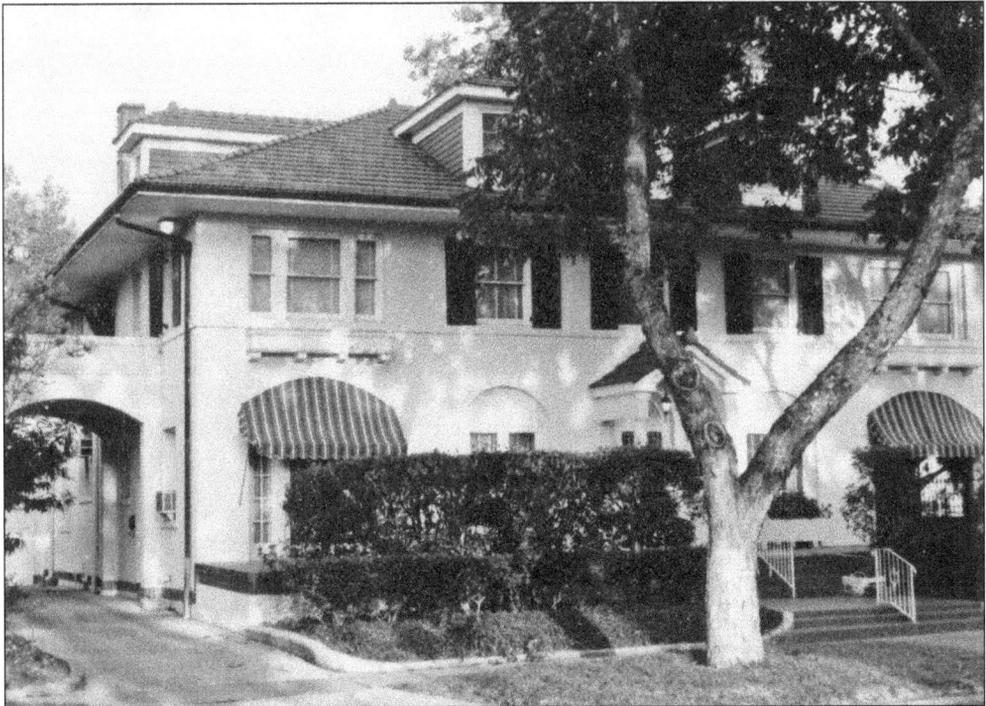

The Dr. Raleigh R. and Annie Campbell White house at 619 North 9th Street is Mission style, as was the old Scott and White Hospital. The house has a tile roof. Dr. White, a graduate of Tulane University, was a partner of Dr. A. C. Scott. He died in 1917. (Courtesy of Temple Public Library.)

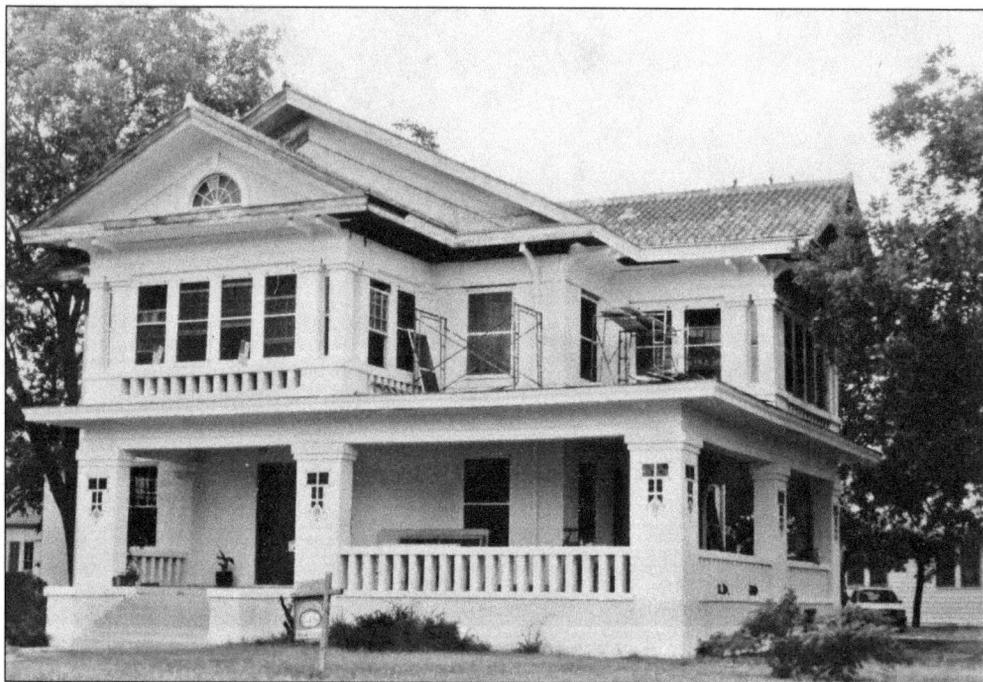

In 1914, Henry Easterling built this two-story stucco house for A. L. Flint at 304 West French Avenue. H. D. Pampel was the architect. The property includes a garage and servant's quarters. On the first floor are the dining room, den and library, kitchen, and breakfast porch. Four bedrooms, two tile bathrooms, and two sleeping porches are on the second floor. (Courtesy of Kelsey Collection.)

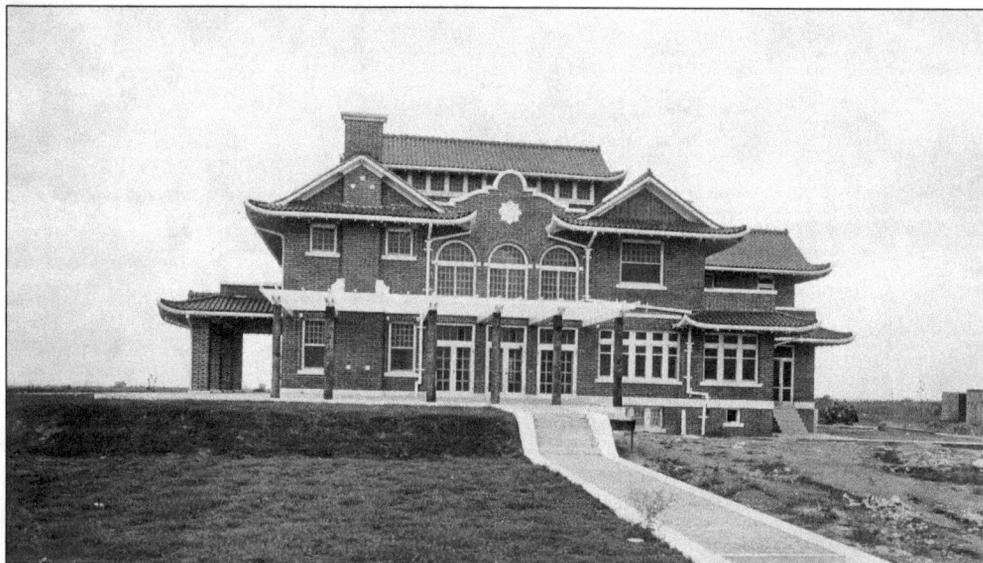

Contractor McCoy started construction on this Japanese-influenced house in 1913 for Dr. James Madison Woodson, a successful eye, ear, nose, and throat specialist. The $35,000 two-story house had a basement, brick exterior with white stone trim, a red tile roof, grounds, park, and steam heat. The house is located on a small promontory that dominates the surrounding architecture. It still stands. (Courtesy of Temple Public Library.)

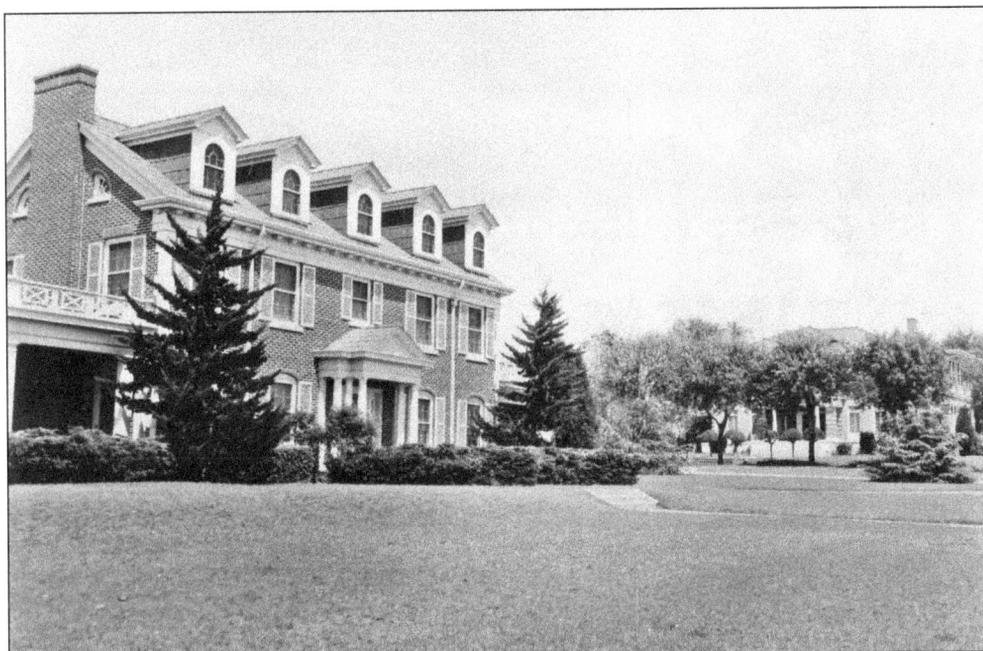

Pictured is the brick house at 1216 North 9th Street. Alice Crenshaw Simmonds, widow of B. B. Simmonds, and Annie Simmonds lived in the house for some time. A native of Logan County, Kentucky, he came to Bell County at the age of two. He was associated with J. K. Hughes in the oil business and held a large farming interest in Nueces County. (Courtesy of Temple Public Library.)

Construction began in 1910 on the R. L. Barclay house at 904 South 5th Street. The house, constructed of solid concrete, took two years to build. The concrete walls alone took a year to cure. There are 10 rooms on the main floor. The hardwood parquet flooring came from Michigan. (Courtesy of Kelsey Collection.)

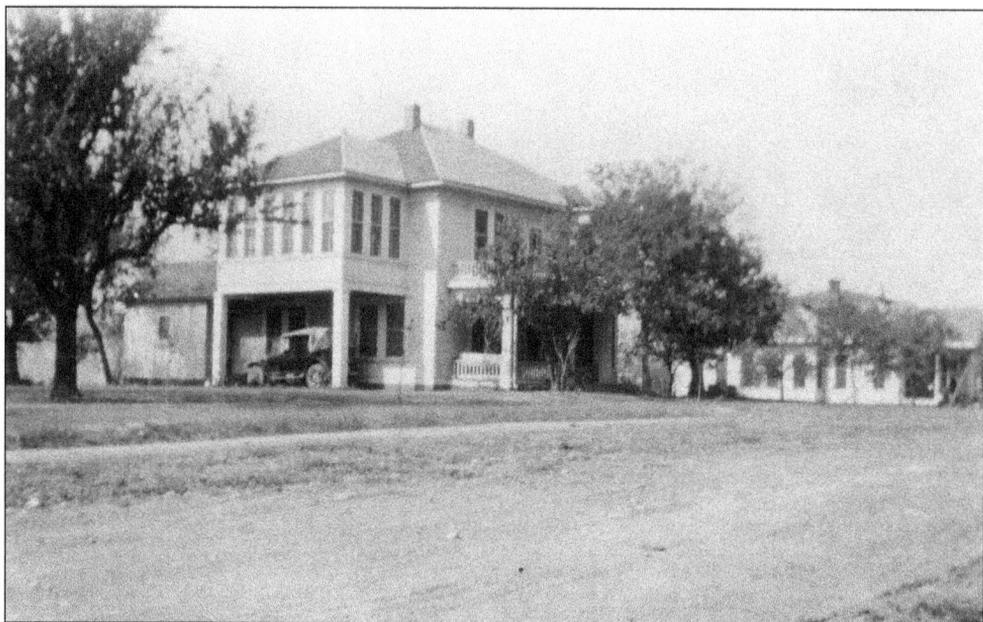

The William Simpson Chapman (1833–1907) and Dr. Murray L. Chapman house is at 806 South 3rd Street. The senior Chapman, William Simpson, came to the area before Temple was established. He was a charter member of Knob Creek Masonic Lodge. Murray L., his son, was a pioneer in the field of radiology. The house still stands although it has been altered. (Courtesy of Kelsey Collection.)

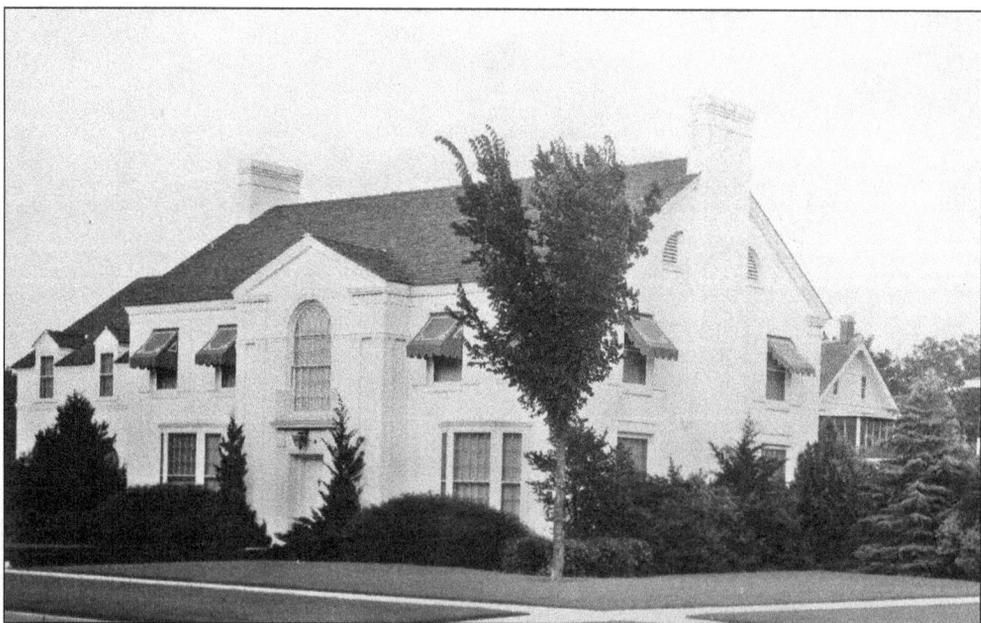

Pictured is the English Manor–style house of Dr. Marcel W. Sherwood on North 9th Street. His sister was married to Dr. A. C. Scott. After graduating from medical school in 1906, he interned at Bellevue Hospital in New York. He was a ship surgeon for one year, and became director and co-owner of Scott and White Hospital. He was a member of Temple Lions and was an avid hunter. (Courtesy of Temple Public Library.)

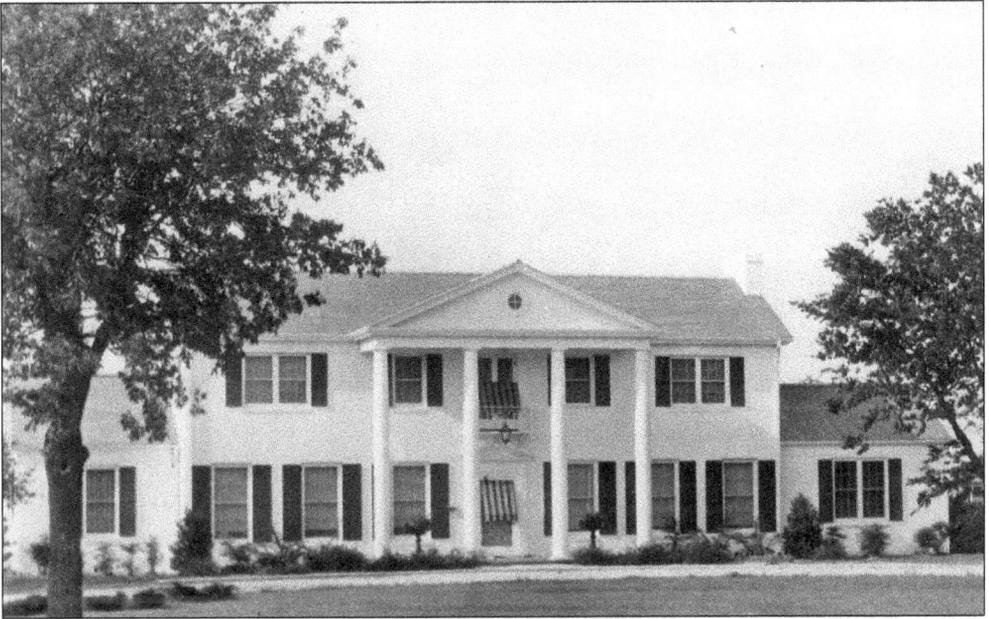

Built in 1940, the Colonial Revival Joseph Woods–Keifer Marshall Jr. house is at 516 West Nugent Avenue. Woods served as chairman of the board at Temple National Bank. Marshall, a World War II veteran, is in the insurance business. He served two terms as mayor of Temple. Although not evident now, Nugent Avenue was the old Waco road, and in the next block to the west was the White City tourist court. (Courtesy of Temple Public Library.)

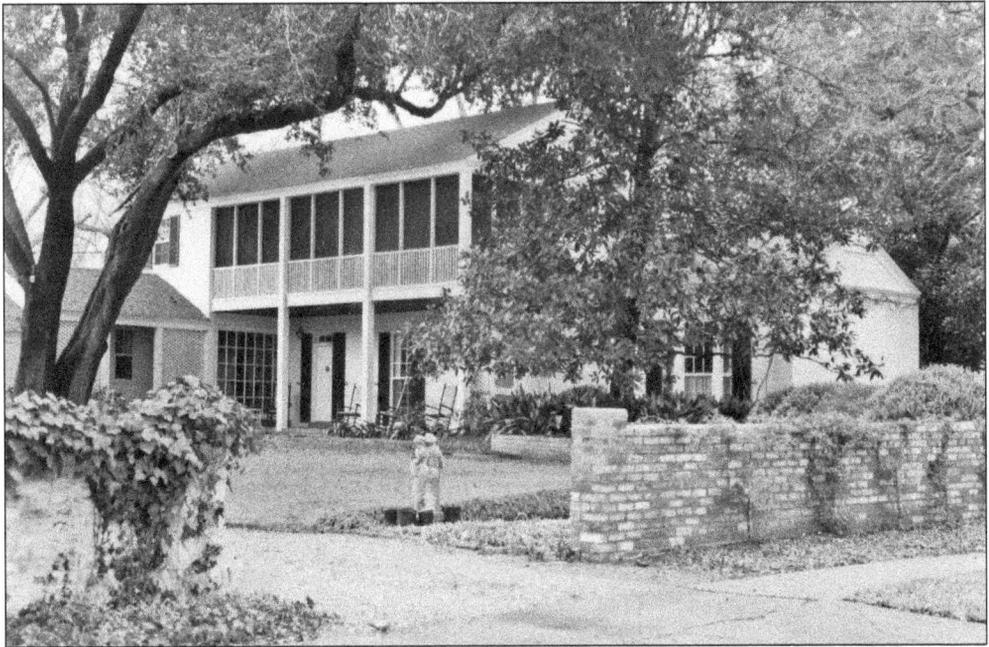

The brick veneered two-story frame house at 1014 North 9th Street was built in 1940 for Rev. Michael MarYosip, a native of Persia, and his wife, Johnnie MarYosip. He was pastor of First Presbyterian Church. The L-shaped 45-by-75-foot house cost $7,800 to build. Offset from the street, it faces a small creek and still stands. (Courtesy of Temple Public Library.)

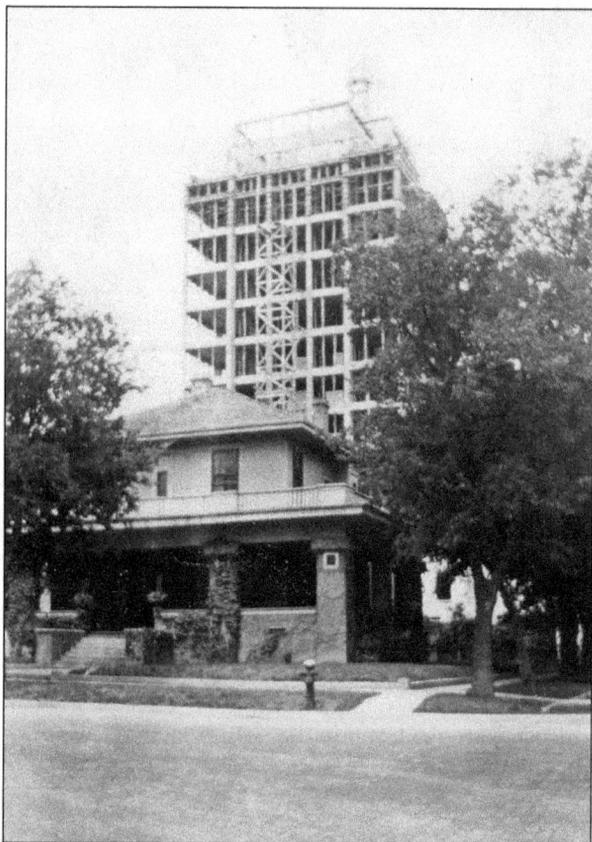

This is a 1928 photograph of the Costello B. and Cora Sample Hutchison house at 118 North 2nd Street. Costello Hutchison was cashier at the First National Bank. His son Downs was a professional baseball player and owner of a paint store in Temple. His son Joseph was a bookkeeper at First National Bank. The Kyle Hotel is visible under construction in the background. (Courtesy of Kelsey Collection.)

The three-story brick Wilkerson Building, constructed in 1894 by W. A. Wilkerson, was at Avenue A and 2nd Street. It was also known as the Post Office Building, and at one time Cheeves Brothers occupied it. A large ballroom was on the third floor. The large cornices were copper, and the inside and the supports were mostly of wood. The building burned in 1924. (Courtesy of Temple Public Library.)

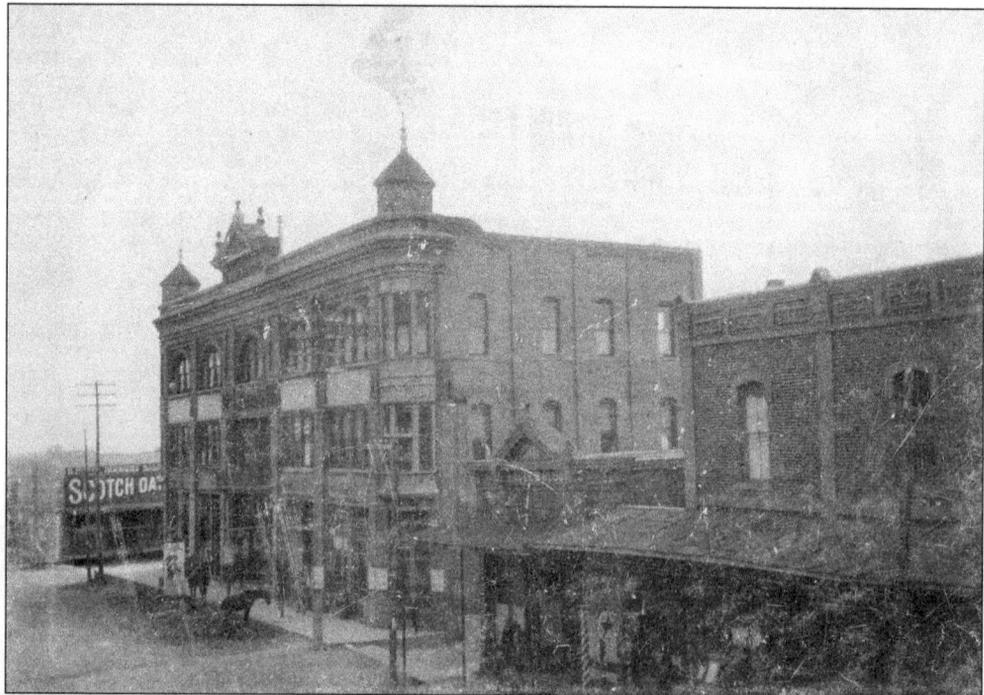

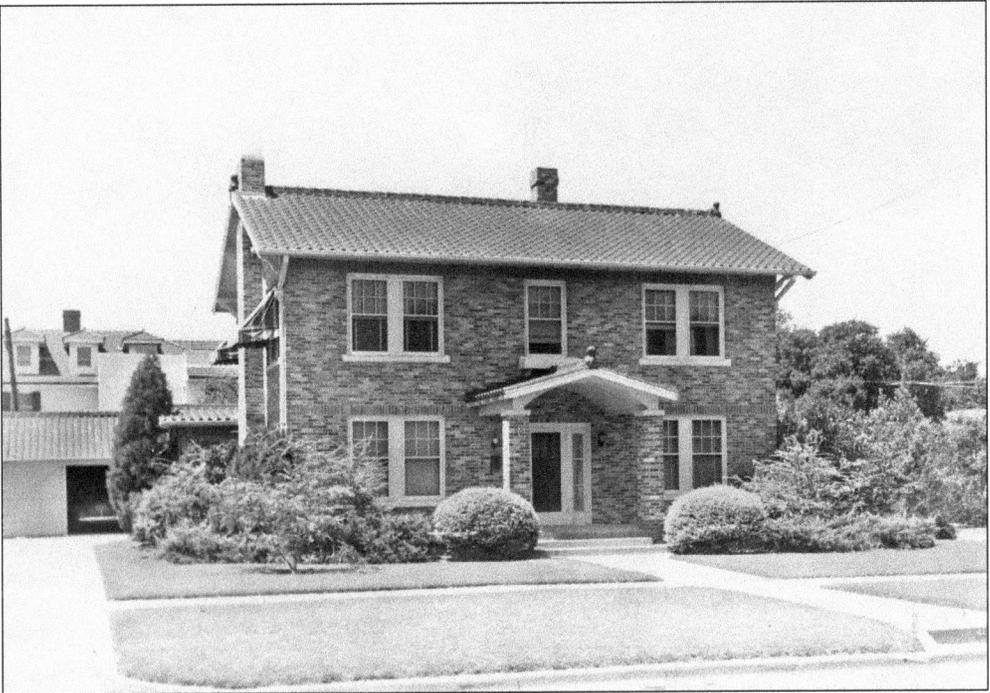

Pictured is the multicolored brick house of Dr. H. B. Mason (1884–1957) at 618 North 7th Street. The house still stands and the red tile roof remains. Shutters were added. Mason graduated from osteopathy school in 1907. He was from Kirksville, Missouri. In 1913, his wife died, leaving a baby son. He constructed several buildings and financed Temple citizens to obtain businesses. (Courtesy of Temple Public Library.)

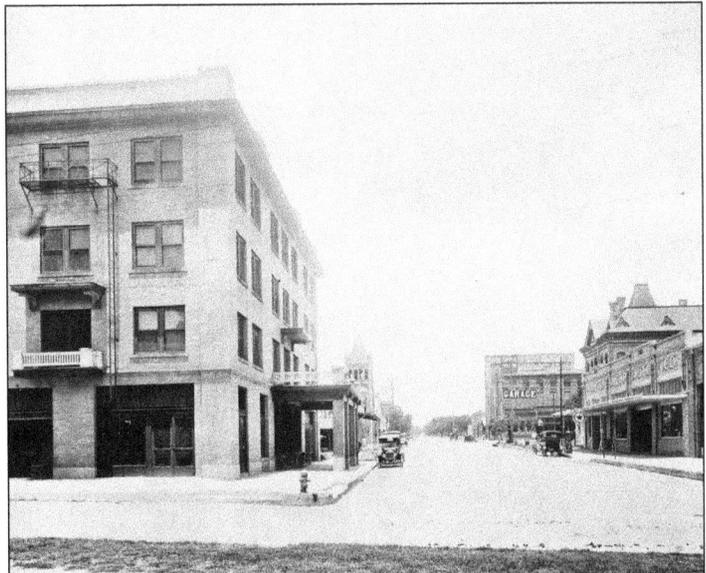

This view is of 3rd Street looking north. The first structure to the left is the Martin Hotel, and the second is Central Fire Station. On the right is Webb Auto Company. Fred E. Bird of Granger moved his automobile agency to Temple and located his business in Webb Auto. Bird Motor Car Company handled Marion-Handley automobiles. Notice the Texaco gasoline pump by the curb. (Courtesy of Temple Public Library.)

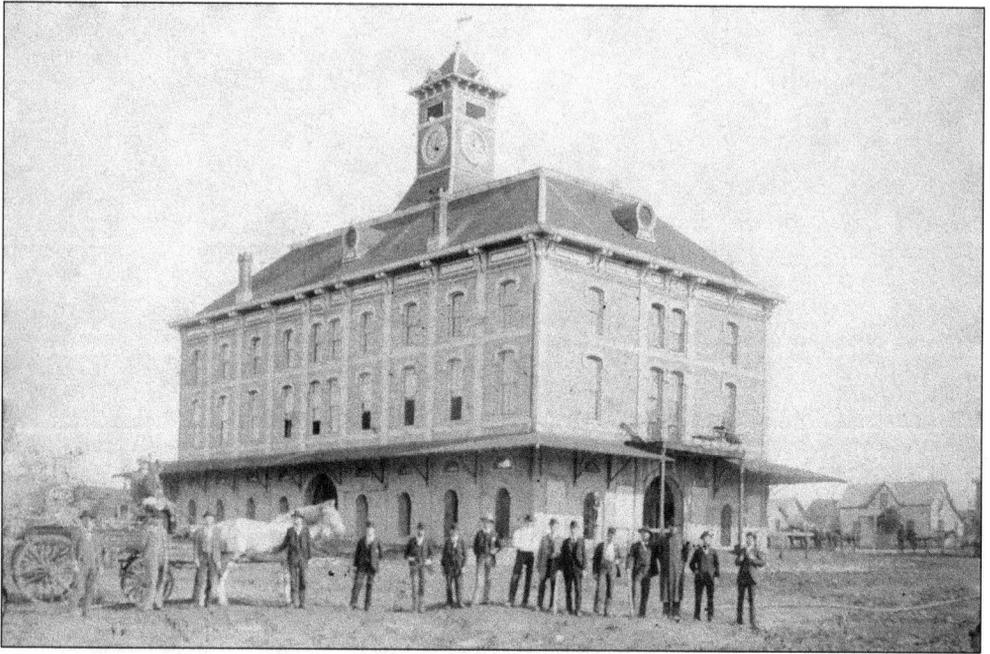

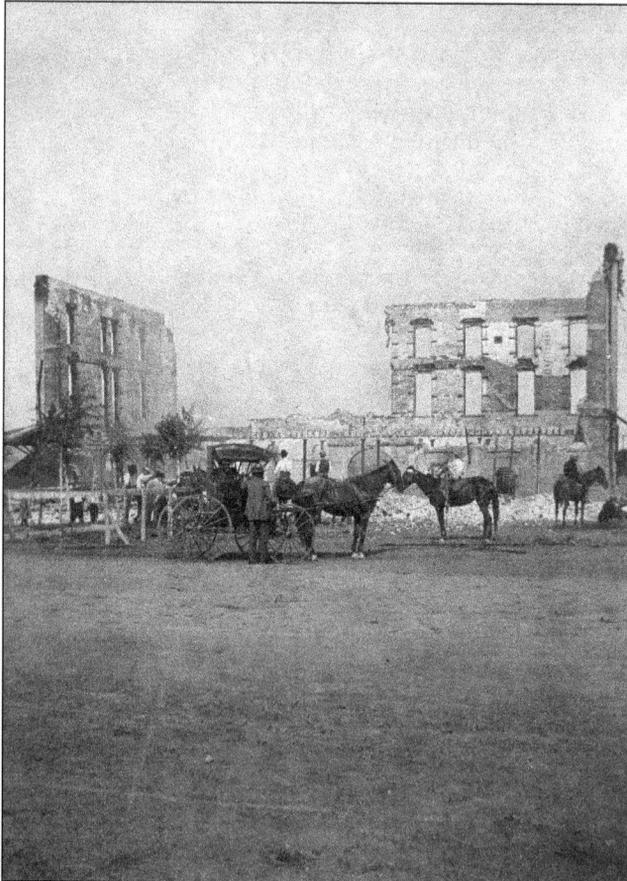

Pictured is the $26,000 Bijou Opera House built by Donald A. McAlexander in 1887. The opera house occupied the same location as the present municipal building on Adams Avenue. The upper floor was for public functions, and the lower floor served as a market for town butchers. An ordinance prohibiting the sale of meat within seven blocks of the public square protected butchers from competition. (Courtesy of Temple Public Library.)

Bijou Opera House burned in 1898, and this photograph shows its remains. Soon after the fire, Capt. James Rudd erected a two-story frame structure known as the Exchange Opera House, located on South 5th Street near the depot. In 1911, fire destroyed this building. (Courtesy of Temple Public Library.)

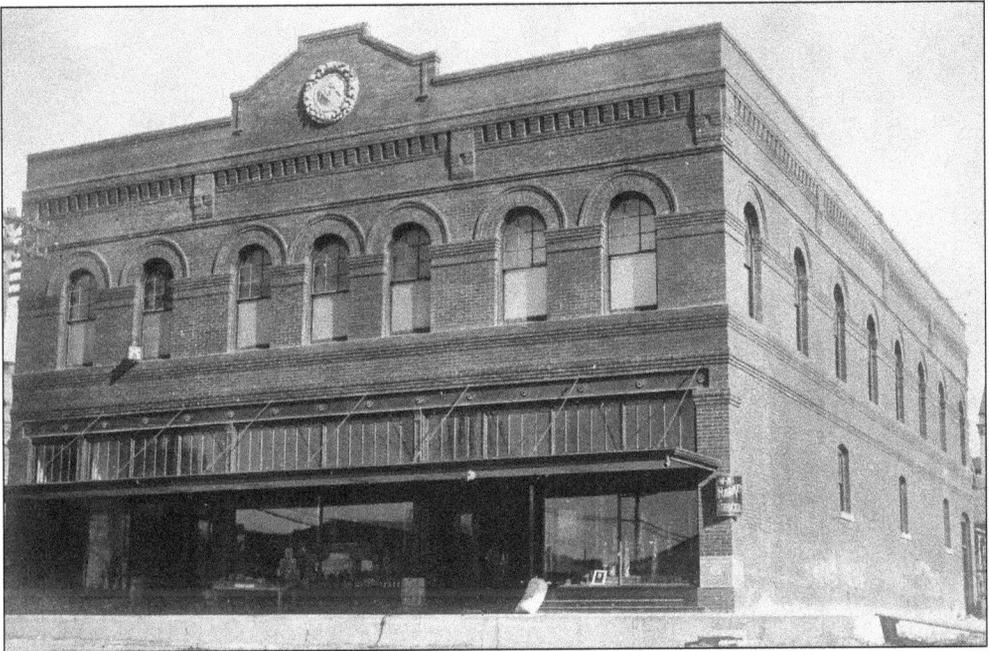

Knob Creek Masonic Lodge, located at Central Avenue and 2nd Street, was erected in 1906. In this early photograph, Harkey Grocery occupied the lower floor and the lodge was on the second floor. The inside of the building burned in 1987. Only the lower floor was rebuilt, and the Masonic Lodge currently occupies it. The cornerstone remains visible on the right front of the building. (Courtesy of Railroad and Heritage Museum.)

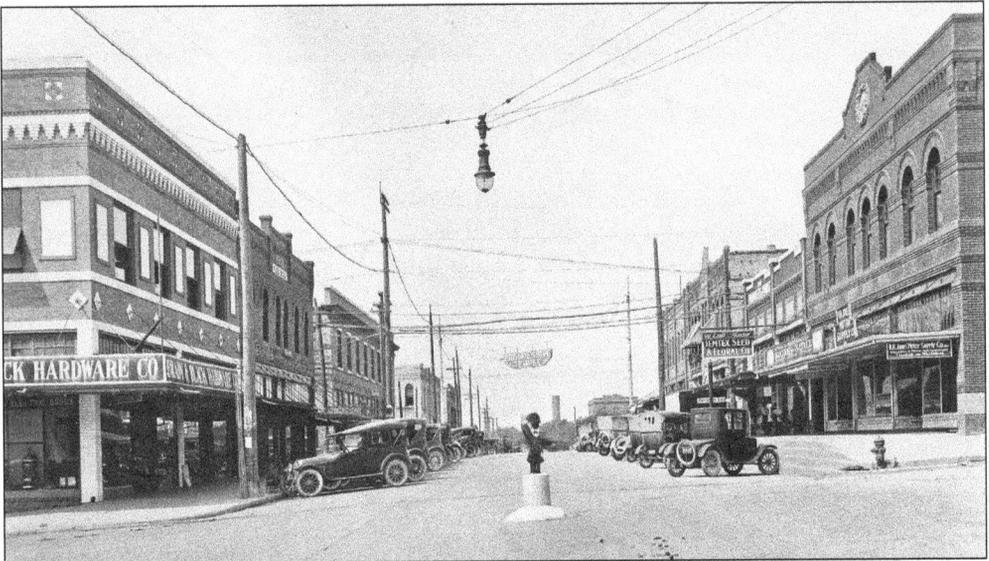

This view is of Central Avenue looking west around 1922. The Brady and Black Hardware building (left) was constructed in 1913. Next is the Rudd Building, which was constructed in 1909. Sherrill Mercantile occupied it. The first building on the right is the Masonic Lodge, constructed in 1906. These three buildings still stand. The two-story structure with awnings at right is the Wortham Building, probably erected in 1906. The Progressive Temple banner, hanging across the street, was used until 1930. (Courtesy of Temple Public Library.)

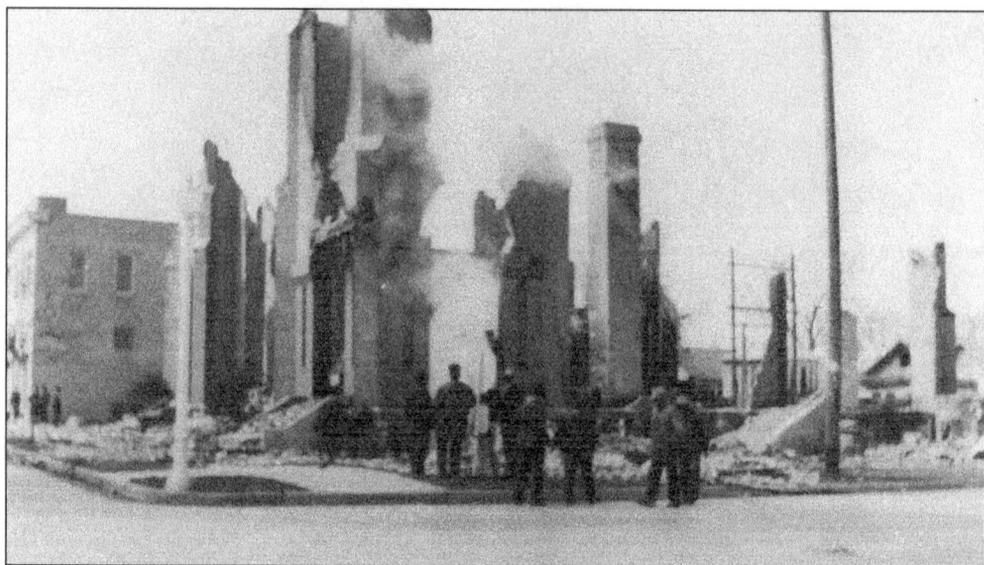

The First Baptist Church organized as the Birdsdale Baptist Church in 1874 at Birdsdale, a community about one mile west of Temple. Soon after Temple was established, church members voted to move there. In 1895, a brick veneer building was constructed at North Main Street and Barton Avenue. The photograph above was taken after the 1938 fire that destroyed the church building. (Courtesy of First Baptist Church.)

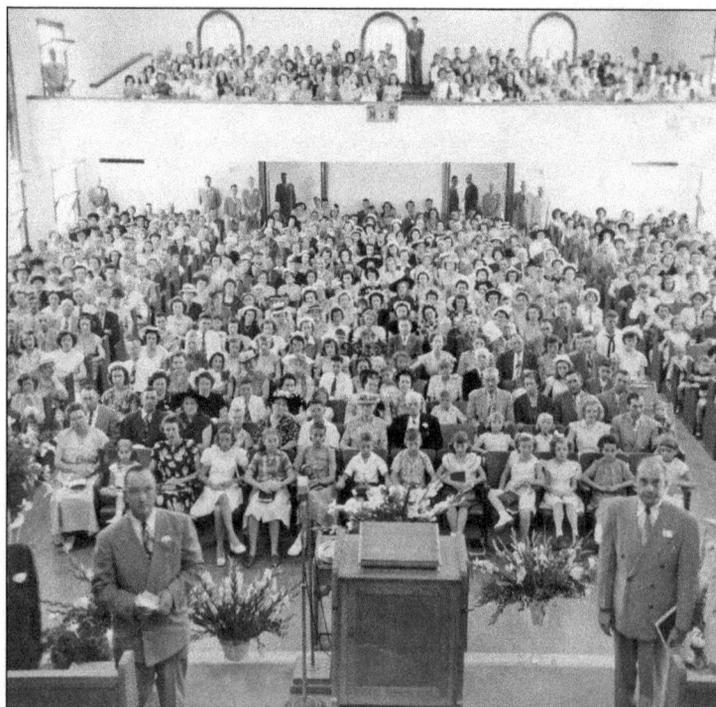

Memorial Baptist Church organized with 12 charter members in 1892. Dr. John Hill Luther was pastor. A new church was built at Avenue I and South 13th Street in 1913. Bruner and Patterson, tinners, plumbers, and steamfitters, made a cornerstone box cover for the church at a cost of 50¢. By 1936, membership was 775. Pictured is the sanctuary at 801 South 13th Street. (Courtesy of Kelsey Collection.)

Pictured in this 1986 photograph is Mount Zion Baptist Church at 417 South 13th Street. In 1909, Peaceful Rest and New Hope merged and became Mount Zion Baptist Church. Rev. J. C. Curtis was the first pastor. He resigned in 1917 and moved to Galveston. In 1914, the church built a one-story frame building with a shingled roof. (Courtesy of Kelsey Collection.)

The 8th Street Baptist Church was erected in 1911 at 215 South 8th Street. Dr. Robert E. Lee Holland was one of the trustees. The brick church building shown in this 1986 photograph was constructed in 1929. T. S. Boone was the pastor. (Courtesy of Kelsey Collection.)

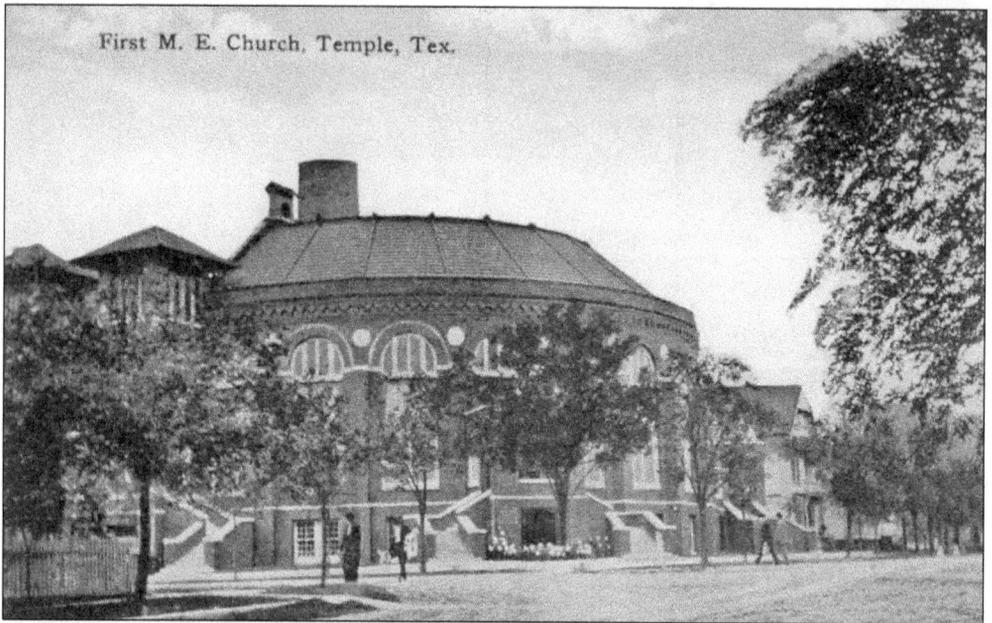

First M. E. Church, Temple, Tex.

Before Temple was established, the First Methodist Church organized in the Double File community southwest of Temple. About 1882, the congregation moved to Temple. Pictured is the brick $75,000 First Methodist Church built in 1914 at the corner of Adams Avenue and North 2nd Street. This structure replaced the church built in 1894 that burned in 1911. Membership in 1936 was 1,048. (Courtesy of Kelsey Collection.)

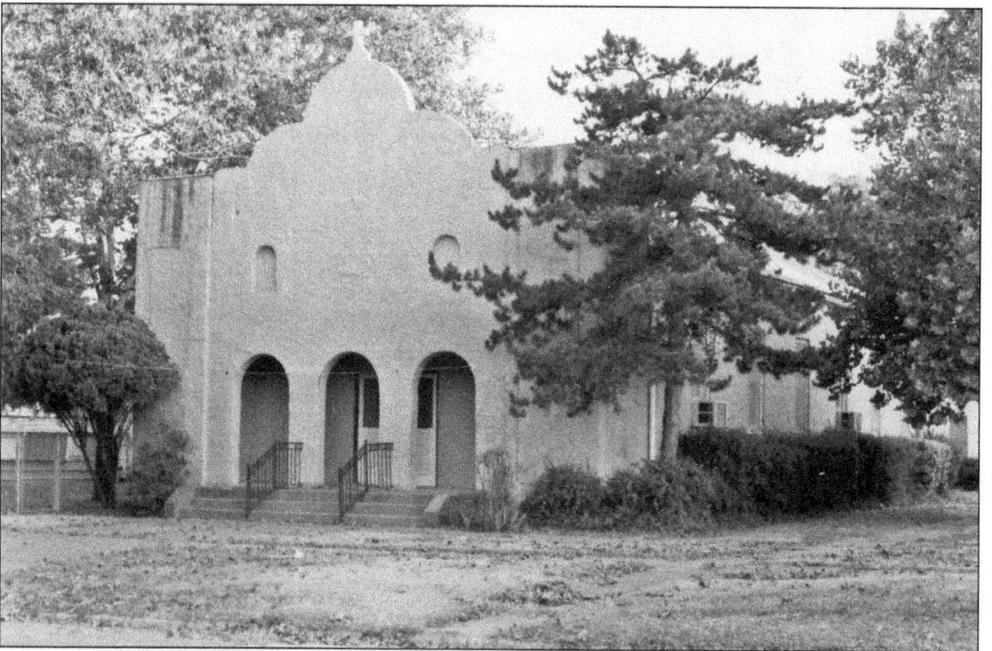

Our Lady of Guadalupe Church was organized for Mexican Catholics. The church building was constructed in 1945. Bishop G. C. Byrne of Galveston blessed the new church and presided at the mass held by Rev. Michael Vidal of Newark, New Jersey. This building was used until 1964, when a new $280,000 church was built at South 6th Street and Avenue G. (Courtesy of Kelsey Collection.)

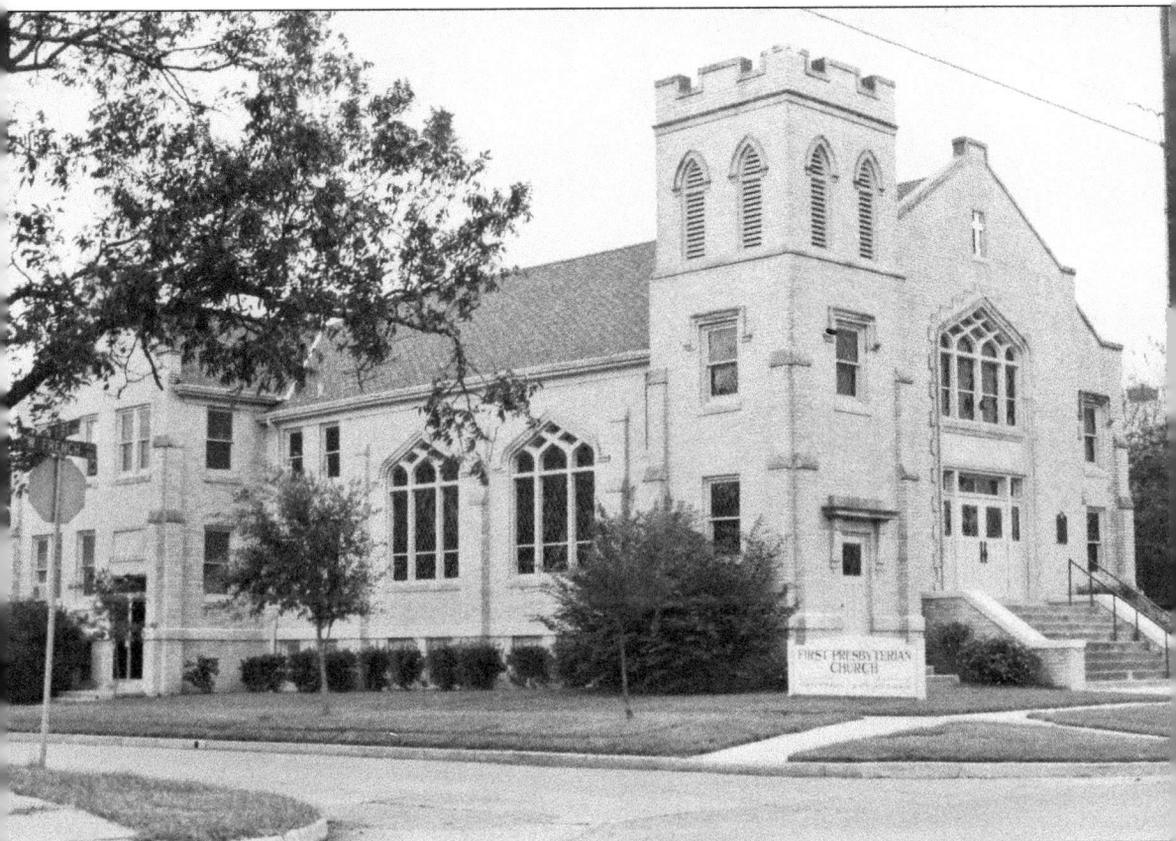

Pictured is the First Presbyterian Church at the corner of French Avenue and North 1st Street. The brick church was built in 1929 at a cost of $35,000. Local contractor John McAlexander did the excavation, concrete, brick, tile, and art stone for the building. The church was organized in 1881 by members of the First Presbyterian Church in Belton, and the first services were in a frame building at 1st Street and Barton Avenue. A second structure was erected in 1892 and used until the present building was constructed in 1929. The first ministers were C. W. Peyton, M. W. Millard, and John Young. The Women's Missionary Society organized in 1895 with nine charter members. In 1899, the George Pendleton family moved into the J. W. Roach house that stood at the present church building site. Later they built a house of their own, and after the death of Helen Embree Pendleton, this house was torn down to make room for the church building. It was her wish to have a church built on the property. Membership in 1925 was 200. (Courtesy of Kelsey Collection.)

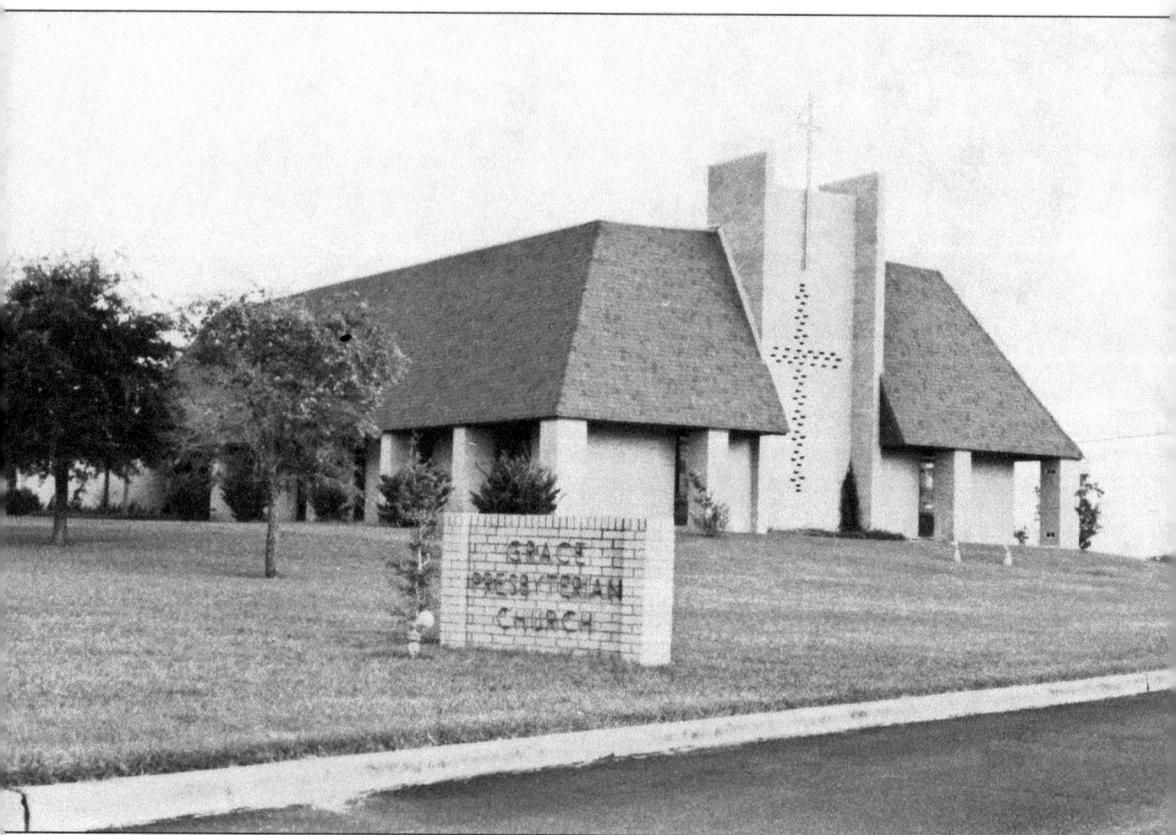

B. F. W. Construction built Grace Presbyterian Church in 1965 at South 57th Street and Avenue Z. The sanctuary followed a new design concept. The pulpit and communion table extended toward the congregation, bringing the ministry and laity closer together. Six windows on the sides were stained glass in a Mondrian pattern. The choir loft was at the rear of the sanctuary. The church organized on December 17, 1893, as the Cumberland Presbyterian Church. The 18 charter members met at first in a lodge building. In 1900, the church moved to North 3rd Street and Barton Avenue. It remained at that site until this church was built in 1965. When the Cumberland Presbyterian Church and the Presbyterian Church U.S.A. united in 1906, the congregation became known as Grace Presbyterian Church. The photograph was taken in 1986. (Courtesy Kelsey Collection.)

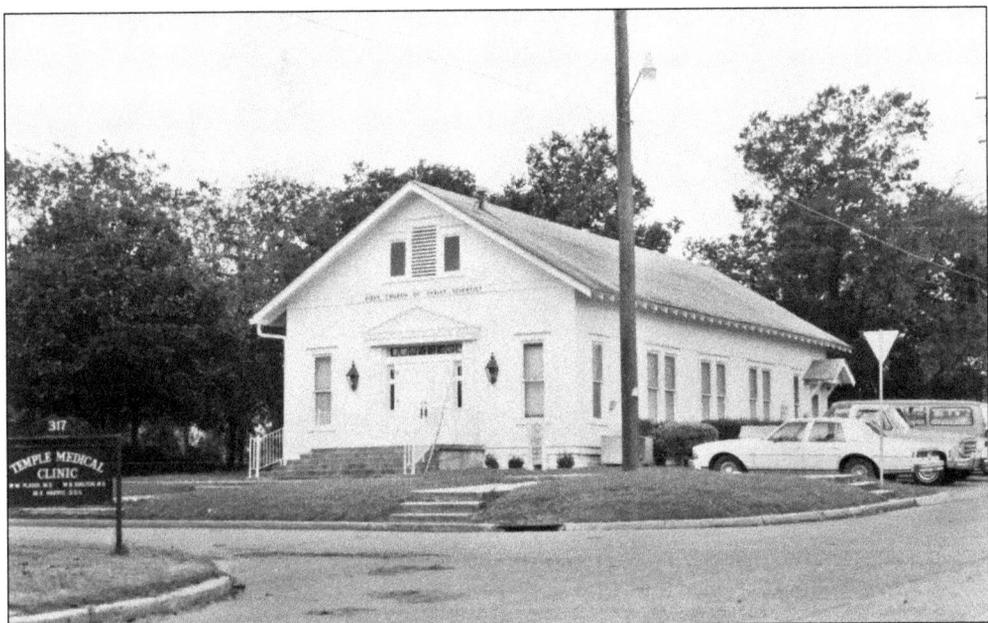

Local students of Christian Science formed a Christian Science society in 1903. In 1914, the group obtained a charter and officially organized a church. A lot was purchased in 1923, and a church building was completed in 1925. The First Church of Christ, Scientist, is on the corner of North 2nd Street and Downs Avenue and is still in use. This photograph was taken in 1986. (Courtesy of Kelsey Collection.)

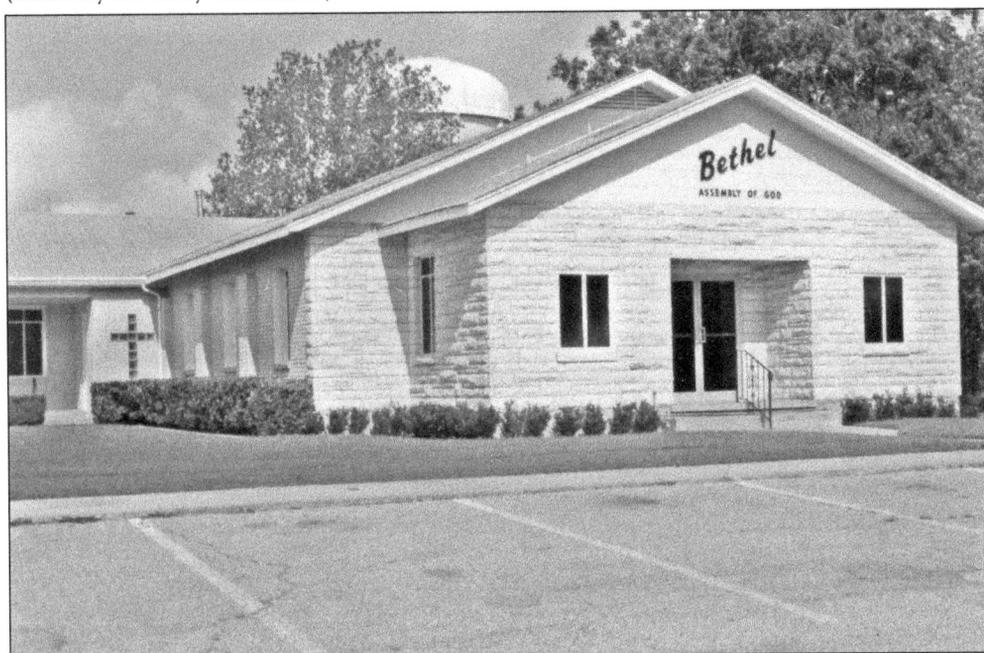

Bethel Assembly of God Church, pictured here in 1986, was at 1700 North 15th Street. The tile block and Austin stone building was constructed in 1952, with a nursery in the front of the building. A prayer room and the pastor's study were in the back. The auditorium was 40 by 60 feet. The building is still used as a church. (Courtesy of Kelsey Collection.)

Corinth Baptist Church, organized from Temple Chapel Baptist Church, was built in 1916 and rebuilt in 1964. In 1965, Rev. Herbert Boykins became pastor and remained at the church until 1989, when Rev. A. A. Norris became pastor. U. C. Barnes Sr. became pastor in 1990. The Lincoln Baptist Association met in 1916 at the church. Membership in 1936 was 225. (Courtesy of Kelsey Collection.)

Grace United Methodist Church worshiped in this building at the time of this photograph in 1986. In the early years, the German Evangelical Church used the building and organized in 1882 with 30 members. Membership in 1924 was 104, and in 1936 it was 58. The building is on the corner of South Main Street and Avenue F. (Courtesy of Kelsey Collection.)

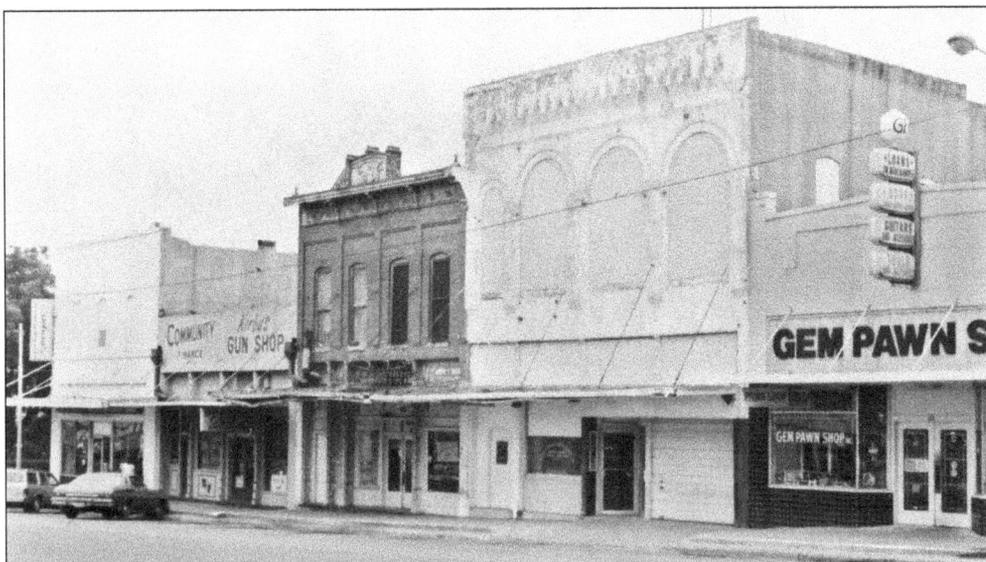

This photograph, taken in 1986, shows the west side of South 1st Street. The first building on the left, Veteran's Café, was the Buranelli fruit stand from 1889 to 1909. The Buranelli family lived on the second floor. The third building from the left, a two-story brick structure, was erected in 1895 by C. Blum and used as the Cotton Exchange Saloon. H. Seigal erected the second building from the right in 1895. (Courtesy of Kelsey Collection.)

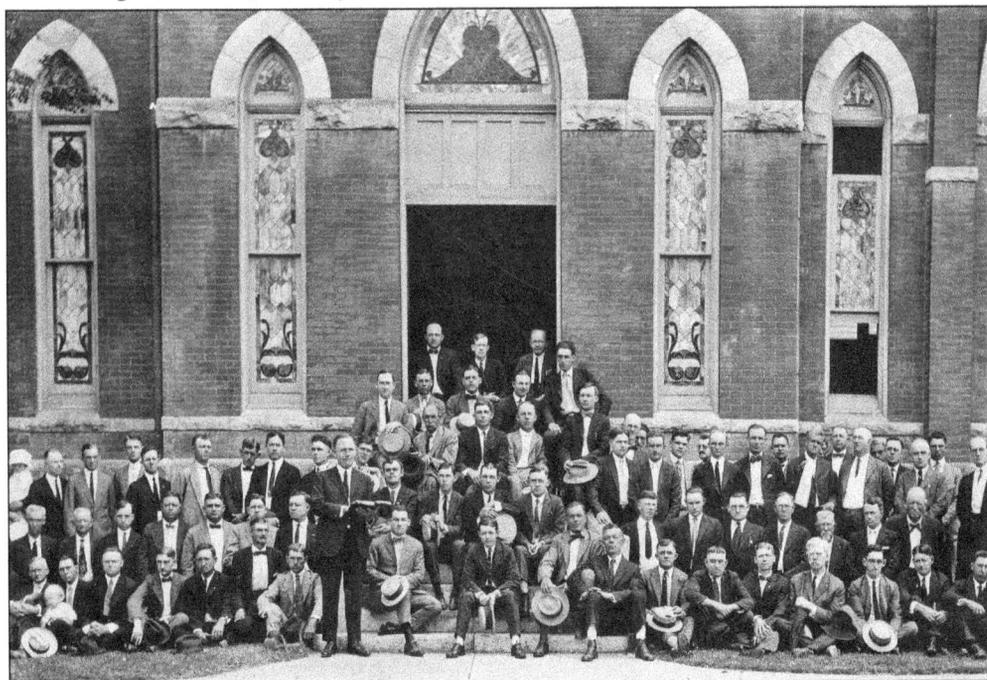

Pictured is the Men's Bible Class of First Christian Church. They are in front of the church that stood at the corner of North 3rd Street and Adams Avenue. Rev. J. W. Holsapple is standing in front with an open Bible. The red brick and white stone church building was used from 1901 to 1946. Church membership in 1936 was 500. Currently, a Jack-in-the-Box is located at this corner. (Courtesy of Kelsey Collection.)

Rev. Early Greathouse organized Mount Vernon Baptist Church in 1870. This church was on South 5th Street. Later the name changed to Taylor's Valley Baptist Church. A new church, west of the present location, was built in 1905. In 1909, the church moved to its present site on Taylor's Valley Road. Major remodeling to the church occurred in 1982 and is visible in this 1986 photograph. (Courtesy of Kelsey Collection.)

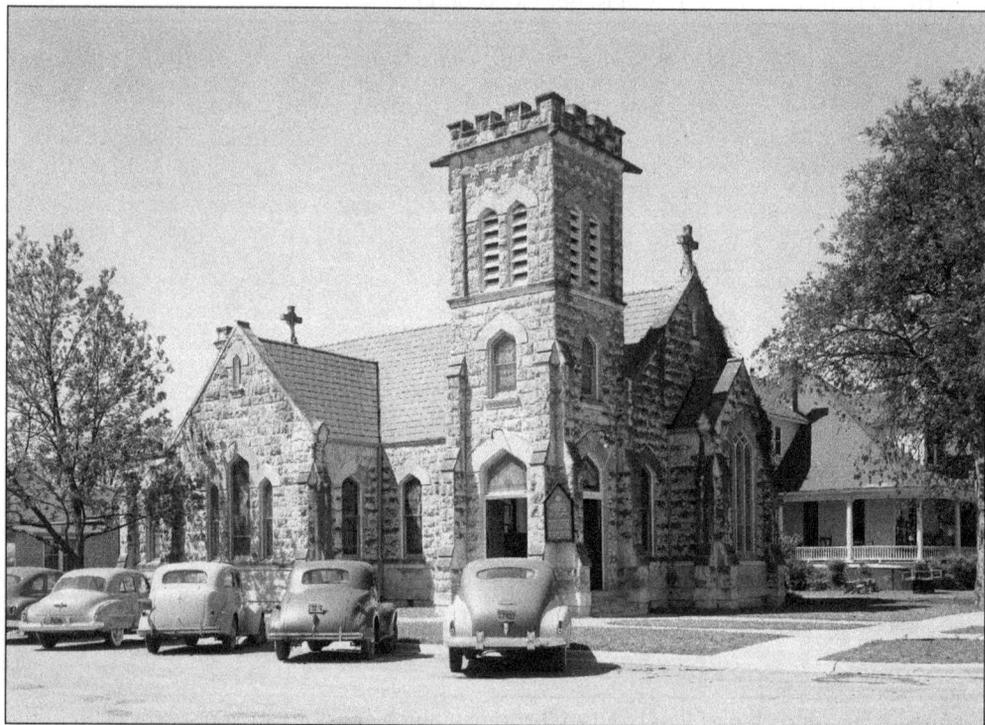

The Gothic-style native stone Christ Episcopal Church was built in 1905 at 304 North Main Street. After 35 years in use, the slate roof was replaced with a composition roof. Restoration was completed in 1968, and an addition was made in 2003. The church celebrated its 100th anniversary in 1983. (Courtesy of Temple Public Library.)

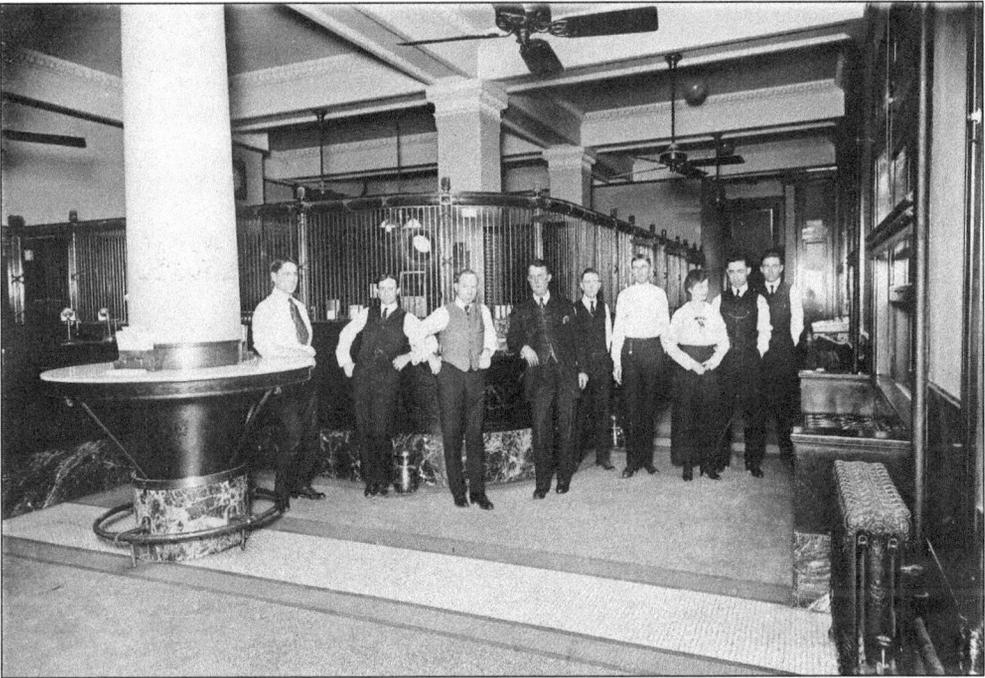

City National Bank organized in 1902 with Charles Campbell, president; A. J. Jarrell, vice president; W. A. Rowland, cashier; and C. B. Wade, assistant cashier. A new six-story concrete bank building was constructed in 1910. Businesses such as insurance agencies, realtors, accountants, and Smith-Cameron Secretarial School occupied the building. Among those pictured inside the bank in 1916 are Campbell and cashiers Will Moore and Fred Day. (Courtesy of Temple Public Library.)

Farmers State Bank organized in 1910 with A. L. Flint as president. The bank opened at South 2nd Street and Avenue A, later moving to South Main Street and Avenue A. In 1931, it merged with City National Bank. In 1942, the name changed to Temple National Bank. The bank was torn down in 1975 to make way for the Federal Building. (Courtesy of Kelsey Collection.)

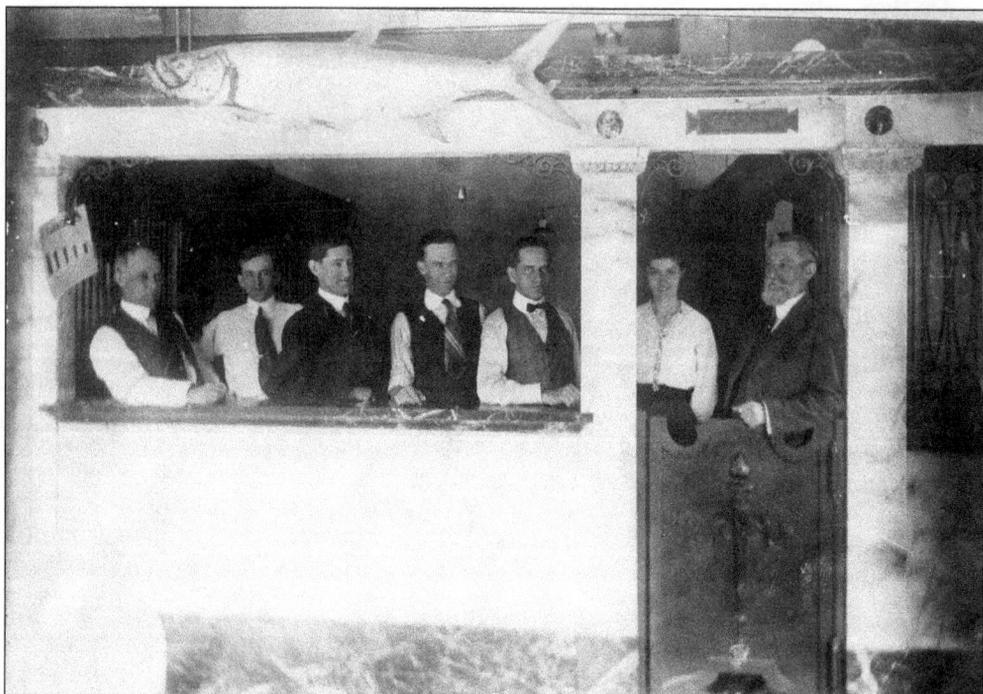

Pictured inside the First National Bank at 20 South Main Street, from left to right, are three unidentified; Costello B. Hutchison, cashier; P. L. Downs Jr., assistant cashier; Ida Wells, secretary; and P. L. Downs, vice president. The cashier's office had a marble railing. Wainscoting was solid mahogany and copper-set art glass. In 1924, the bank had capital of $1 million. (Courtesy of Temple Public Library.)

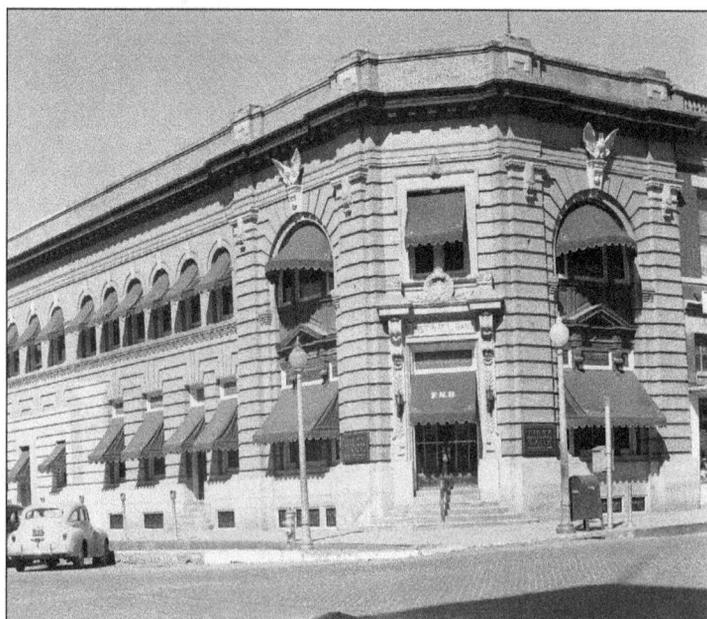

First National Bank moved to this new building in 1908. The stone base was six-foot-high Bedford, Indiana, limestone. Copper frames cased the windows, and flat, woven, steel grillwork enclosed the four teller cages. The entire face of the counters was constructed of Skyros marble, imported from Italy. The furniture was made of solid mahogany in the Mission style, and the staircase was Vermont marble. (Courtesy of Temple Public Library.)

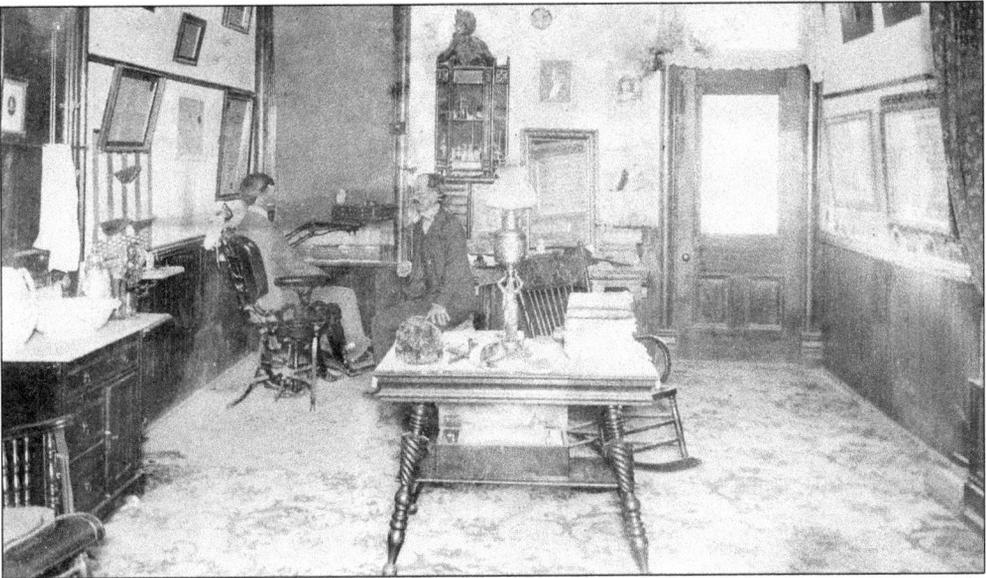

Dr. Alexander Dienst came to Temple in 1890. Soon after his arrival, he established a dental practice in the Temple National Bank building. This early-20th-century view of a dental office shows Dienst (right) consulting with an unidentified patient. He was a noted author, lecturer, and collector of Texas documents and opened a free museum of natural history of Central Texas. (Courtesy of Railroad and Heritage Museum.)

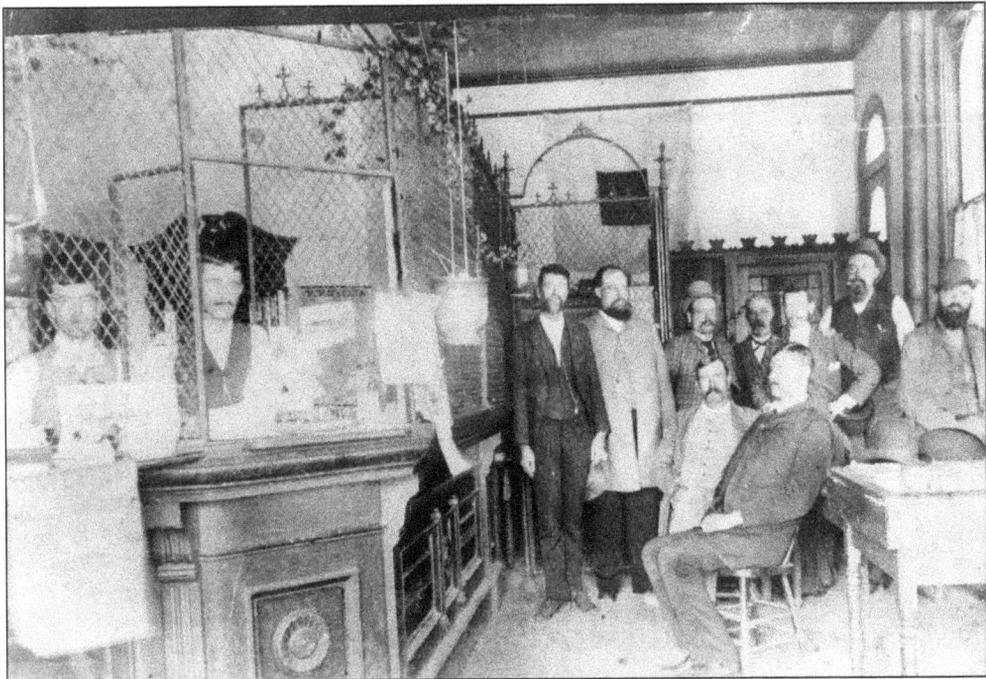

Here is the inside of the Temple National Bank on June 1, 1890. From left to right are Fred McDowell and Walter Roland (cashiers behind the cage), J. E. Moore, Gov. James Hogg, George Willcox, Dr. W. M. Woodson, W. Goodrich Jones, L. R. Wade, and C. U. Yancy. Seated in front are O. P. Smith (left) and Judge J. S. Sheffield. Hogg was in town campaigning. (Courtesy of Temple Public Library.)

The five-story City National Bank building, constructed of Elgin-Butler brick and trimmed in limestone and granite, was completed in 1910. The floors were terrazzo and Vermont marble. A decorative exterior copper cornice adorned the front of the building. The bank contained three vaults. (Courtesy of Temple Public Library.)

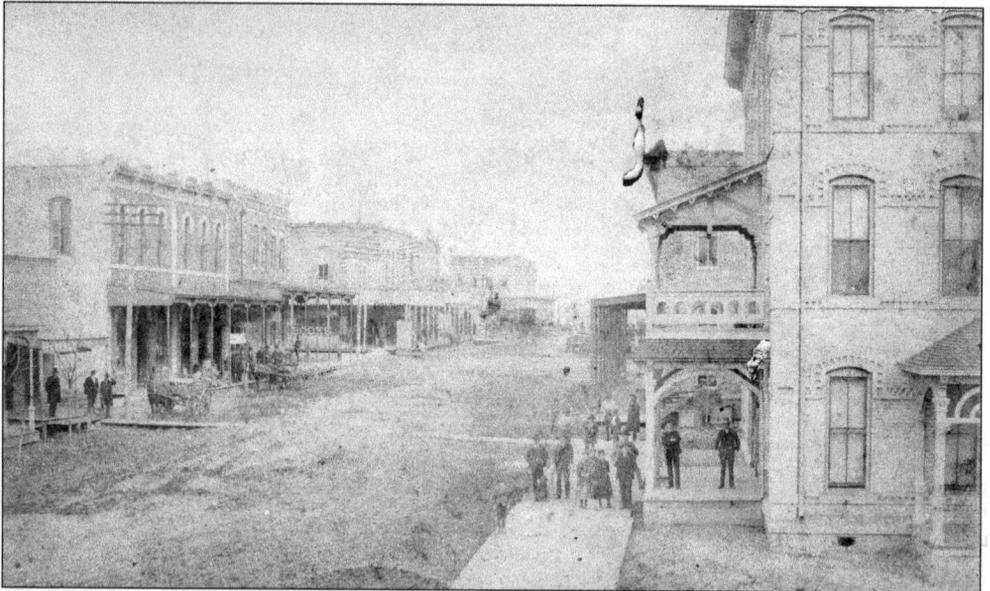

This street scene from about 1889, looking east from 3rd Street and Avenue A, shows buildings on the north side of Avenue A. The two-story brick buildings in the left foreground housed a grocery, a printing office, and the First National Bank (Downs brothers, proprietors). The two-story building in the far background was the Temple National Bank (W. Goodrich Jones, proprietor). It is the only building still standing. On the right is the Central Hotel. (Courtesy of Railroad and Heritage Museum.)

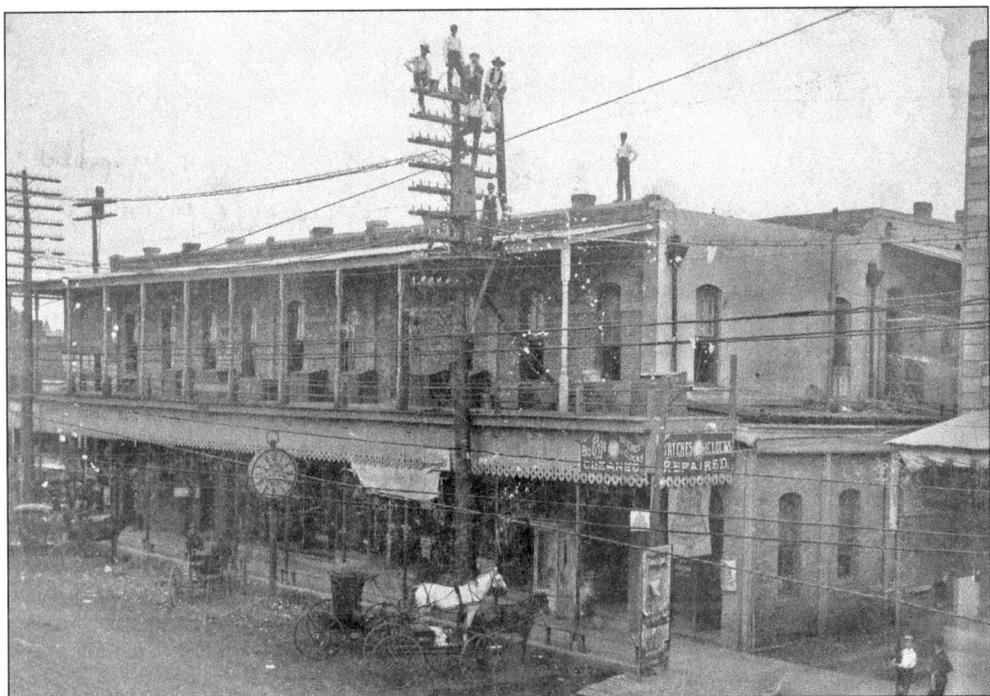

This view is of the Temple National Bank Building on Avenue A about 1900. Dr. Alexander Dienst's dental office was upstairs. B. Booth Jewelry and the postal telegraph office occupied the building. Southwestern Telegraph and Telephone Company occupied the first floor, and the men on the poles appear to be installing lines. (Courtesy of Temple Public Library.)

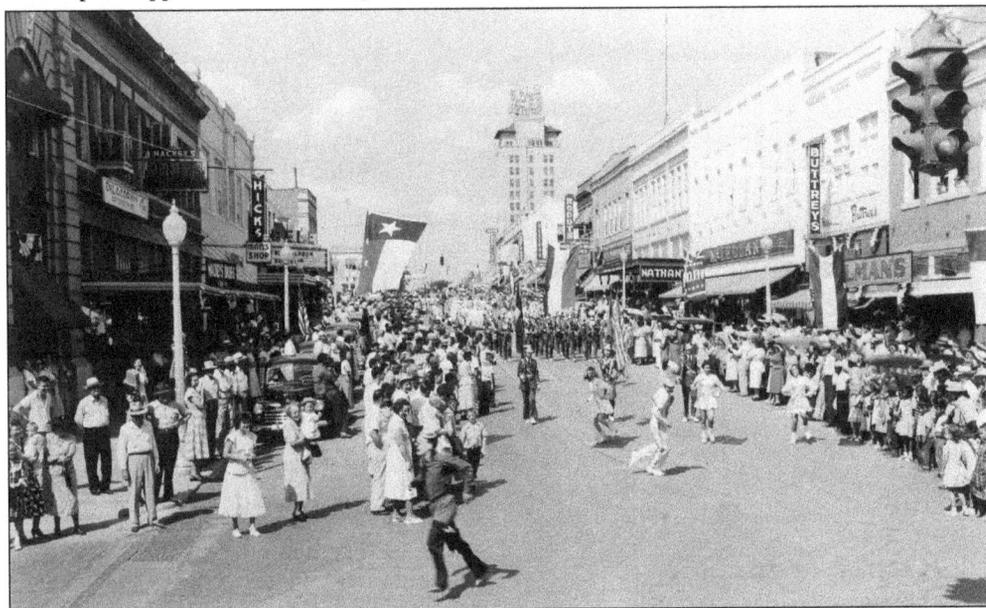

A parade marches south on Main Street in the late 1940s. The photograph shows buildings in the heart of the business district before major alternations and loss of structures in the late 1950s and 1960s. Many of the buildings in the photograph retain their original facades. Brick paving and the old trolley track are visible in the foreground. (Courtesy of Temple Public Library.)

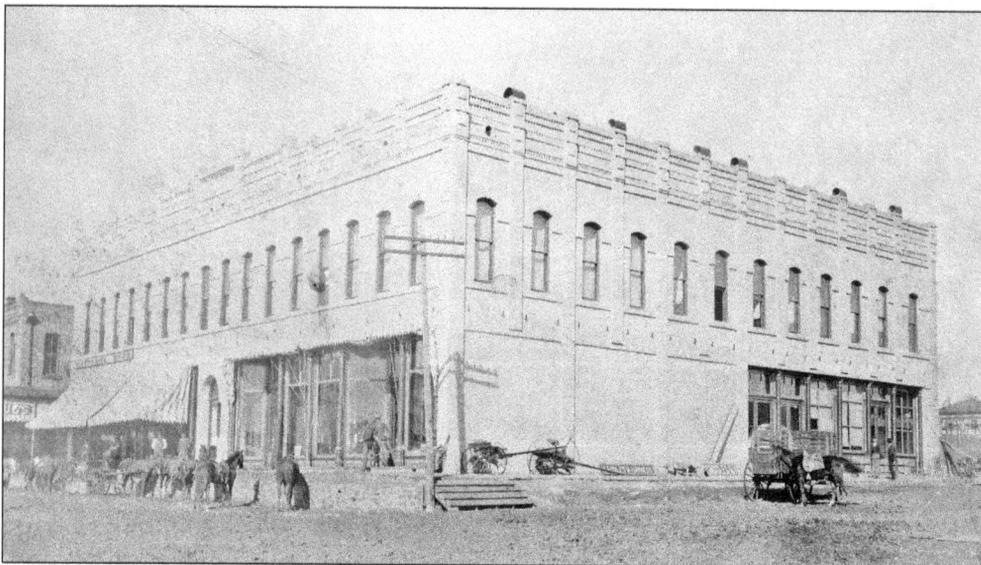

Pictured is the building at Avenue A and South 2nd Street. Matthews Brothers Tailors, to the left, occupied a floor space of 60 by 100 feet and carried a complete line of clothing, shoes, hats, and other items. Notice the horses and wagons. Mollie's Deli has occupied the right side of the building for many years. (Courtesy of Temple Public Library.)

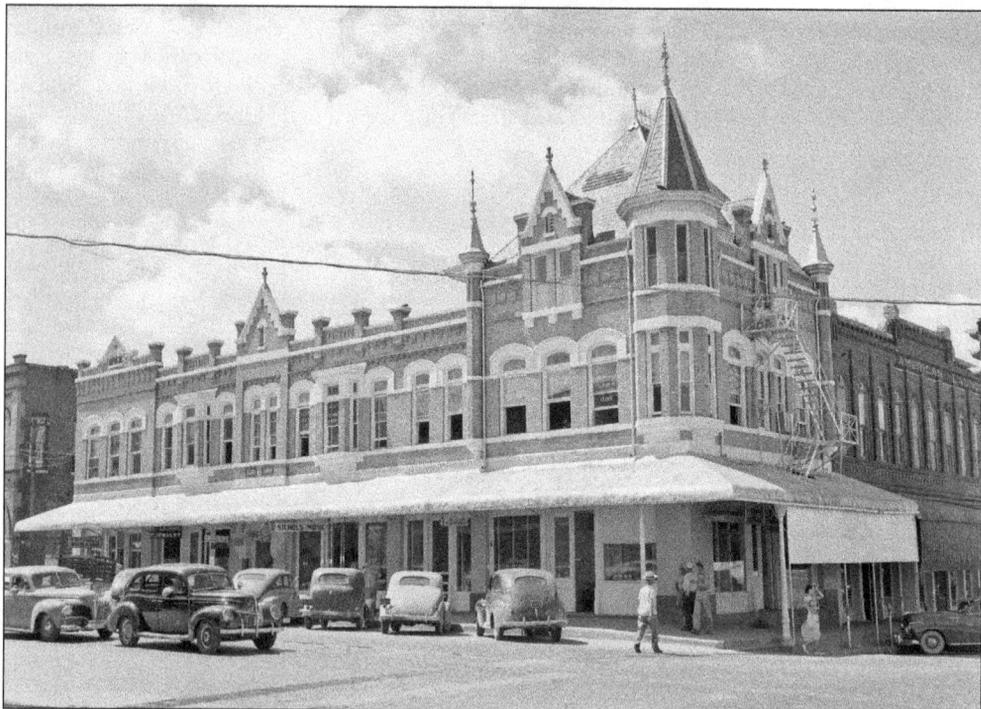

Capitalist George Willcox erected the brick Willcox Building at the southeast corner of South 1st Street and Avenue A. It later became known as Hammersmith Building and was demolished in the 1960s for a drive-in bank. At the time of this photograph, Henington Barber Shop, James Jewelry, Romine Chiropractic clinic, Nichols Music, and Roberta's Beauty Shoppe occupied the building. (Courtesy of Temple Public Library.)

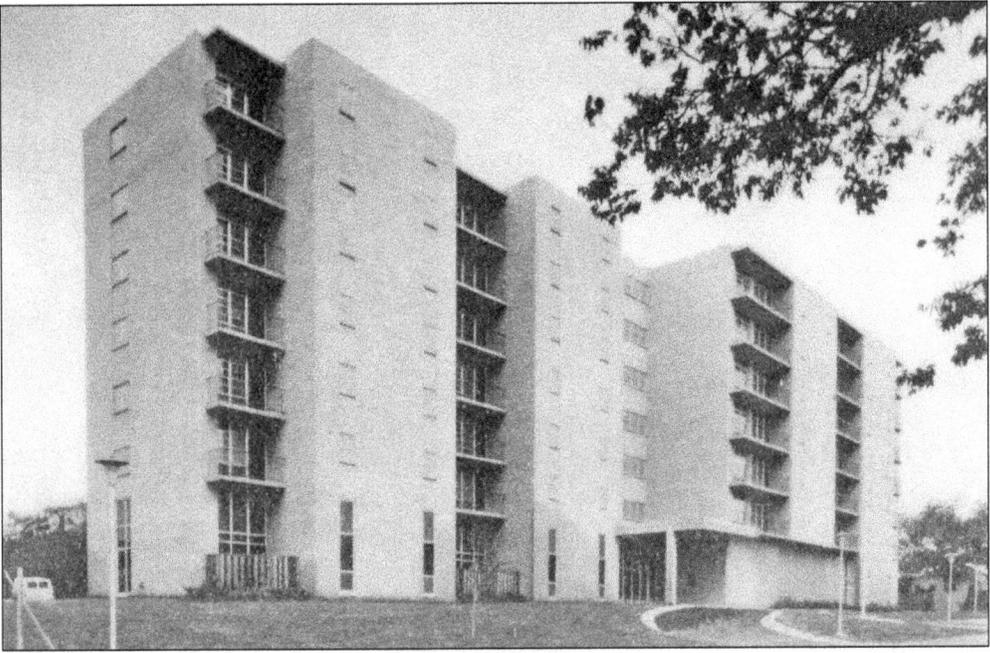

Frances Graham Hall, built in 1971, was the second high-rise apartment building in Temple. The seven-story 100-unit brick apartment building is located at 100 North 7th Street. Designed for the elderly, each room has a balcony for outside use, and elevators are available for travel between floors. Mailboxes and a dining room are on the first floor. Parking is available. (Courtesy of Kelsey Collection.)

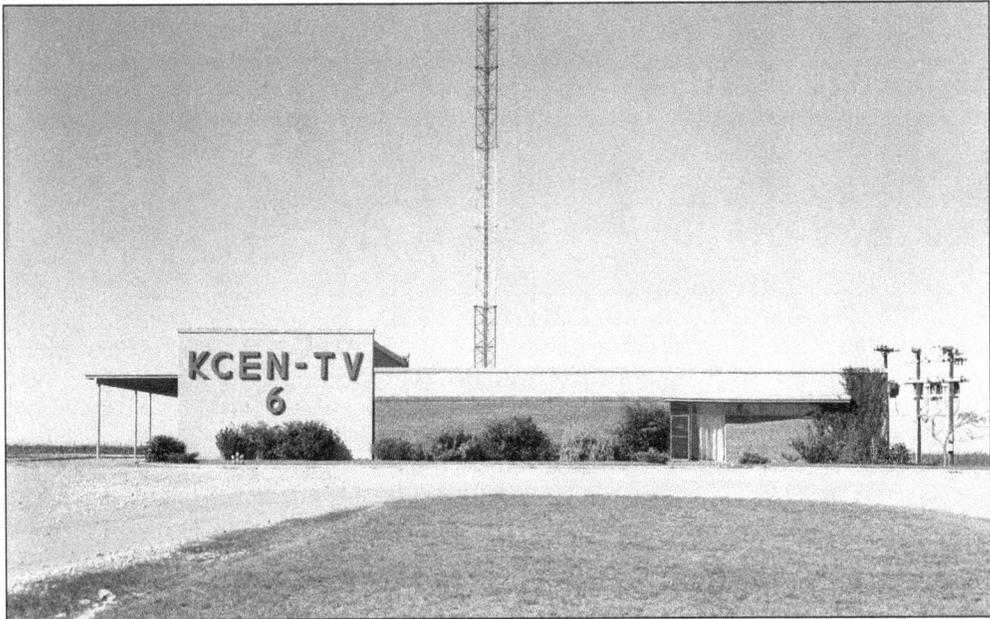

The KCEN television building was constructed in 1953 on Interstate 35. The studios are one mile south of Eddy on a 25-acre tract of land. *Blue Bonnet Barn Dance*, a popular Saturday night television show, started on KCEN in 1953. Harry Stone was manager of the popular band. (Courtesy of Temple Public Library.)

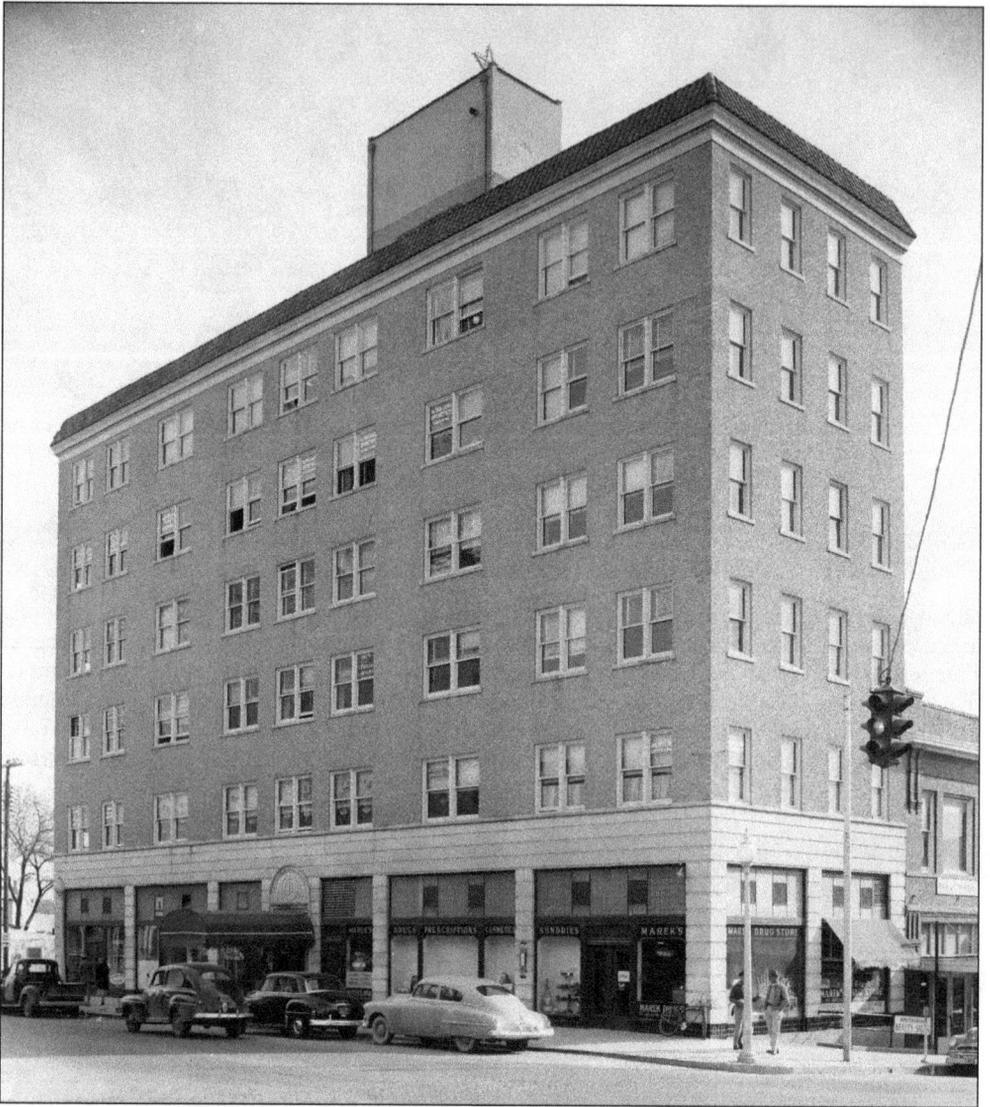

In 1929, Temple native Louis J. Bryan built the six-story $200,000 Professional Building at 105 East Central Avenue. Original occupants were barber D. A. Bryant, MacGregor School of Stenography, lawyer DeWitt Bowmer, J. T. Spencer grocery, A. B.'s Smoke Shop, and Temtex Seed and Floral. Houghton and Vernon Insurance and Realty opened in 1935. Brothers L. J. and R. A. Marek opened a drugstore in the building in 1938 on the bottom floor, visible in this photograph. In addition to filling prescriptions, the drugstore sold stationery, magazines, pipes, cosmetics, electric razors, and school supplies. W. D. "Shorty" Casey moved his radio shop to the building. The Slavonik Benevolent Order of the State of Texas purchased the Professional Building in 1953 and used it as its state headquarters until the new octagon-shaped half-million dollar building at 520 North Main Street was built in 1971. The Professional Building has been vacant for a number of years. (Courtesy of Temple Public Library.)

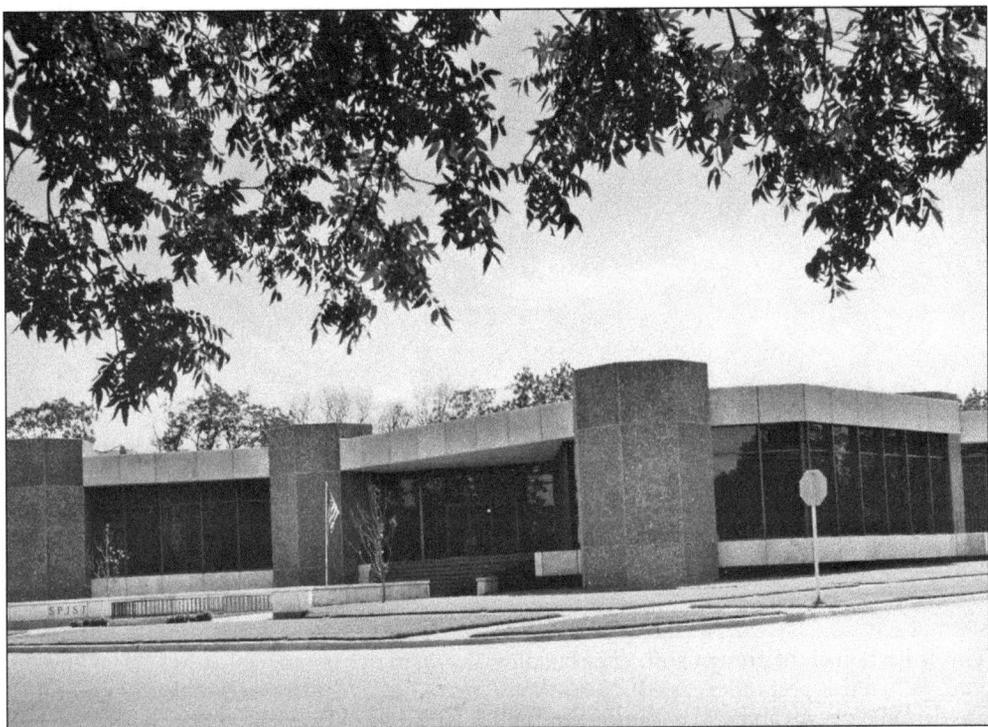

The Slavonik Benevolent Order of the State of Texas "promotes charity, benevolence, and educational advancements among its members; and provides for benefits to the widows, and orphans in case of death of its members." The organization was established in 1897 with 25 lodges. By 1935 there were 156 lodges, and Bell County led in membership with seven lodges and 1,104 members. Pictured is the new state headquarters built in 1971. (Courtesy of Temple Public Library.)

Temple applied for a post office in December 1880. It was located in several places until 1912. This photograph shows the Masonic cornerstone ceremony for the $100,000 Colonial-style post office at Main Street and Adams Avenue. Cecil Saunders was the contractor for the building, completed in 1912. Robert Wells, a drayman who specialized in the moving of pianos, was the subcontractor on the excavation work. (Courtesy of Temple Public Library.)

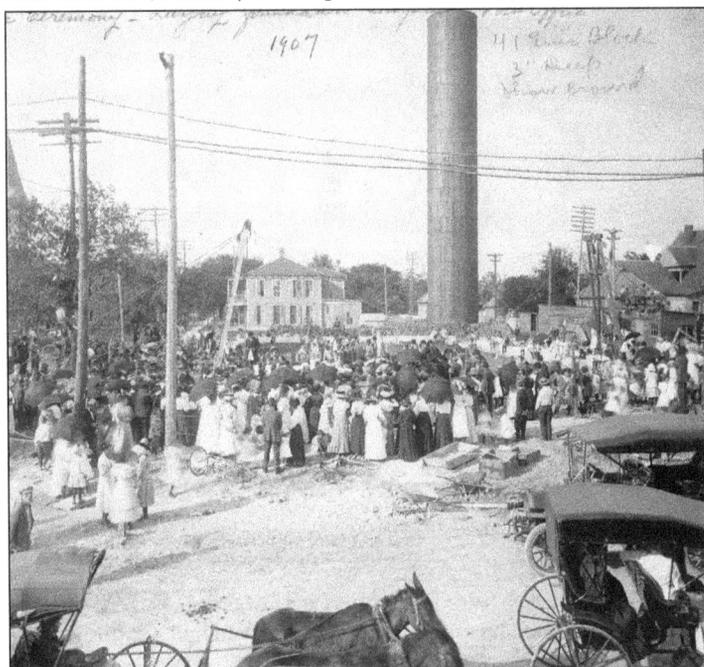

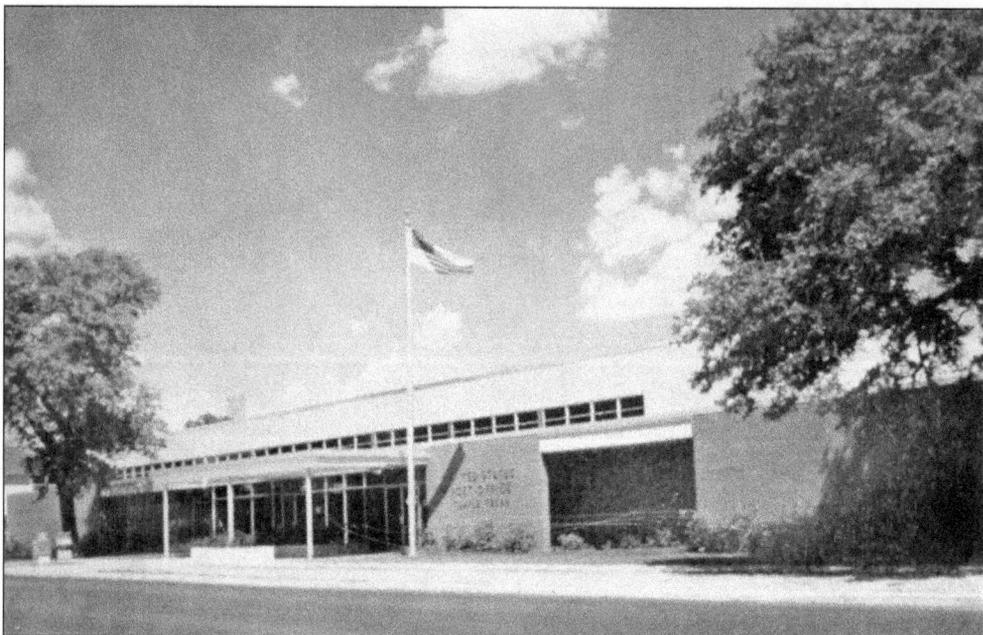

The dedication of the present post office building, shown in this photograph, was held on June 30, 1962. When this post office, at 401 North Main Street, was completed, the old 1912 post office was declared surplus and sold to the City of Temple for use as a library. In the 1990s, the building was sold to Temple College and is still in use. (Courtesy of Kelsey Collection.)

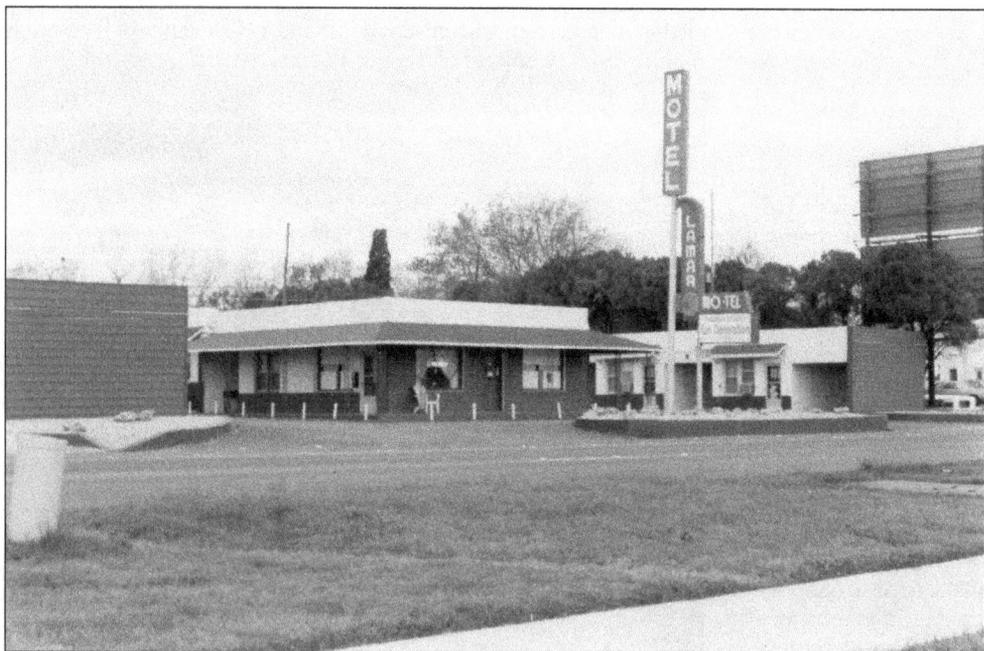

The Lamar Motel, pictured in 1986, is at 1510 South 1st Street. It opened in the late 1940s across the street from the Veterans' Hospital. Each room had a parking area. The north and west sections of the motel were torn down in the early 2000s. (Courtesy of Kelsey Collection.)

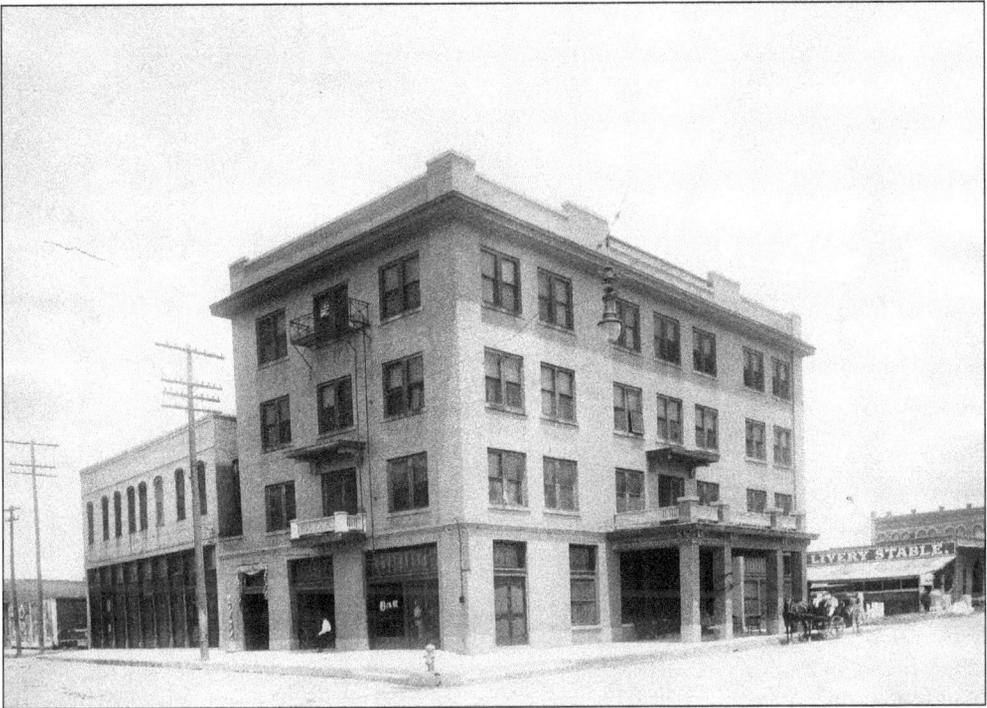

The Martin Hotel, built in 1911 on the site of an old saloon, occupied the northwest corner of South 3rd Street and Avenue B. The new four-story building cost $40,000, including remodeling of the annex that was constructed about 1892. The hotel included conveniences such as hot and cold water, and many of the rooms had baths. The entire lower floor was tile. Notice the bar sign on the window and the tombstones at right. (Courtesy of Temple Public Library.)

Temple Theatre, located at 118 West Avenue A, began operation about 1913 and cost $35,000 to build. George Walker, the proprietor, is credited with bringing the first professional vaudeville attraction to Temple. Temple Theatre went through extensive remodeling in 1919, and in 1920, the city purchased it. The building was torn down in the early 1990s for a parking lot. The *Temple Daily Telegram* newspaper building is at right. (Courtesy of Temple Public Library.)

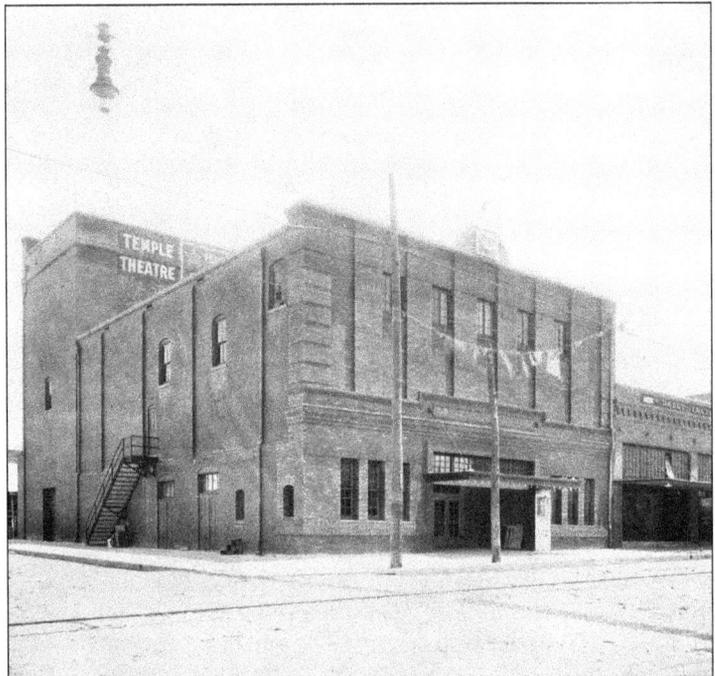

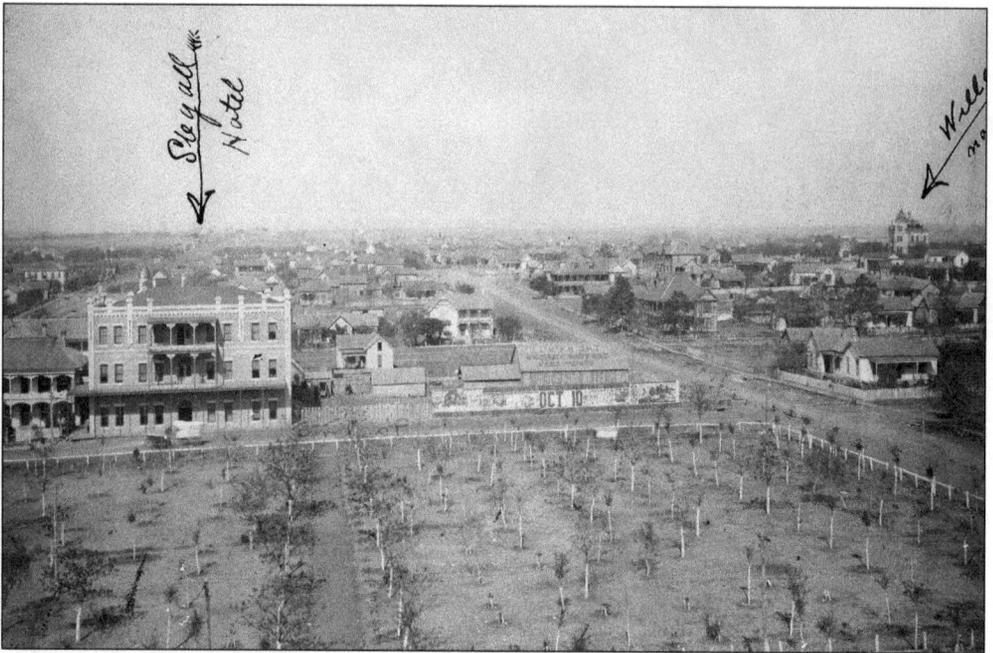

This photograph, taken from the opera house, shows the three-story brick Stegall Hotel (left) built in 1896 on North 3rd Street. The hotel advertised good cistern water, sample rooms, electric lights, and all modern improvements. To the right of the hotel is the McKnight grocery and feed warehouse. The three-story house in the right background is the George E. Willcox home on North 9th Street. (Courtesy of Railroad and Heritage Museum.)

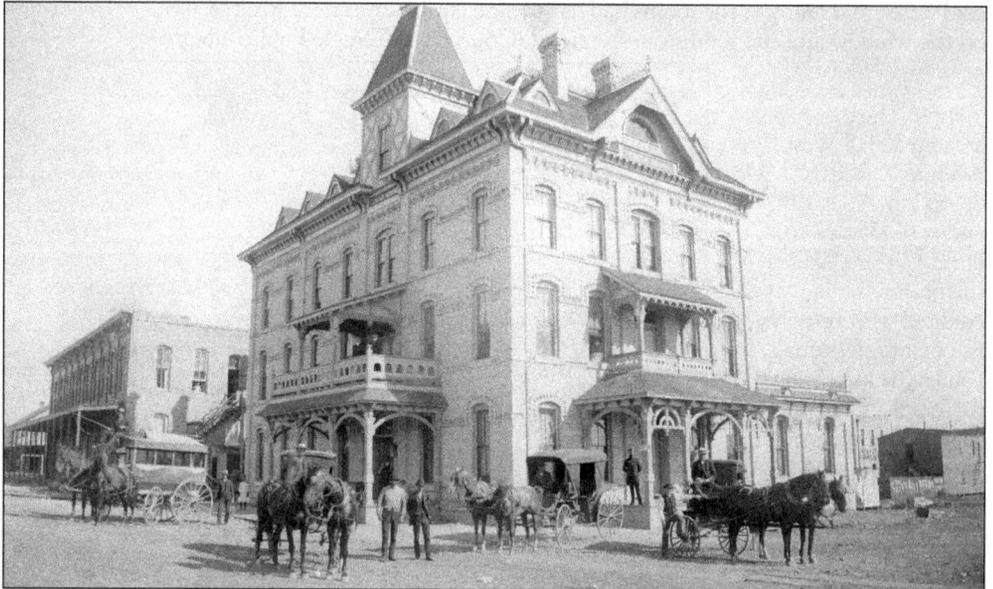

The brick Central Hotel at South 3rd Street and Avenue A was one of the most popular of early hotels. In May 1889, the hotel registered 771 guests, and it was common for travelers to come from Austin, Houston, Dallas, Galveston, San Antonio, and as far away as New York. Rates were $2 at the dawn of the 20th century. The building was demolished in 1957. Notice the omnibus at left. (Courtesy of Kelsey Collection.)

Eskar Sullivan is pictured at Sullivan Grocery and Market No. 5. The frame store with wood floors was located at 1218 South 13th Street. Sunshine crackers, paper towels, pure lard, Curtiss pancake mix, Baird's bread, Jones Fine Bread, canned goods, and Kellogg's cereals were sold. A fresh meat market was in the back. On each screen door is a Jones Fine Bread sign. (Courtesy of Sullivan family.)

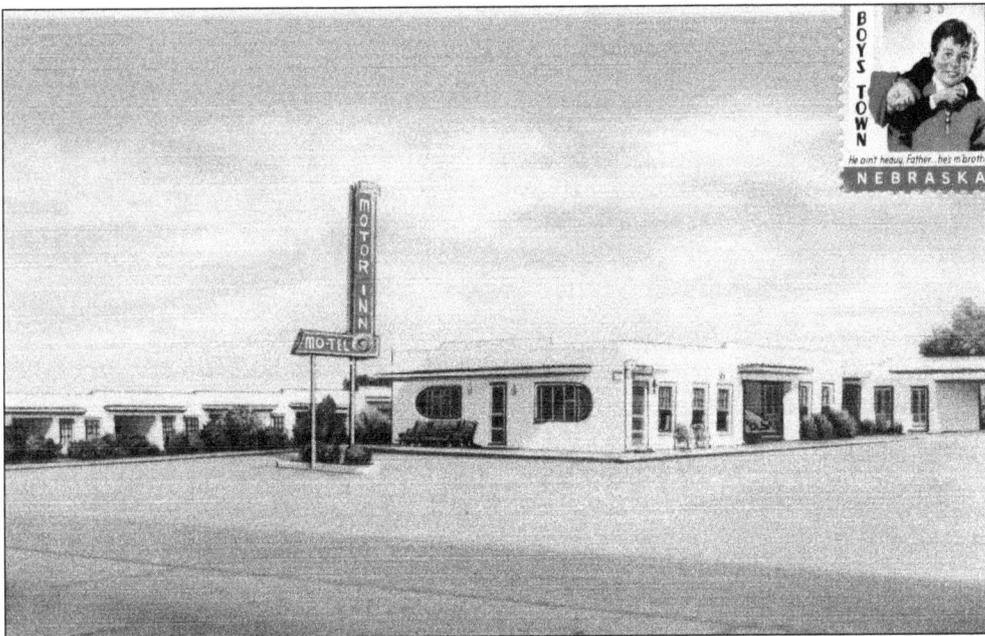

Motor Inn Motel was located at 1601 North 3rd Street across Highway 81 from another motel, the Temple Auto Court. The 22-unit motel advertised "tile baths, private garages, carpeted floors, innerspring mattresses, and radios." The units were air-conditioned, and maid service was provided daily. The American Automobile Association and American Motel Association rated the motel. (Courtesy of Kelsey Collection.)

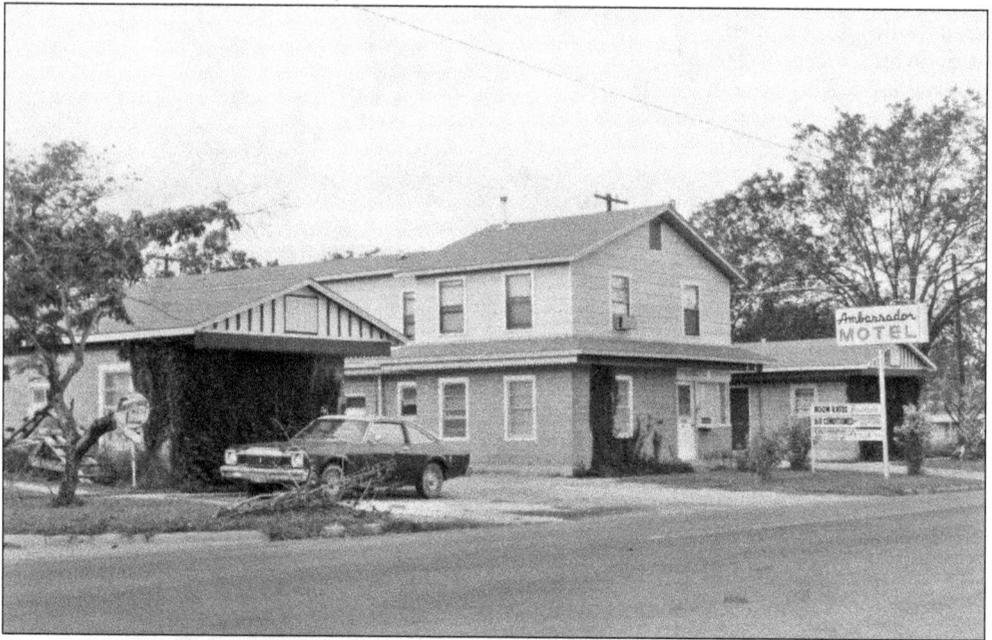

The Ambassador Motel at 901 West Avenue G is a typical example of the tourist courts constructed in the 1950s. It accommodated patients from the old Scott and White Hospital and Santa Fe Hospital. This photograph, taken in 1986, shows how the Ambassador appeared when serial killer Kenneth McDuff stayed there. The motel closed several years ago. (Courtesy of Kelsey Collection.)

KTEM radio, "the Voice of Central Texas," went on the air in 1936. After four months, it increased its power to 250 watts to make it the strongest station between Dallas, Houston, and San Antonio. Coverage extended over 100 miles. KTEM moved into this building at 301 North Main Street in 1971. Temple was home to one of the first radio broadcasting stations in the state. (Courtesy of Kelsey Collection.)

Four

SCHOOLS

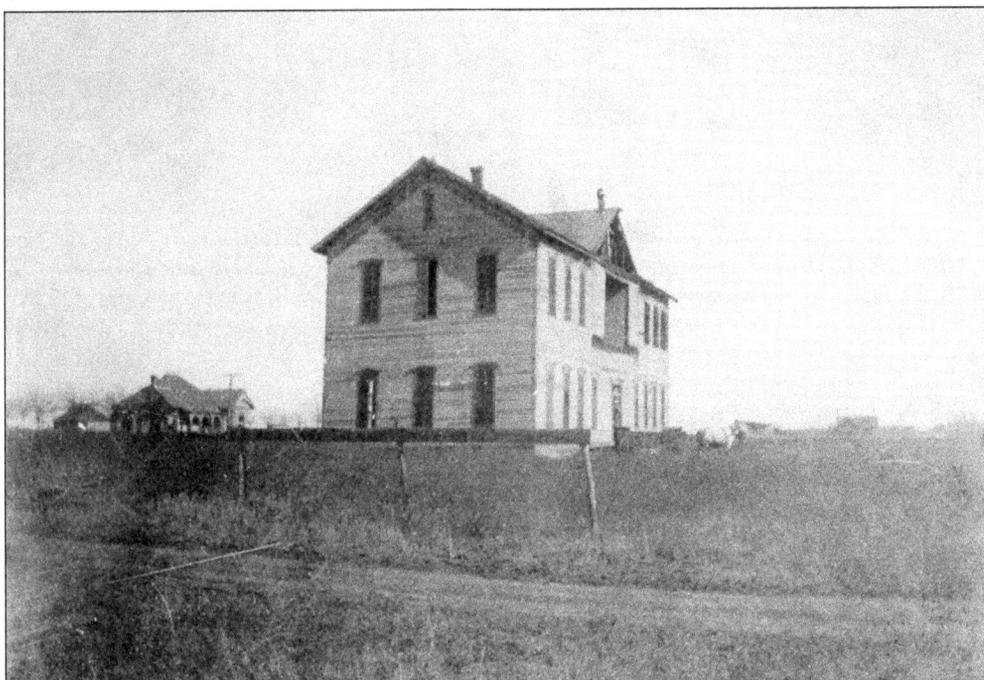

Pictured is Temple's first public school. Notice the wagon and horse in front. After holding classes in churches or private homes, citizens recognized the need for a public school building and a stock company organized on June 13, 1883, to raise funds to erect one. The contractor was C. W. Austin. The two-story 80-by-30-foot building had a 26-by-36-foot ell. Temple Academy was the name of the new school, and it was located at Main Street and Downs Avenue. Teachers were J. Waggoner, ? DeWitt, and Jennie Gray. On December 26, 1883, the city purchased the building from the stock company and it became Temple's first public school. The town held an election on September 24, 1883, and by a vote of 114 to 2, it assumed complete control of the public schools and removed them from the state district system. At an election held on December 17, 1883, voters approved a school tax, with only five votes cast against it. (Courtesy of Temple Public Library.)

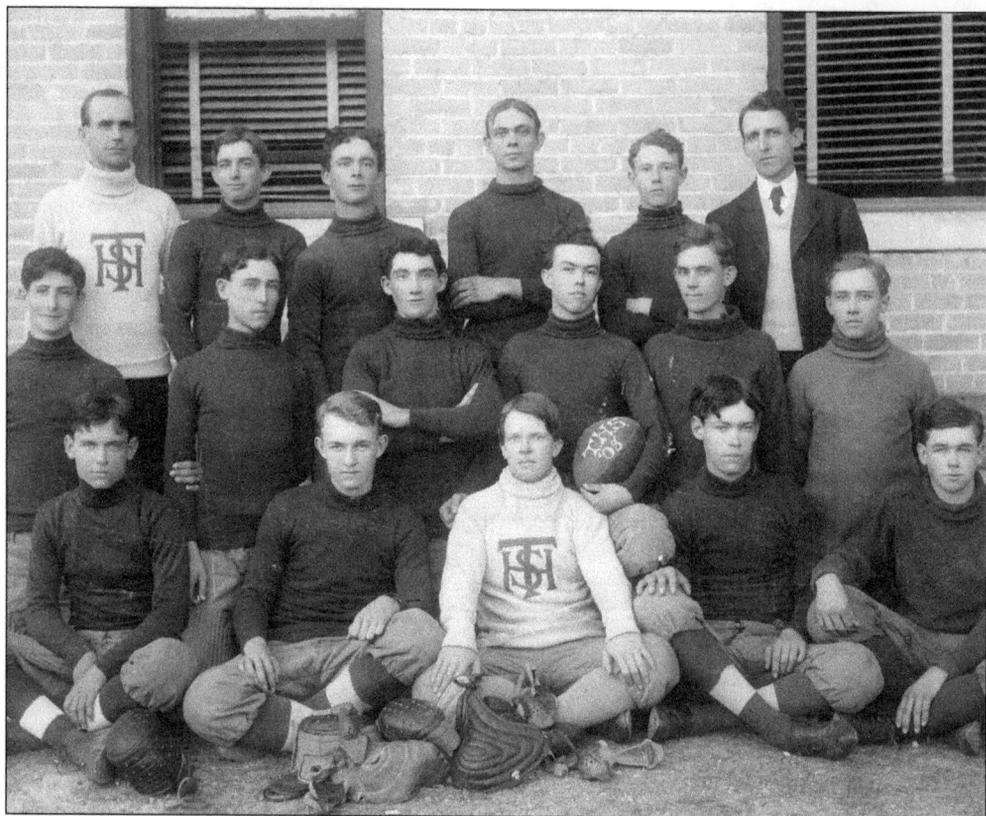

Members of the 1908 Temple High School football team from left to right are (first row) Raymond King, Thomas Calloway, Garrett Matthews, Frank King, and Clinton Swink; (second row) Charles Green, Fred Day, Robert Stakeley, Caskey Lowry, Winn Sherrill, and Arthur Scott Jr.; (third row) coach J. L. Head, Marvin Hewett, Harry Stakeley, Clyde Knight, Guy Sherrill, and professor W. W. Clement. (Courtesy of Temple Public Library.)

Reagan Elementary, named for John H. Reagan, postmaster general of the Confederacy, was at South 5th Street and Avenue J. The first Reagan school building was constructed in 1896. In 1928, a majority of the structure was torn down, and a new building was erected around a portion of the old one. In 1922, there were 540 students. (Courtesy of Temple Public Library.)

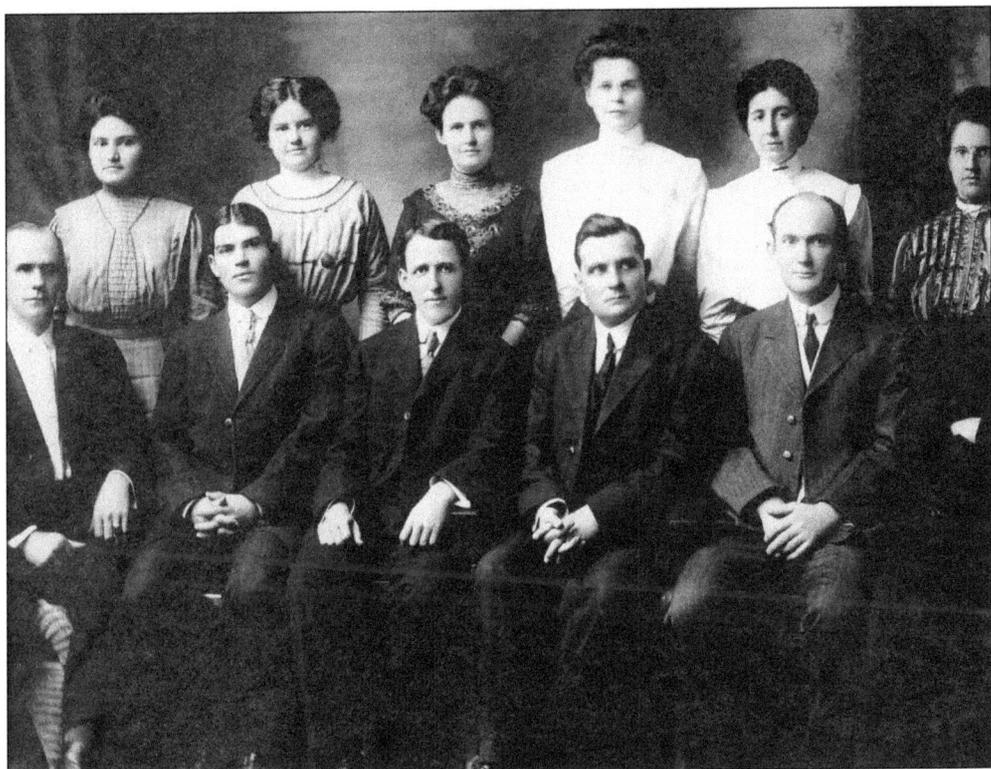

Pictured, although not listed in order, are members of the Temple High School faculty in 1911: J. L. Head, L. F. McKay, W. W. Clement, J. F. Kimball, W. H. Adamson, L. C. Proctor, Mary Hanover, Mattie Mitchell, Susan Weld, Lydia Linstrum, Alice Moore, and Georgia Ella Holt. Clement was the principal, Head was the coach, and Kimball was the superintendent. (Courtesy of Temple Public Library.)

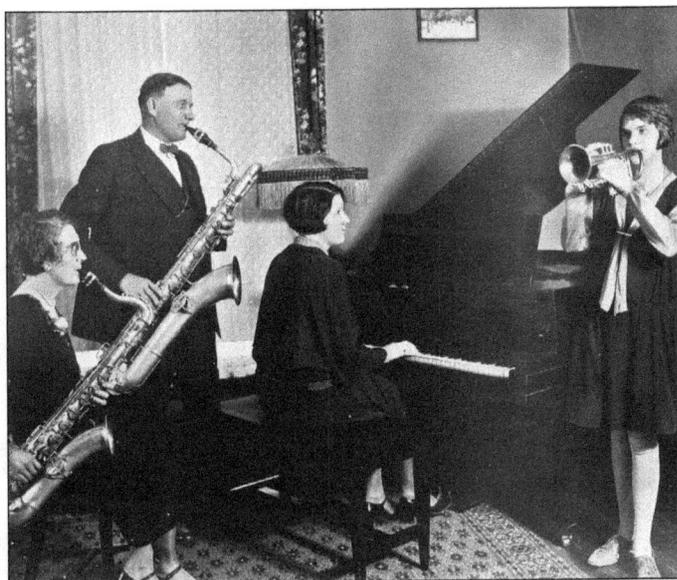

Temple High School band director Elie Shepperd's family is pictured here. From left to right are Annie, Gladys, and Mildred. In 1931, Mildred beat Harry James in a trumpet contest with a score of 97 to James's 98. When James returned to Temple in 1982, Mildred joined Mayor J. F. Sammons in presenting him an honorary Temple citizenship. The family attended Memorial Baptist Church, and Annie is credited with being the founder of childcare in churches. (Courtesy of Kelsey Collection.)

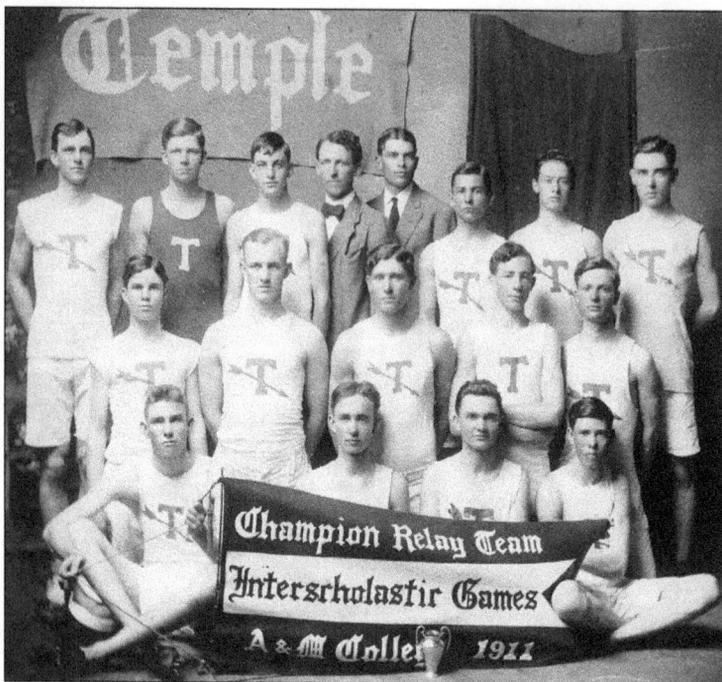

The 1911 Temple High School track team won the state champion relay banner at Texas A & M University and a silver loving cup for winning the relay championship at Austin. In no particular order, the four team members in the first row are Preston Childers, John Leigh, Harry DeGrummond, and Charles Bassler. (Courtesy of Temple Public Library.)

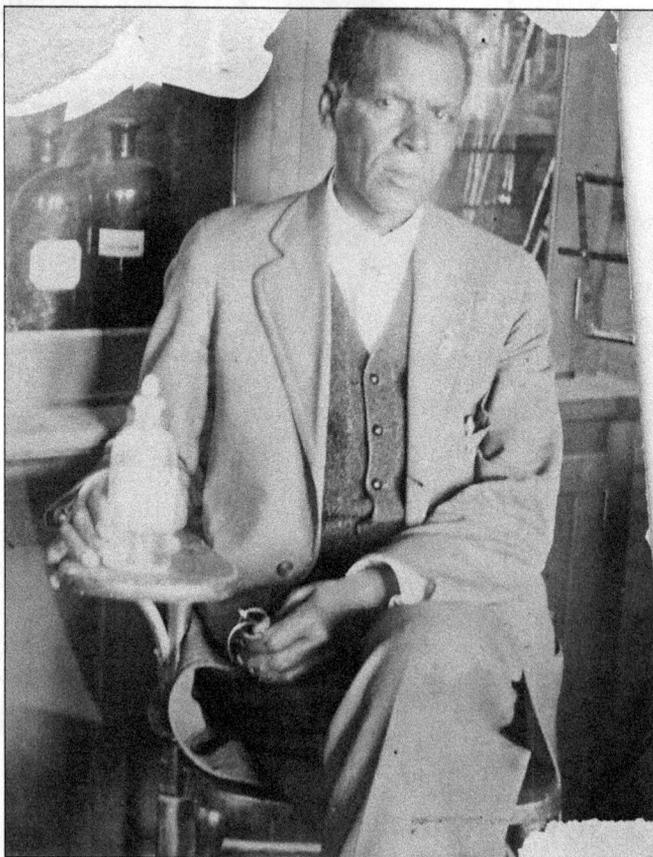

Prof. L. J. LeQuey (pictured) and his wife, E. C. B. LeQuey, were the principal and primary teacher, respectively, of the Colored School at 419 East Avenue D. They lived at 517 South 2nd Street. He was a member of the Magnolia Masonic Lodge. Teachers at the school were C. F. Simmons, W. B. Kuykendall, Celestine Morgan, and Martha Wilhite. Morgan was in charge of the teachers. (Courtesy of Temple Public Library.)

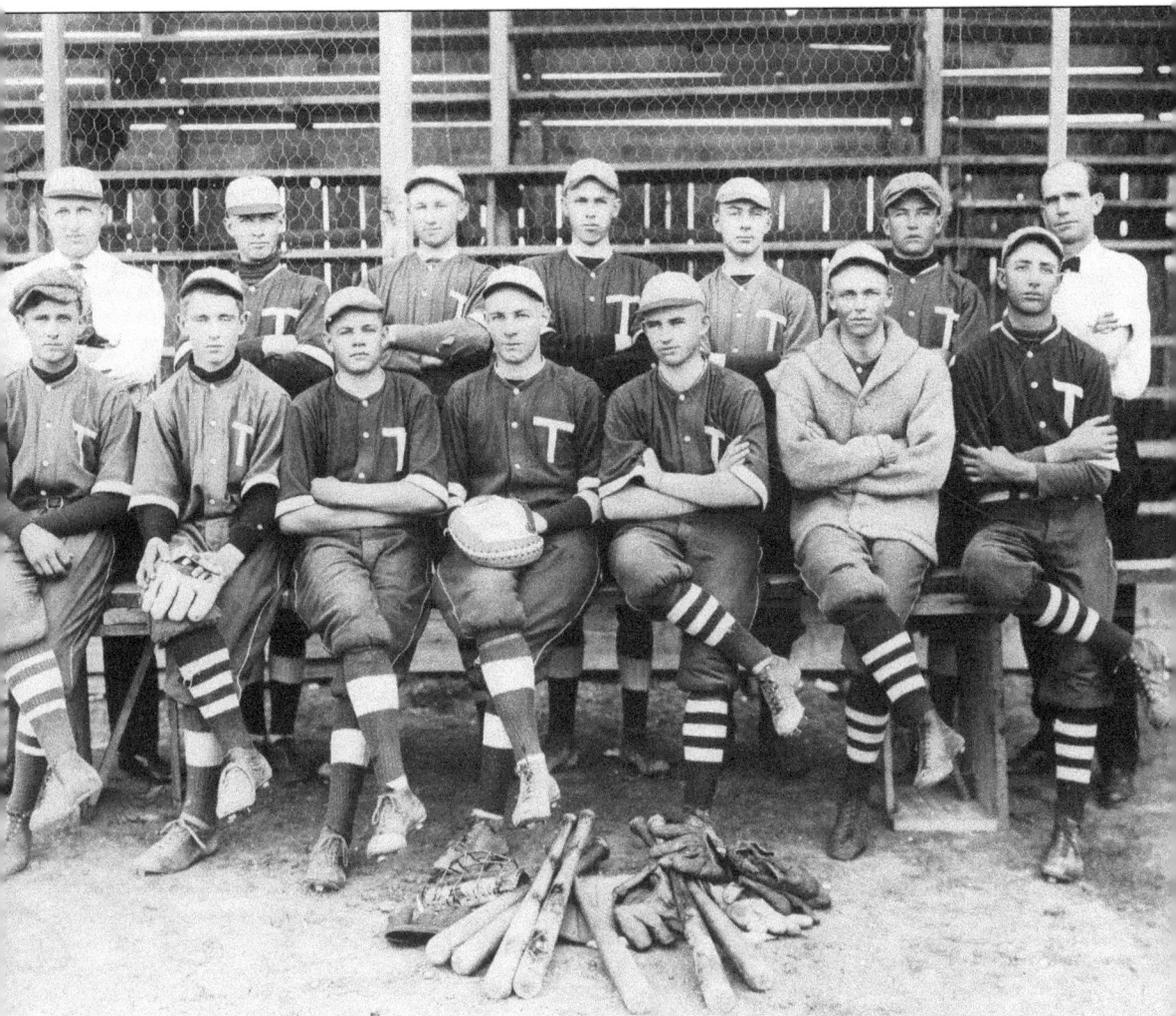

Members of the 1918 Temple High School baseball team are, from left to right, (first row) unidentified; Jack Jones; R. V. "Dutch" Nichols; Downs Hutchison, captain; unidentified; Luther Miller, pitcher; and unidentified; (second row) L. C. Proctor, coach; Bryan Strange; George Robertson; Joseph Wheeler Harris, first base; Shirley Rowland; unidentified; and J. H. Head, coach. Others on the team but not identified in the photograph included Lee Hagler, Earl Adams, Gordon Asbury, William Jones, and Blanche Pollock. Out of eight games played, the team lost only one, to Bartlett, with a score of 3-1. In the last game, Harris drove a ball over the left field fence for the only score either side was able to make during the game. (Courtesy of Temple Public Library.)

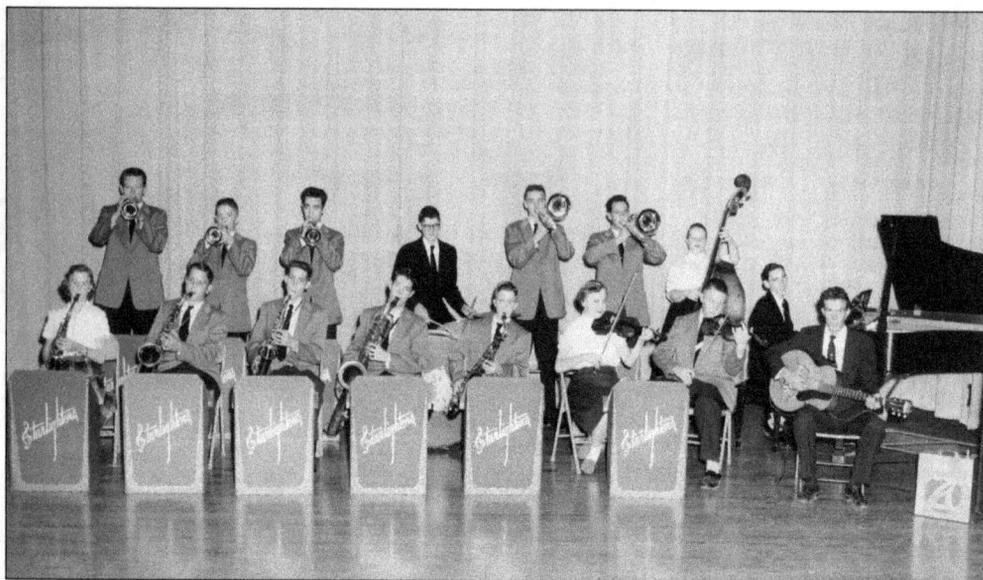

Pictured about 1953 on the stage are members of the Temple High School Starlighters, the school jazz band. Durward Howard, a graduate of the University of Texas and Columbia University, served for many years as Temple High School band director. He was also director of the Pepperettes drill team and Temple High School Orchestra. (Courtesy of Kelsey Collection.)

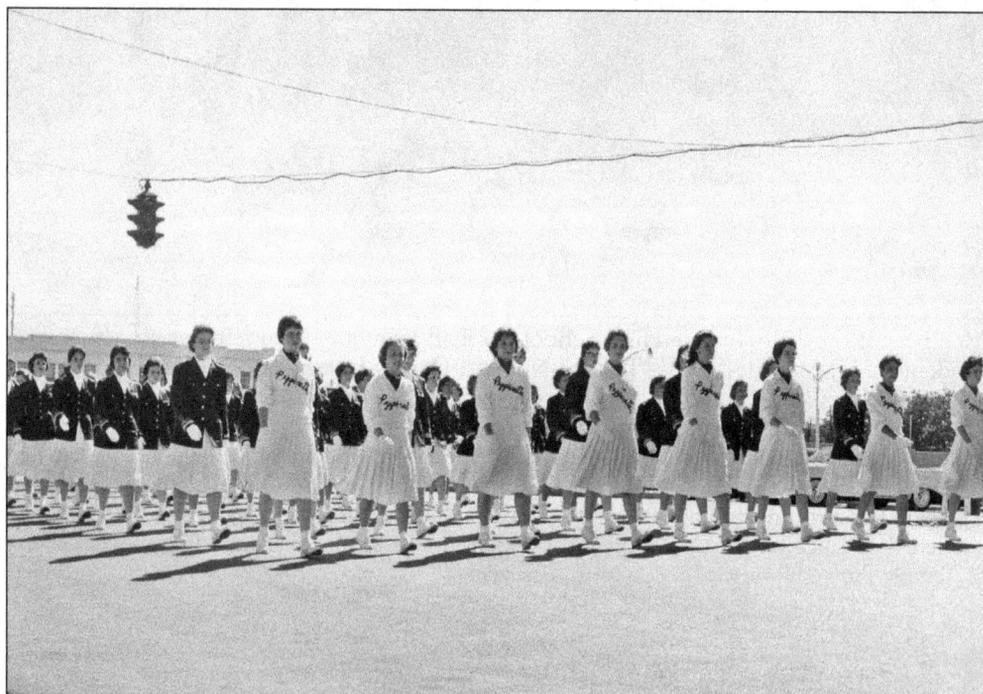

Members of Temple High School Pepperettes are, from left to right, (first row) Kay Schwake, Susan Speed, Elizabeth Walker, Paula Daniel, Lydia Reneik, Juanita Williams, Sandra Shaffner, and Charline Wallace. Howard was the director. The Pepperettes sat in the grandstand during games, and during half-time, the group performed a dance routine. Some time after the 1970s, the name of the drill team changed to Kittens. (Courtesy of Temple Public Library.)

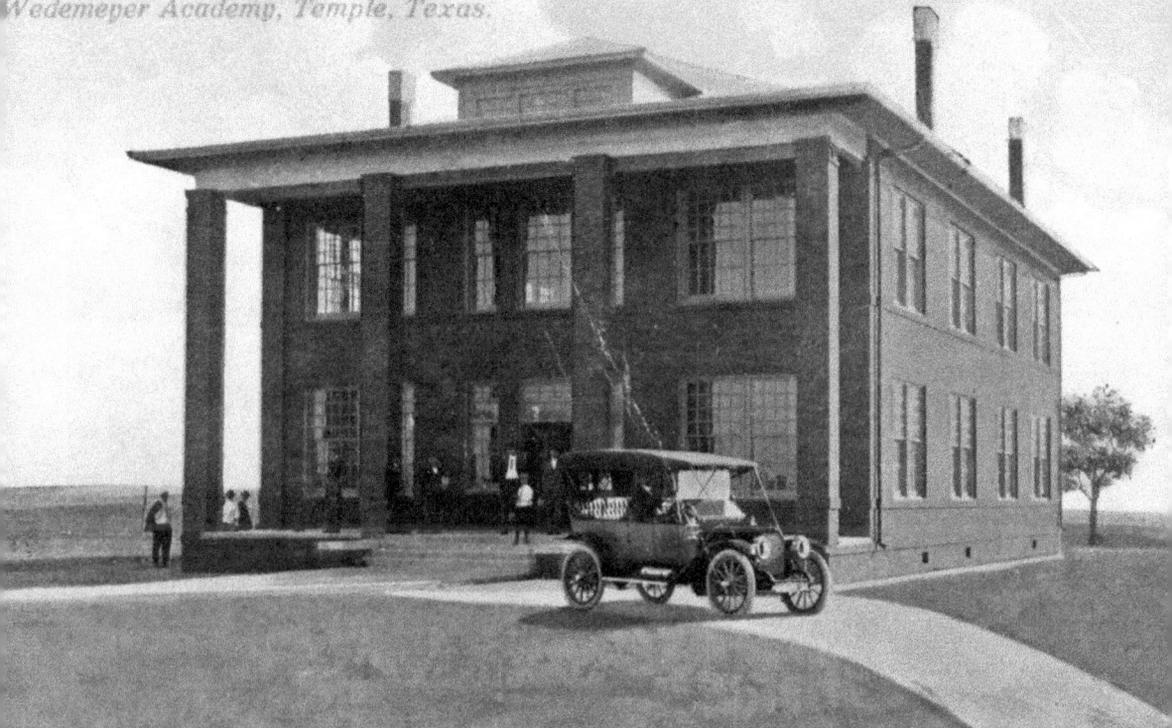

Wedemeyer Academy, Temple, Texas.

Charles H. Wedemeyer, from near Independence, Washington County, graduated in 1878 from Baylor, then located at Independence. Wedemeyer opened a school in Belton. He moved his school to Temple and established Wedemeyer Academy in 1912. Several Temple business and professional men secured the move. Wedemeyer Academy bridged the chasm between lower grade schools and colleges and was the only military school in Central Texas. In the first year, there were 160 students. By the 1914 term, the school had a total enrollment of about 2,900 students. The two-story brick school building was at Avenue J between South 45th Street and South 47th Street. The school was an important factor in the residential growth of that part of town. It only stayed open for three years, closing in 1915 when it was sold at a sheriff's sale to satisfy a $5,600 judgment held by W. Goodrich Jones. A school and church, troops during World War II, a Veteran of Foreign Wars post, and the Cultural Activities Center used the building. It was torn down in 1968. (Courtesy of Kelsey Collection.)

Temple Junior College opened in 1926 with a faculty of five. Students chose "Templar" for the name of the school annual. Students printed college news in the *Temple Daily Telegram*. The first graduating class in 1927 had 11 students. The Luncheon Club, Curtain Club, Glee Club, Choral Club, and a football team were formed in 1929. The name changed to Temple College in 1996. (Courtesy of Temple Public Library.)

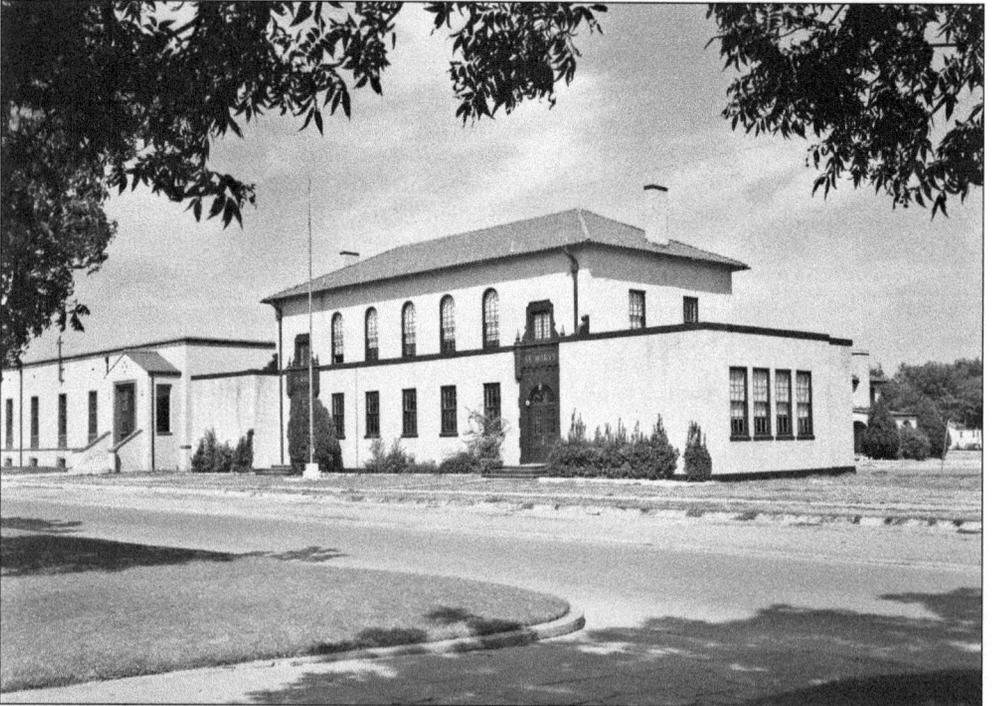

St. Mary's School on South 7th Street was established as St. Mary's Academy by Fr. P. A. Heckman in 1895. He first came to Temple in 1886 and was appointed there in 1892. He remained in Temple until 1919, when he was sent to Waco. (Courtesy of Temple Public Library.)

Five

CITY AND COMMUNITY

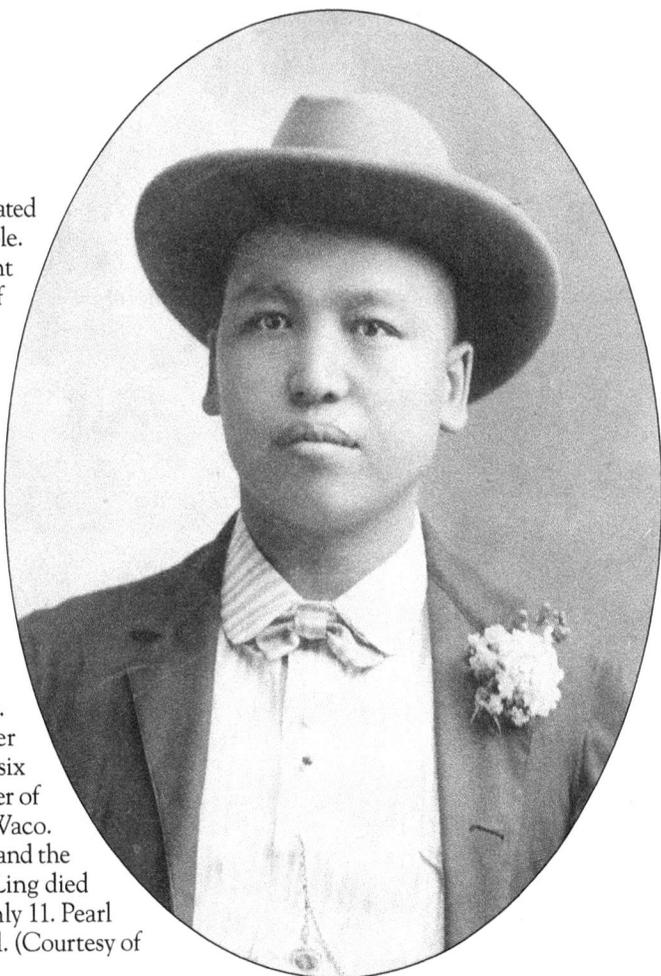

Several Chinese–owned and operated restaurants were located in Temple. Hong Lee owned Star Restaurant and Hong Hing operated one of the first Chinese restaurants, the Hong Hing Restaurant. Yen Lung Quong operated a restaurant on South 1st Street. Y. Pat Ling (1866–1916), pictured here, an educated man from Hong Kong, immigrated to the United States in 1898. Ling's restaurant was a favorite of the residents of Temple, as he owned his own dairy and truck farm and served fresh produce and the "purest of milk" at his restaurant on South 1st Street. Ling and his wife, Pearl Hester Elliott Ling, were the parents of six daughters. Pearl was the daughter of Dan Elliott, a farm laborer at Waco. Ling ran into financial problems and the family moved to Waco. When Ling died in Waco, the oldest child was only 11. Pearl remarried and moved to Haskell. (Courtesy of Temple Public Library.)

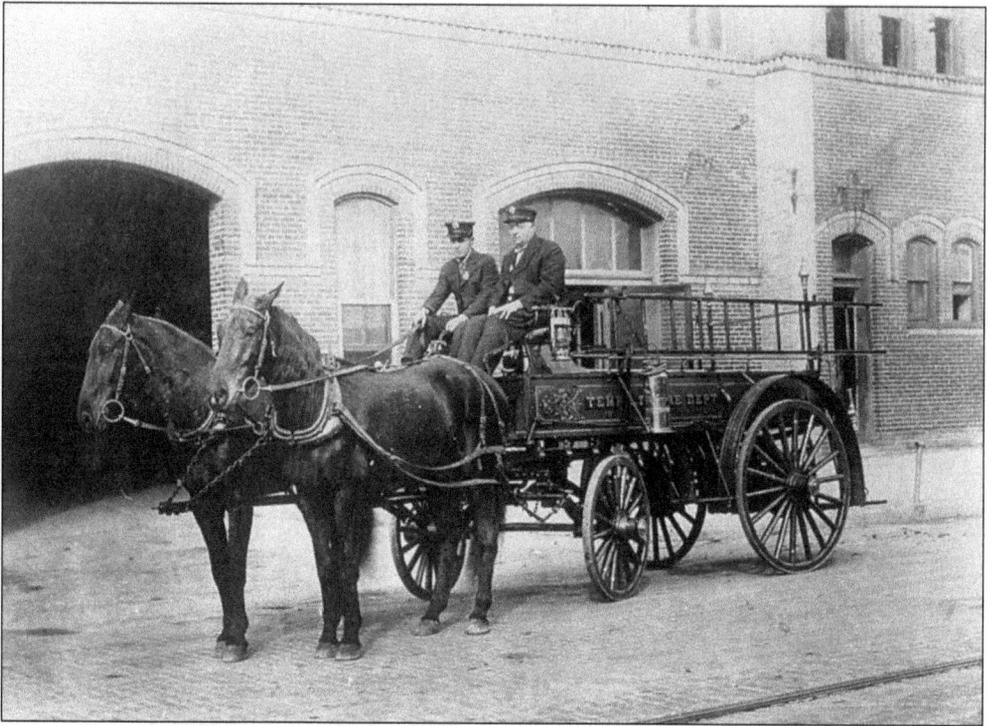

Pictured is a Temple fire wagon at Central Station. The fire department organized in 1883 with a hand-drawn apparatus that was used until 1887 when a wagon and team were purchased. In 1910, the fire department consisted of two companies, eight paid men, one chief and assistant chief, and seven horses. There were 150 volunteers. Fire alarms were issued by telephone to Central Station and then by bell. (Courtesy of Sam Houston.)

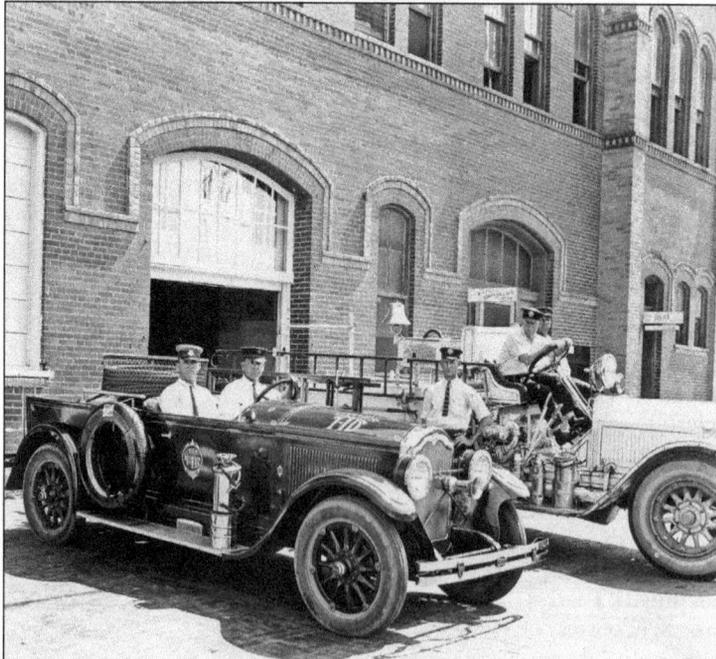

From left to right are Alphes Fisher; George Hoherd, fire chief; Theodure Timeaus; Barton Thompson; and John Homes. They are in front of Central Station at South 3rd Street and Avenue A. This photograph, taken about 1916, shows the fire chief's truck and the combination chemical and 75-horsepower pumper. The fire truck carried two 65-gallon chemical tanks and a 250-foot chemical hose. (Courtesy of Temple Public Library.)

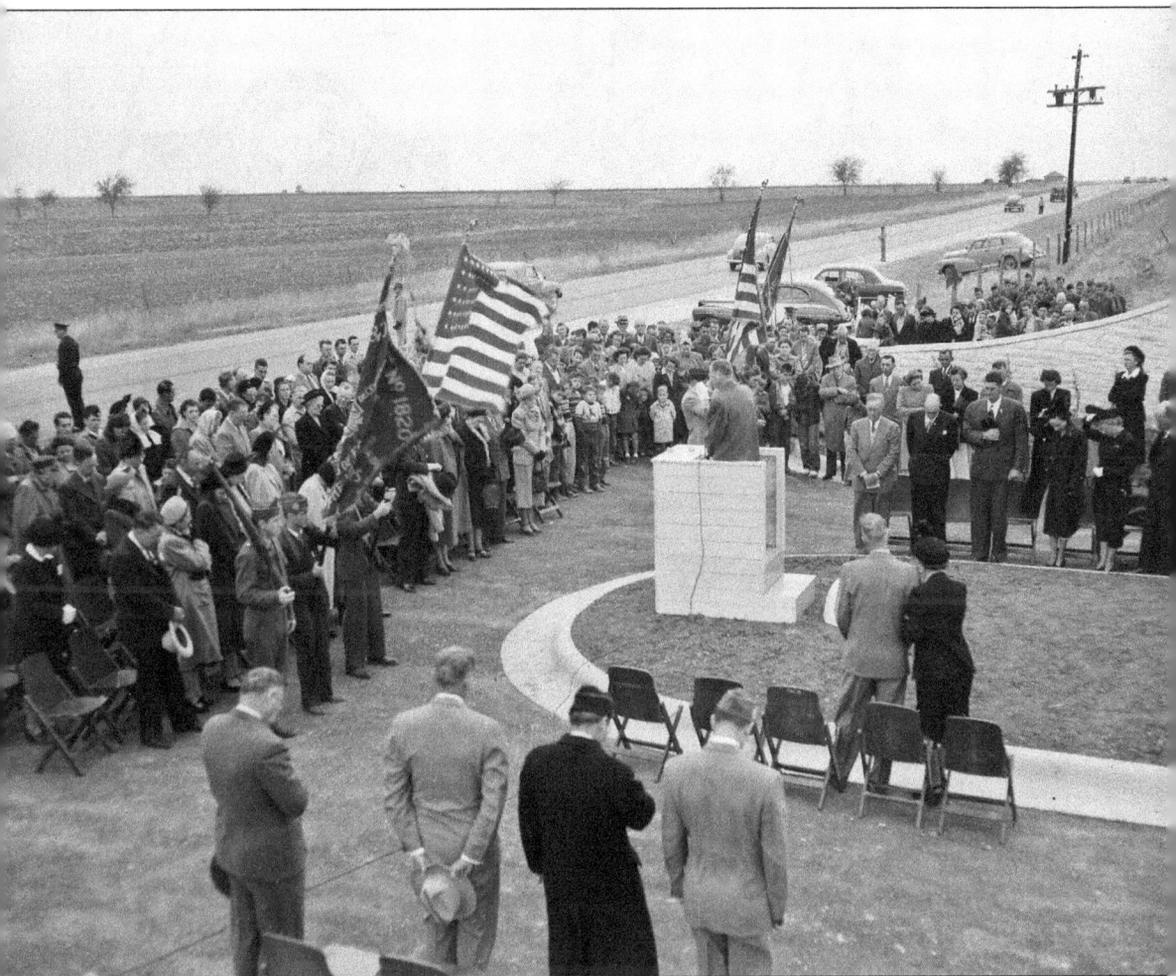

In 1937, the Works Progress Administration built an airport west of Temple. It was first known as Temple Municipal Airport. During World War II, the military operated it as Temple Army Airfield. It became the base for the 157th liaison squadron out of Waco Army Airfield. The airport was renamed Draughon-Miller Airport in memory of Miller Draughon and Raymond Miller, both of whom died during World War II. Draughon was an Army Air Corps cadet and son of city commissioner N. S. Draughon. He was killed on a training flight in California. Miller was killed in a routine training flight near Will Rogers Field in Oklahoma. His father owned Miller Printing. Pictured is the dedication of the memorial entrance to the airport in 1948. The all-day armistice event began at 6:00 a.m. A B-36, the largest bomber of the air force, circled low over the airport several times before roaring over the entrance in tribute to Temple men who gave their life while serving in World War II. (Courtesy of Temple Public Library.)

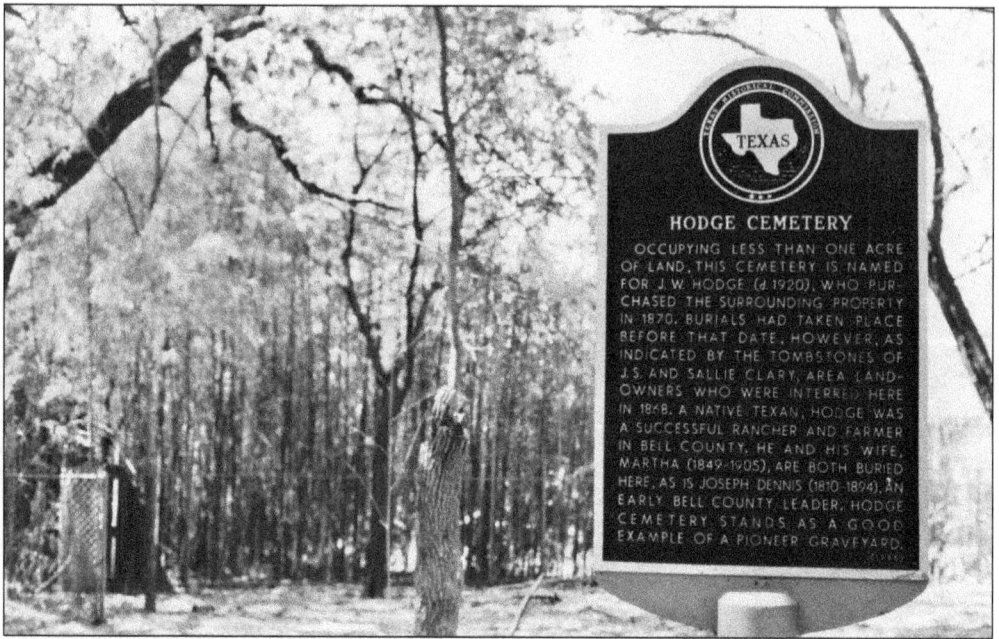

Pictured is the Texas state historical marker at Hodge Cemetery. Hodge Cemetery is one of at least 12 cemeteries within the city limits. The earliest death date at Hodge Cemetery is that of Sarah Clary, who died in 1868. A Texas historical marker was placed in the cemetery in 1984 for Joseph Dennis (1810–1894). (Courtesy of Kelsey Collection.)

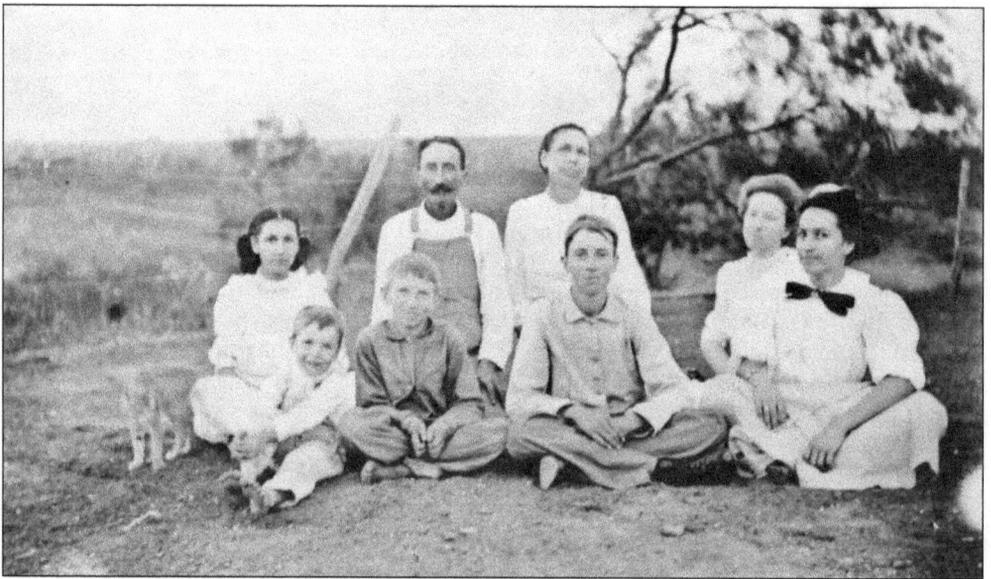

The children of Bedford Forest Thornton and Hannah Etta Neal Thornton are pictured with their parents. From left to right are Lucy, Forest, Billie, Rollie, Nora, and Ruby. Bedford died at the state hospital in Austin in 1943, and Hannah died in 1953 in Temple of tuberculosis. They are buried at Hodge Cemetery. (Courtesy of Kelsey Collection.)

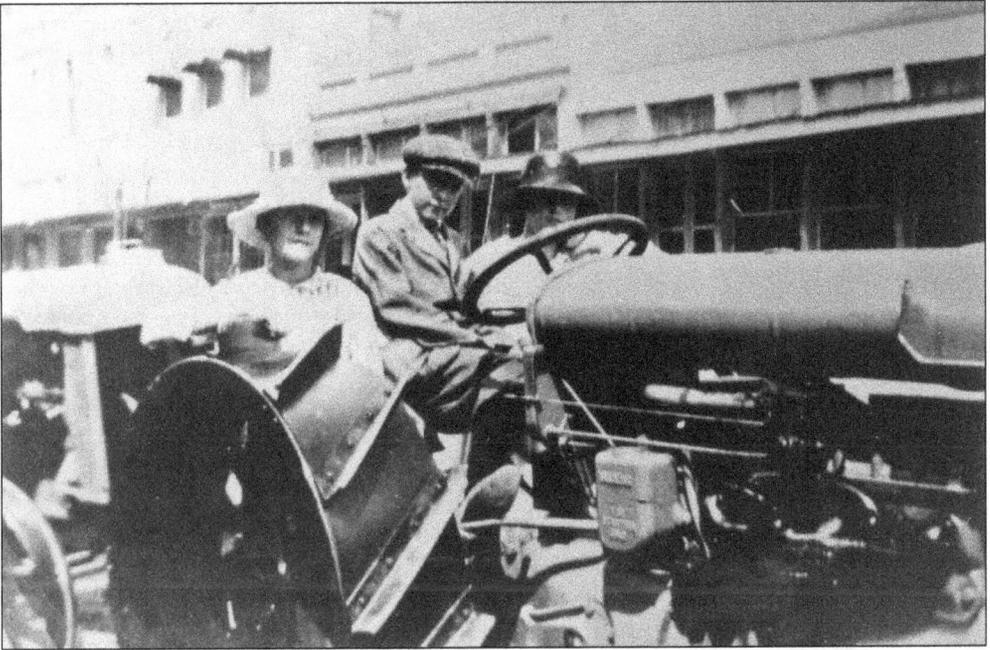

Pictured on a tractor from left to right are Cecil Smith Berry, Clifford Smith, and Lillian Smith Pirtle. They were children of John Howard Smith and Pearl Davis Smith. In 1925, Cecil married Hal Berry, an electrician. She worked at Vera Lee's clothing store. Lillian married Sherman Pirtle. (Courtesy of Carol Dreesen.)

There have been many collectors of railroad and Bell County memorabilia. Dr. Alexander Dienst began collecting in the 1890s, and Hersel Proctor started in the 1950s. Collector Sam Houston is pictured in front of one of his collection cabinets at his home in west Temple. Visible from his collection are railroad dining room china and bottles. He worked for the Gulf, Colorado and Santa Fe Railway for many years. (Courtesy of Kelsey Collection.)

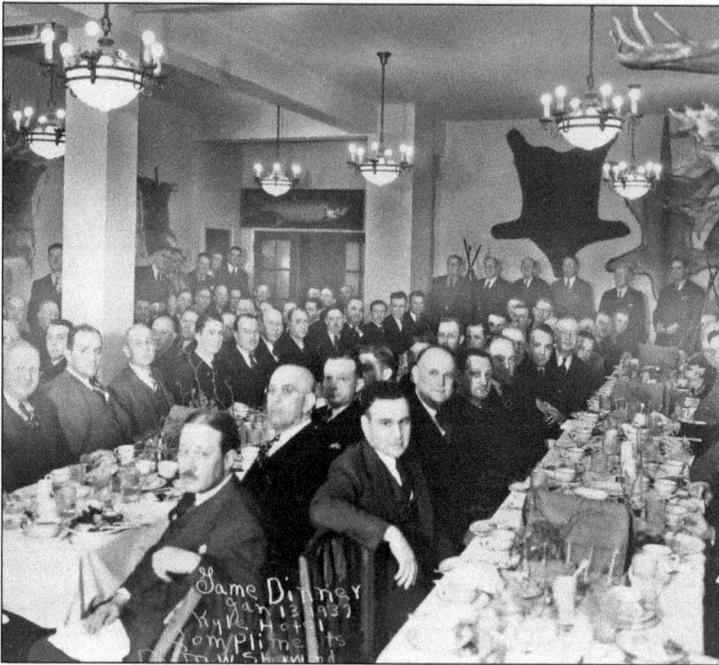

At this game party held in 1937 in the Kyle Hotel luncheon room, 116 men attended. Dr. A. C. Scott exhibited two caribou he shot in Alaska. An avid hunter, Dr. Marcel W. Sherwood was the host for the Stag Party to celebrate the first black bear shot by him in 36 years. Dinner of bear, venison, quail, duck, and squirrel was served buffet style. (Courtesy of Temple Public Library.)

Pictured in 1893 from left to right are R. L. McKnight, ? Harris, and Dr. Murray L. Chapman. Harris and Chapman worked for McKnight in his grocery store. McKnight started in the grocery business in 1892. The three are in Stag Party costumes. The event was in the home of W. Goodrich Jones. (Courtesy of Kelsey Collection.)

Midway Park was halfway between Belton and Temple. Automobile races, dog races, horse races, fairs, Vaudeville acts, picnics, and watermelon feasts were held there. The Ku Klux Klan used it as a meeting place. Pictured at Midway is Dr. Murray L. Chapman, at right. The others are unidentified. (Courtesy of Kelsey Collection.)

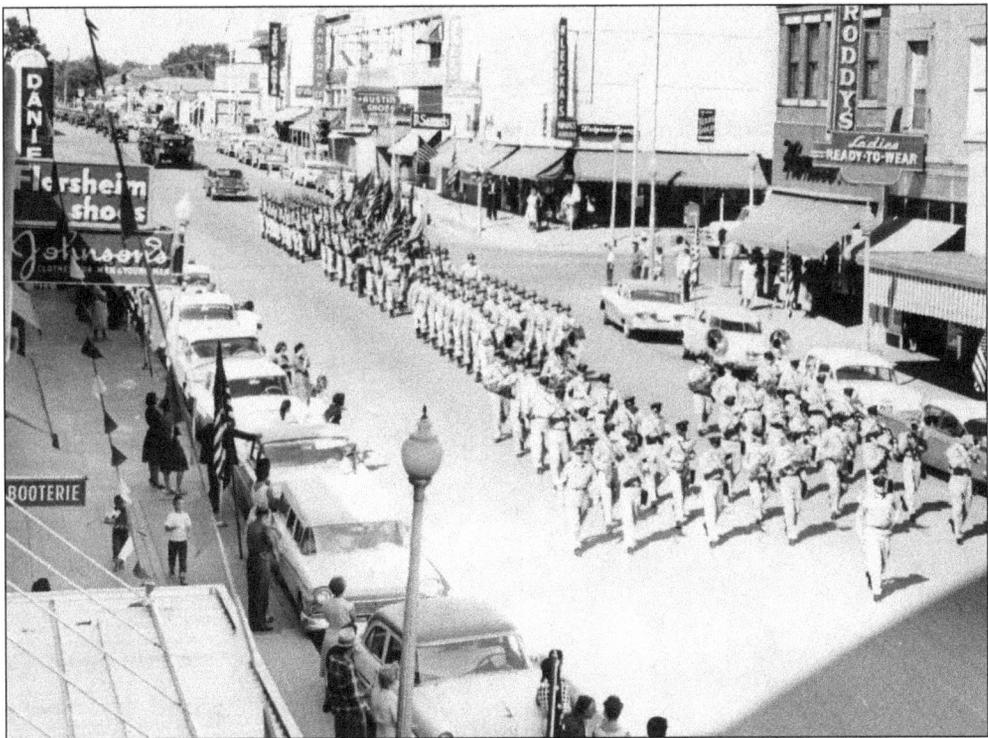

Marching in a parade around 1960 is the 266th U.S. Army Band from Fort Hood. The parade is going south on Main Street at the intersection of Central Avenue. Businesses visible in the photograph are Roddy's, Samuels, Zale's, Anthony's, Terry Farris, and Johnson's. (Courtesy of Temple Public Library.)

Will Allen Droomgoole (1860–1934) of Tennessee was the editor of *Bell County News*, first published in 1884. Her brother-in-law J. Waggoner was a teacher in Temple's first school. She wrote 13 books, 7,500 poems, and 5,000 columns of essays. After returning to Tennessee, she is pictured in 1898 holding a photograph of Pinkney Downs, a Temple banker. Both were members of Temple Literary Society. (Courtesy of Temple Public Library.)

James Madison Davis (1853–1929) and Sarah Ann Elizabeth Richardson Davis, pictured in their buggy, lived southeast of town where he was a farmer. The family moved to Bell County in 1888. They were members of the Church of Christ. Their son William Davis worked for Cooper Grocery, and at one time was superintendent of the county home. (Courtesy of Carol Dreesen.)

Pictured are the 1950–1952 Temple city officials. From left to right are C. L. Walker, mayor; Richard Vannoy, secretary; Shirley Richards; Henry Blum; Louis B. Jenkins; Winston Liles; and William E. Routh, city manager. Not shown is Bryon Skelton, city attorney. Accomplishments in 1950 and 1951 included adding fluorine to the city water system, two-way radios on fire trucks, new streetlights, a municipal retirement system, and a civil defense program. (Courtesy of Kelsey Collection.)

Rev. Anderson Clark and Sara Wilder Clark are pictured on their 65th anniversary in 1922. In 1869, they moved from Mississippi to west of Temple, where he taught school and preached. According to descendants, he carried the piano visible on the porch in a wagon to church meetings; when he sold lots at Cyclone, the deeds had a clause forbidding the sale of liquor. (Courtesy of Jennie Peteete.)

Marcia Sherwood (left) and her daughter Maude Scott were from Gainesville. In 1895, Sherwood was elected state secretary at King's Daughters state convention in Dallas. Scott, the wife of Dr. A. C. Scott, majored in piano and organ and taught music until her marriage. Even though scarlet fever caused her to be slightly deaf, she was recognized as a competent musician and storyteller. (Courtesy of Scott and White Hospital Archives.)

Past presidents of the chamber of commerce pose for this formal photograph. The meeting was to let men who helped build Temple and the chamber join for visitation and fellowship. Bylaws called for past presidents to act as advisors to the chamber and to serve on various committees. At first called the board of trade, regularly-kept minutes and records of the chamber dated to about 1912. (Courtesy of Temple Public Library.)

Three hundred men attended the 18th annual Stag Party held in 1910 at the Carnegie Library auditorium. A feature of the evening was a mock trial by the Grouch Committee. The committee charged A. H. Parsons with sundry offences. George Pendleton won a turkey for telling the funniest story, and Charles M. Campbell spoke on the Temple-Northwestern Railroad. (Courtesy of Temple Public Library.)

Standing at left is cowboy actor Lash LaRue (1917–1996) dressed in his usual black outfit and holding a bullwhip. The photograph was taken just after LaRue, the "king of the bullwhip," knocked, with his whip, a cigarette out of the mouth of Robert Stone. Stone managed Temple Theatre, where LaRue's movie was showing. (Courtesy of Sam Houston.)

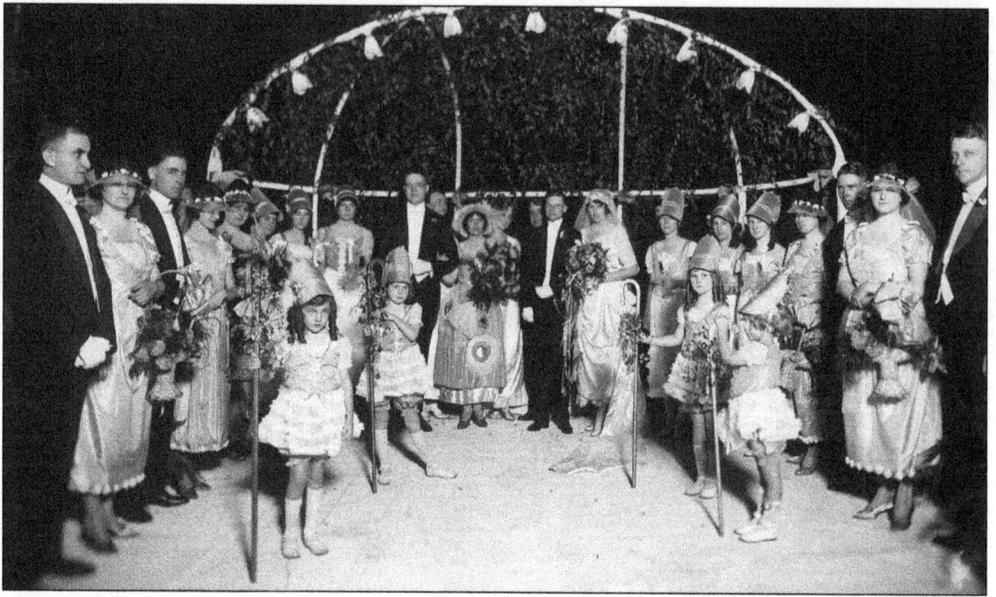

Faye Rudd and Dr. Charles Chiles were married at her home on September 16, 1919. The wedding ceremony had a fairyland theme. Junior bridesmaids Mildred Rudd, Helen Black, Mary McCelvey, Lois Gresham, Katherine Downs, and Dorothy Young were dressed in 15th-century style. Elizabeth Thomas, Doris Barton, Hattie Stokes, and Mary Jones scattered rose petals. By 1930, Faye and her two children lived with her mother in Temple. (Courtesy of Temple Public Library.)

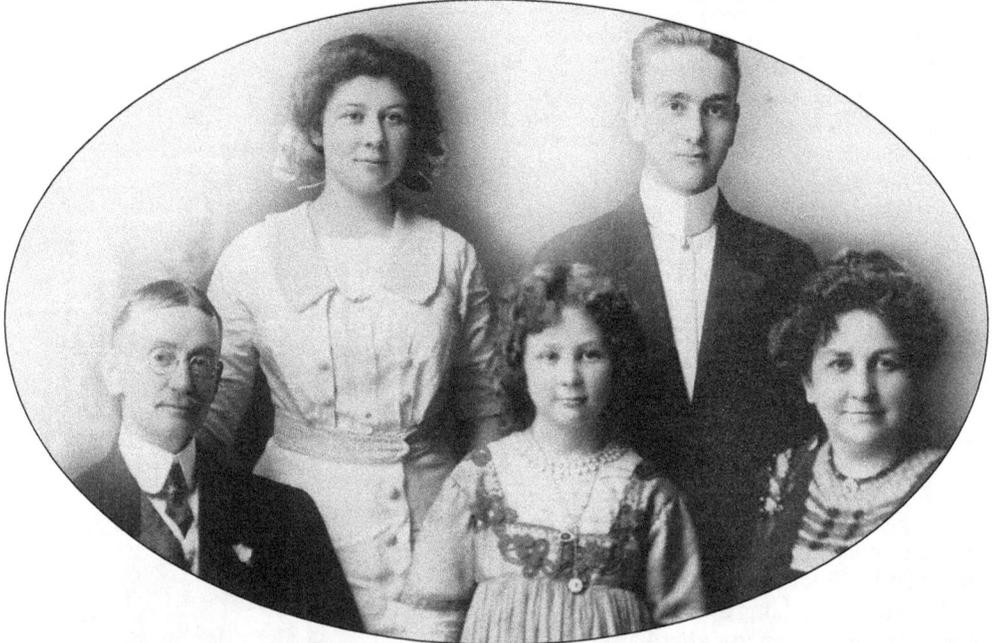

Banker W. Goodrich Jones (1860–1950) and Zollie Luther Jones lived on North 3rd Street. The Jones family came to Texas in the 1830s and lived at Galveston. A teacher, Zollie Luther Jones was the daughter of Rev. John Hill Luther. W. Goodrich Jones, known as the father of forestry in Texas, has a state forest in East Texas named in his honor. He founded Temple Book Concern in 1890. (Courtesy of Temple Public Library.)

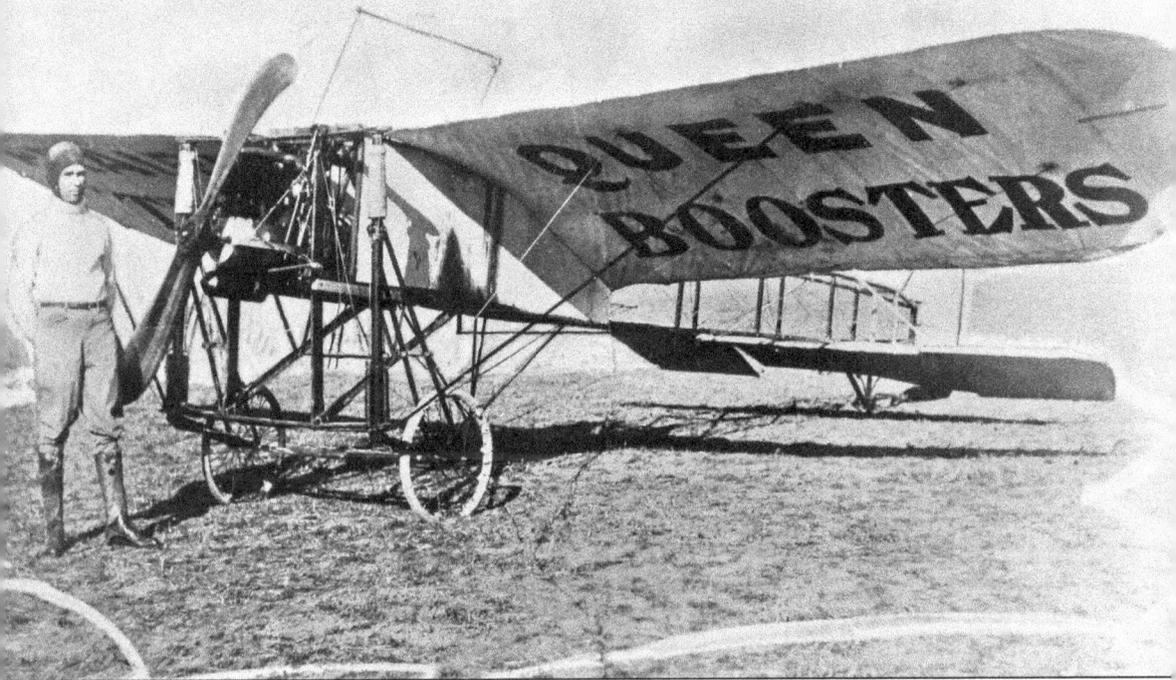

Pictured is George K. Williams standing beside the Prairie Queen airplane. He was one of the aviation pioneers in Texas and built his first airplane in 1910. He took the contraption out to a location near South 29th Street and Avenue L and flew it a short distance. A grass airfield was two miles west of Temple on the Temple–Belton Pike near where the intersection of Interstate 35 and the Loop is today. Williams employed the services of Eric A. Locking and formed Temple Aero Club. The club offered flying lessons, passenger flights, aerial photography, stunt flying, and aerial advertising. Williams is credited with having the first aircraft factory in Texas. In 1928, he developed and manufactured the 25-foot-10-inch-long Temple Monoplane from the facilities at the *Temple Daily Telegram's* Woodlawn Flying Field. In 1920, Temple Aero Club sent its public service hospital stretcher Standard J-O airplane to Eastland, where there was a district medical association meeting. Only 12 planes were built before Williams's death in 1930. (Courtesy of Temple Public Library.)

Seated in front of their home at 1401 North Main Street in 1944 are John and Mary Ethel McAlexander. He was a brick contractor, and in addition to work in Temple, he did concrete, plastering, and brickwork in Mexia, Belton, McGregor, Taylor, Austin, Bartlett, Rosebud, Rogers, Rosenburg, Killeen, and Cameron. His father, Don A. McAlexander, came to Temple in 1887 to build the opera house. (Courtesy of Kelsey Collection.)

Pictured from left to right are Myrtle Bayless Vann, Henry Vann, and their daughter Grace Elizabeth Vann. The photograph was taken in their yard at 1106 North Main Street. The Vanns were from Brown County in West Texas. He worked in Temple for the railroad as a mail clerk, retiring in 1948. He never learned to drive and walked to and from the depot to work. (Courtesy of Kelsey Collection.)

Eva Kimble poses in this 1935 photograph on the Santa Fe Hospital grounds on South 25th Street. She was three years old. The ornate hospital entrance is visible at left, and two service stations on South 25th Street are visible in the photograph. Although modernized, the Texaco station still stands and is one of the oldest in Temple. (Courtesy of Jennie Peteete.)

McDowell Band organized in 1895. The roster of the McDowell Band in 1899 included: X. B. Saunders Jr., president; W. A. Jakel, bandmaster; E. T. Williams; Stuart Shaw; Joe Freedman; J. L. Hunter; A. A. Sampson; Walker Stephens; O. B. Dickey; R. E. Brotherman; Walter Freeland; Hjalma Brotherman; D. McFarlan; Frank Wallney; J. C. Parnell; W. T. Menge; E. O. Smith; and R. T. Dennis. (Courtesy of Temple Public Library.)

Pictured are officers of the Knob Creek Masonic Lodge at the 1967–1968 installation. The following are in the photograph: Thomas S. Clifton, Luke E. Sommers, Frank Bruner, H. E. James, A. L. Liles, J. W. Gregory, W. R. Whitehead, Kyle Turknett, Jerry H. Stephens, John Weaver, and Edward O. Hurta. (Courtesy of Kelsey Collection.)

Pictured from left to right are Weir Routh, Louis Jenkins, Winston Liles, C. L. "Chick" Walker, Shirley Richards, and Henry Blum in 1951 at the new 278-meter parking lot ribbon cutting. Walker was mayor, Routh acting city manager, and the others were city commissioners. There were five exits and five entrances to the largest metered parking lot in the state. Parking fees were a nickel for two hours. (Courtesy of Kelsey Collection.)

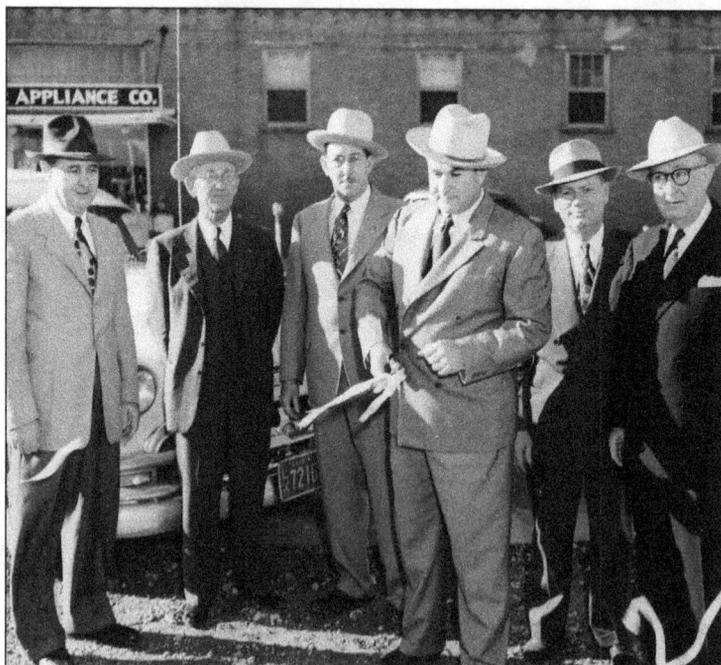

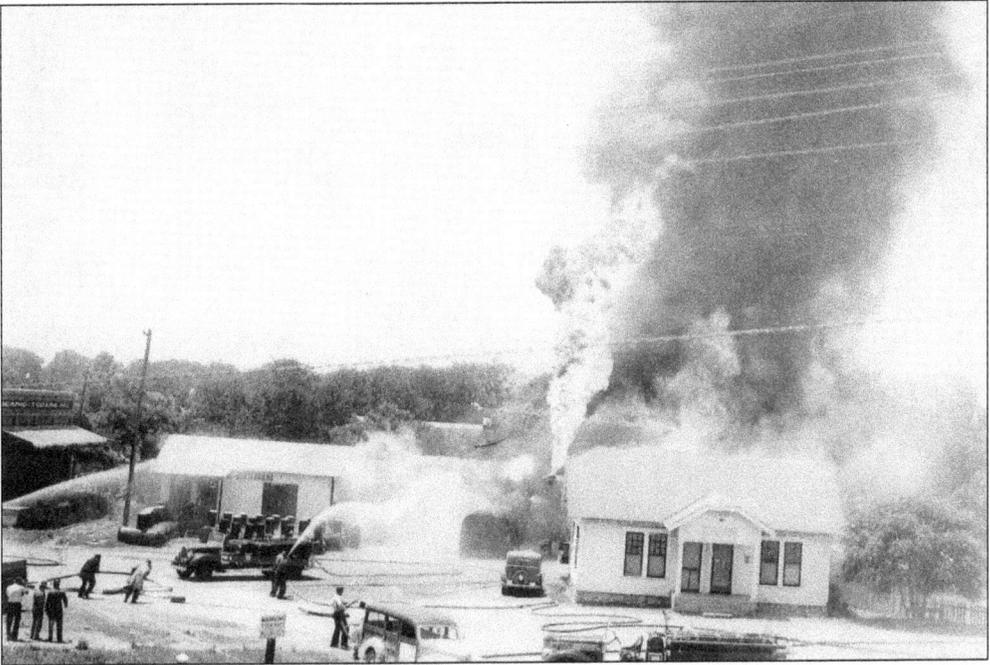

Pictured is the Temple Fire Department fighting a fire on South Main Street across the street from Temple Granite and south of the Gulf, Colorado and Santa Fe Railway track. The fire started with an explosion at Bigham Butane. The flames were so big that they crossed South Main Street. People were seen running in all directions. (Courtesy of Kelsey Collection.)

A patriot parade passes down Main Street. The view is of the east side of the town square as it appeared in the early 1950s. Post–World War II alterations to the buildings' facades have already taken place. Montgomery Ward occupied the site of the Mississippi Store, a Temple landmark for many years. (Courtesy of Temple Public Library.)

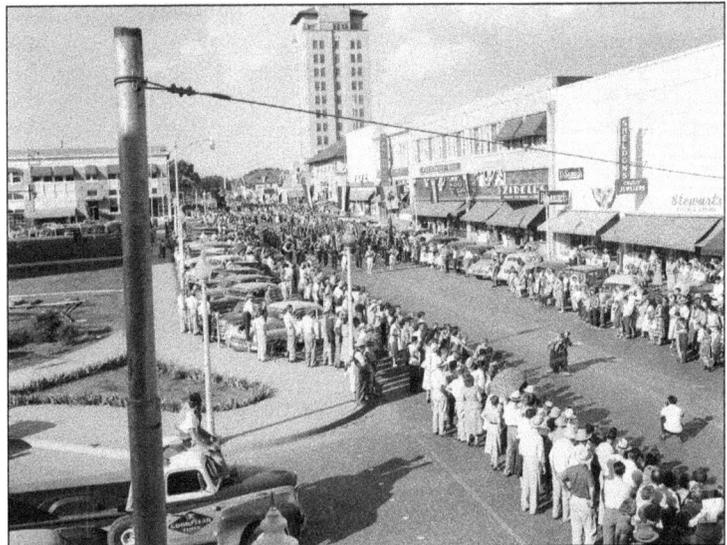

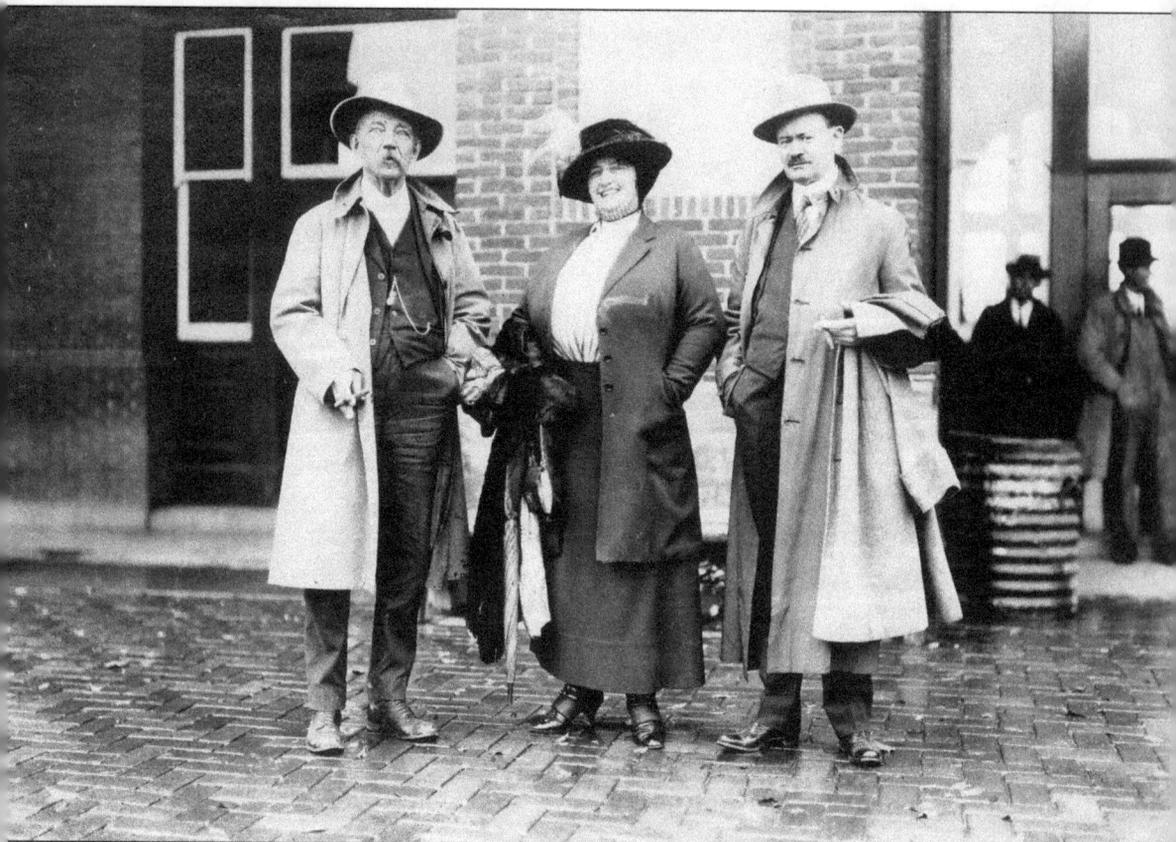

Pictured on the left is John R. Lunsford (1857–1934) at the Santa Fe depot. The other two people are unidentified. Lunsford was in the newspaper business for more than 50 years. His first job was selling the *Charleston Mercury* newspaper. During the Civil War, his father, John Randolph Lunsford, sublet a part of their three-story brick residence to the newspaper. The elder Lunsford was a member of the Marion artillery and was at Fort Moultrie when the first gun of the war fired. He came to Belton in 1878. Soon after admission to the bar in 1881, he went to work for the *Waco Examiner*. Then he came from Corsicana to Temple in 1887 and went to work for the *Temple Times*. He went on to work for newspapers in San Antonio, Galveston, Austin, Chicago, and New Orleans. In 1917, he returned to Temple to work for the *Ferguson Forum*. He also worked at the *Temple Mirror* and *Temple Daily Telegram*. (Courtesy of Tom and MaryBelle Brown.)

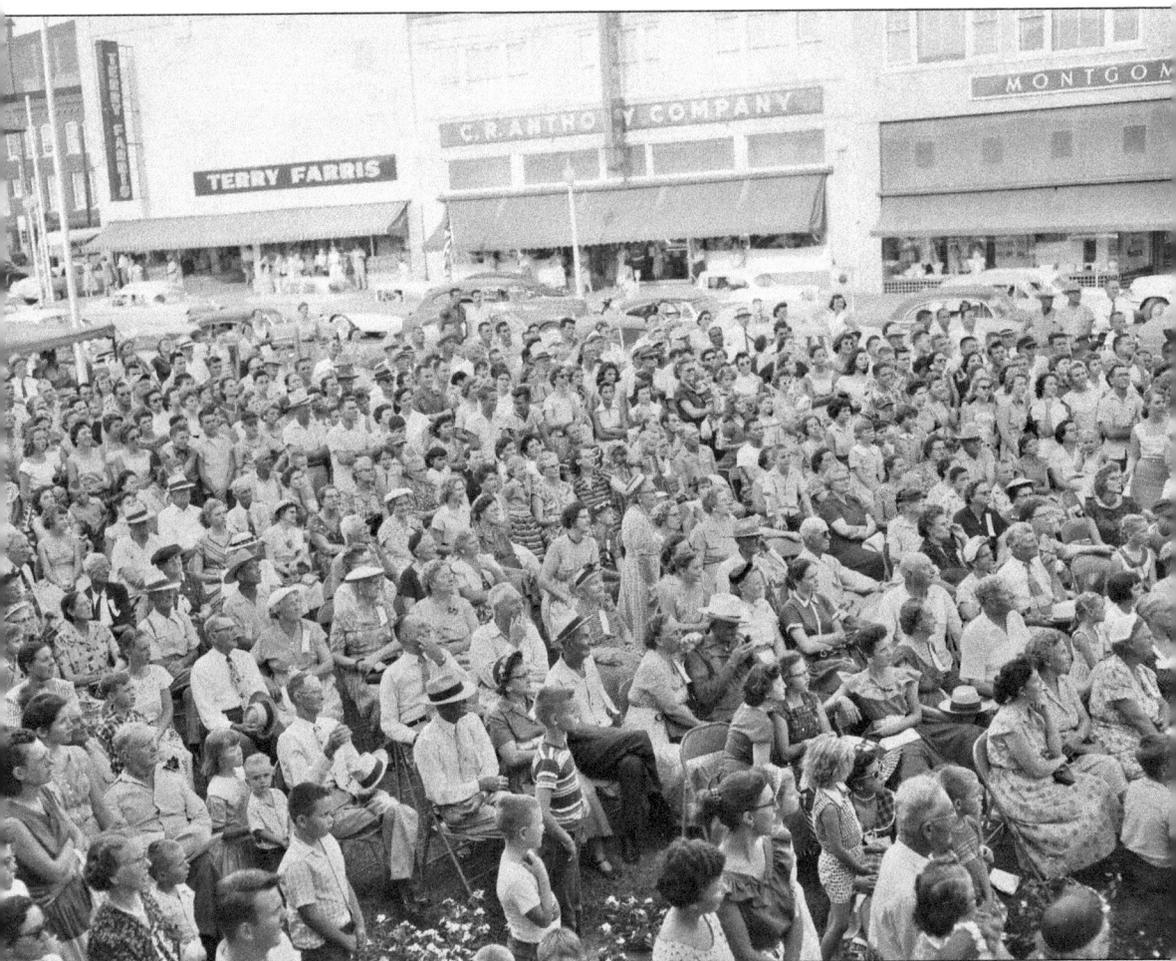

Since 1882, Temple has celebrated its birthday. At the time of Temple's 10th birthday in 1891, Parson's Brigade had its reunion in Temple. On the 50th anniversary of Temple's birth, in 1931, was the first Pioneer Day. Since then, the *Temple Daily Telegram* has hosted the annual event. Anyone who lived in Central Texas for 50 years or more was eligible to join. There were no dues. Essays, reminiscences, music, fiddler contests, speeches, and parades were events of the celebration. On Pioneer Day in 1940, Lou Holcomb joined at the age of 90. She had lived in Bell County for 88 years. Pictured is the crowd on the grounds of the Municipal Building on Pioneer Day on Temple's 75th birthday in 1956. Mr. and Mrs. W. E. McElroy won the prize for being the oldest couple. Their combined ages totaled 170 years. Ralph Yarbrough attended the event and paid homage to the pioneers who founded Temple. (Courtesy of Temple Public Library.)

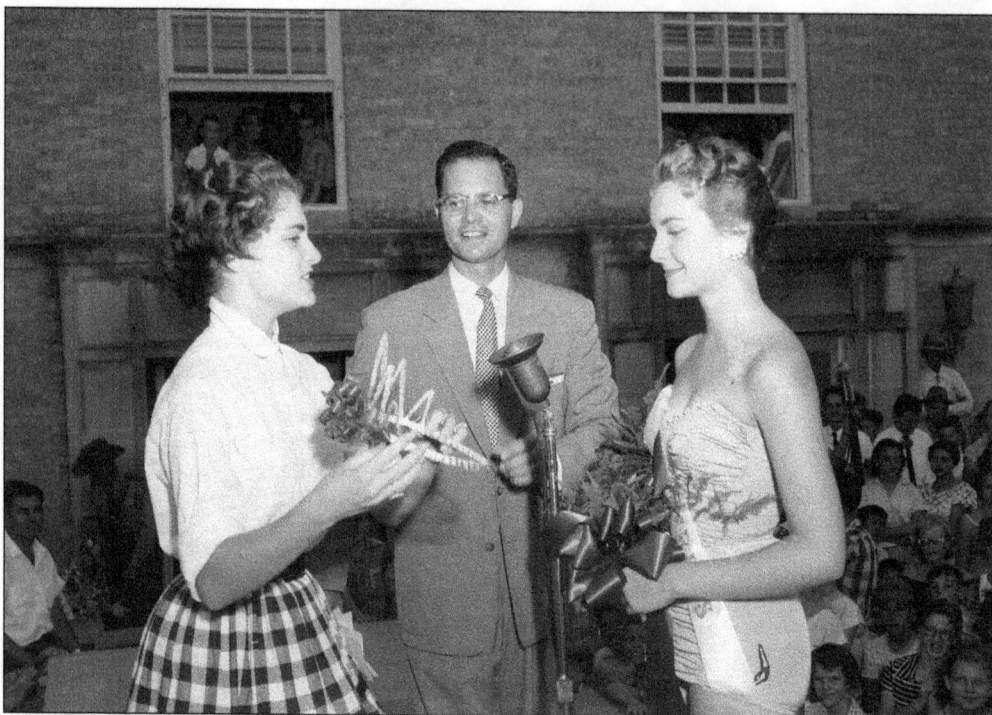

On Pioneer Day in 1956, Janice LaRue Gothard, age 16, won the beauty contest and was crowned Miss Temple. Charlsey Smith of Belton, Miss Central Texas of 1955, crowned the new queen. Dale Phares was the master of ceremonies and announced the three-judge decision on the winner of the beauty contest. (Courtesy of Temple Public Library.)

In a contest on Pioneer Day in 1956, Mrs. William Schuake, a Central Texas Pioneer Club member, won a Bible for being the mother present at the event with the greatest number of living children. She was the mother of 12 children and lived on Route 4 near Temple. (Courtesy of Temple Public Library.)

Temple Public Library at 100 West Adams Avenue and the Railroad and Heritage Museum at 315 West Avenue B have excellent archives of photographs of Temple and Bell County. Here Craig Ordner, archivist for the Railroad and Heritage Museum, displays a rare city map of Temple from 1892 that was donated to the museum by an Amarillo collector. His contact information is 254-298-5190 and craigrrhm@sbcglobal.net. Michael Kelsey is the contact person at Temple Public Library, and his contact information is 254-298-5283 and mkelsey@ci.temple.tx.us. The mission of the Railroad and Heritage Museum is to collect, preserve, and exhibit the history of railroading in the southwest United States, in order to engage a diverse audience in appreciating their heritage as a part of the foundation for their future. The museum accomplishes this through an archive collection, exhibitions, programs, and publications that enlighten, educate, and entertain all ages.

Visit us at
arcadiapublishing.com

www.ingramcontent.com/pod-product-compliance
Lightning Source LLC
Chambersburg PA
CBHW050601110426
42813CB00008B/2426